The Galápagos

92° 91° 90°

Roca
Redonda

Pinta

Marchena Genovesa

Santiago

Fernandina

Baltra

Santa Cruz

Santa Fe

Isabela

Floreana

contour interval = 1,000 ft

Galápagos Islands

Equator

Island Names

Current	In Darwin's time
Baltra	South Seymour
Española	Hood
Fernandina	Narborough
Floreana	Charles
Genovesa	Tower
Isabela	Albemarle
Marchena	Bindlow
Pinta	Abington
Santa Cruz	Indefatigable
Santa Fe	Barrington
Santiago	James
San Cristóbal	Chatham

San Cristóbal

Española

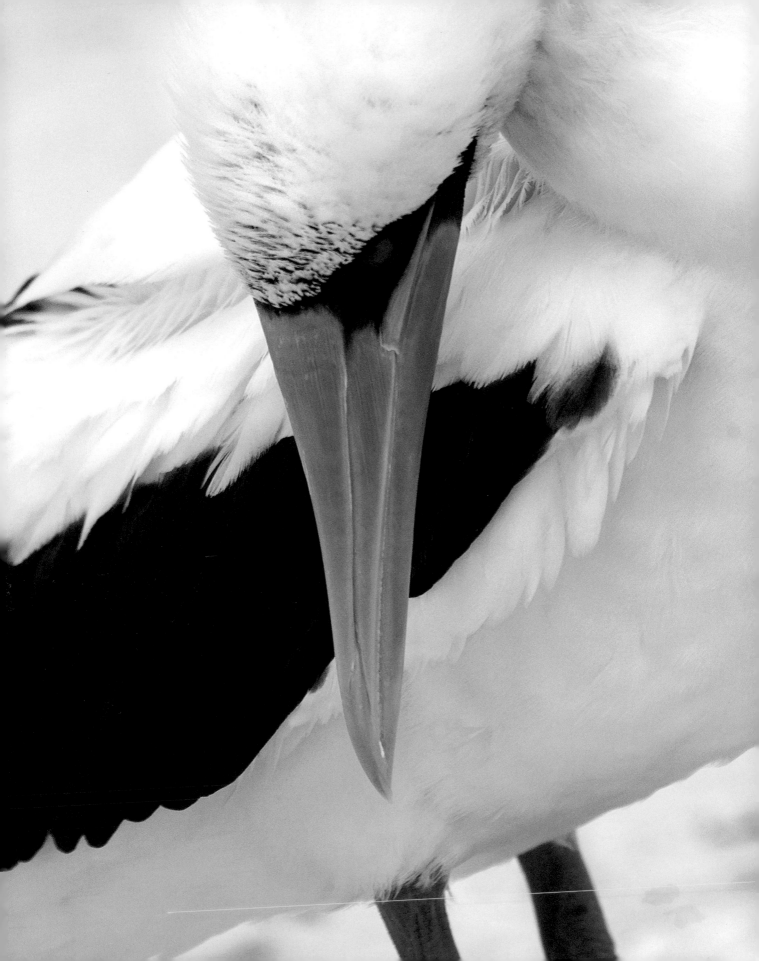

The Galápagos

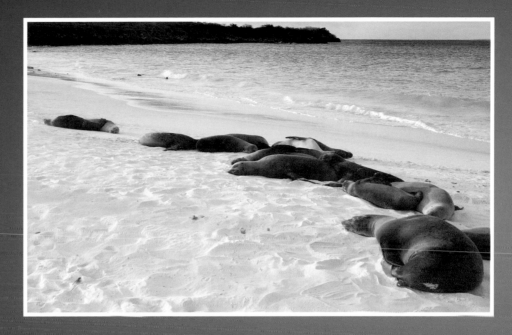

Exploring Darwin's Tapestry

— John Hess —

University of Missouri Press

Columbia and London

Library of Congress Cataloging-in-Publication Data

Hess, John. 1942–
The Galápagos : exploring Darwin's tapestry / John Hess.
 p. cm.
Includes index.
Summary: "Evolutionary ecologist and photographer John Hess presents the Galápagos in
stunning photographs and insightful prose, celebrating the archipelago as a unique place
to appreciate the achievements of Charles Darwin and other biologists as well as a place for
visitors to experience the wonders of the natural world"—Provided by publisher.

ISBN 978-0-8262-1837-7 (alk. paper)
1. Animals—Galapagos Islands. 2. Animals—Galapagos Islands.—Pictorial works 3. Natural
history—Galapagos Islands. 4. Natural history—Galapagos Islands—Pictorial works. I. Title.

QL345.G2H47 2009
508.866′50222—dc22 2008043151

∞™ This paper meets the requirements of the
American National Standard for Permanence of Paper
for Printed Library Materials, Z39.48, 1984.

Design and composition: Jennifer Cropp
Printer and binder: Four Colour Imports, Ltd.
Typefaces: Minon, Expectation, and Golden Cockerel

*The University of Missouri Press offers its grateful acknowledgment to the
University of Central Missouri, College of Science and Technology for a
generous contribution toward the color production and printing of this book.*

To Gina—my wife, my best friend, and quite
probably the kindest person I've ever met.
This is the book we couldn't find anywhere.

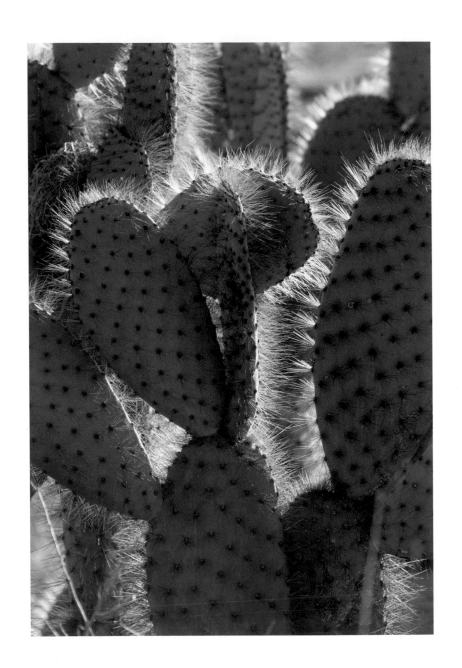

Contents

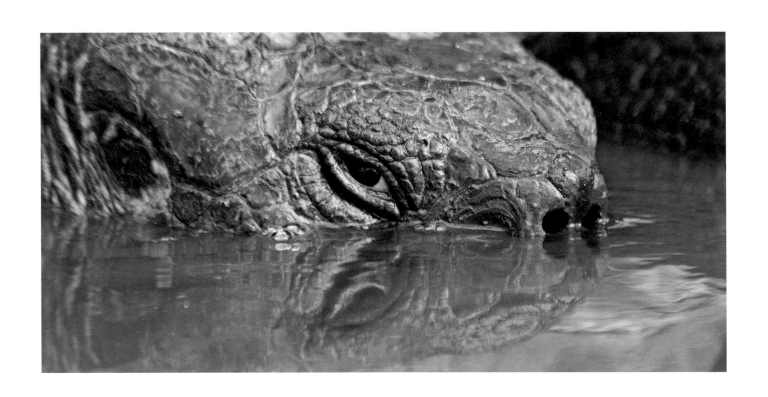

Preface

The Galápagos archipelago is a forbidding cluster of volcanic desert islands astride the equator. It is a bit of Eden lost, or as Herman Melville would have it in *The Enchanted Isles,* a little piece of hell. This place lends itself to paradox—it is both old and young, simple and complex, sterile and fertile, oasis and prison. It is worthless and it is priceless.

This book is my tribute to a place, and to a profound idea that envelops it like a swaddling blanket. I've been steeped in photography and evolutionary biology for more than forty years, so it is not surprising that my tribute takes this form. Together these two disciplines—art and science—have been the lenses through which I see the world and the mouthpieces through which I share what I have learned. I call myself a naturalist. For a naturalist, the journey to the Galápagos is a pilgrimage, not so much to visit a "shrine" as it is a rare opportunity to experience a place so wonderfully unique that it nurtured the idea that Charles Darwin officially presented to the world in 1859.

The Galápagos Islands arouse metaphor as surely as flowers draw bees, but this book is foremost a portfolio of images and only secondly a narrative of insights. I can "write science," but I know that the surest path to the reader's consciousness doesn't go through the left brain. It goes through the right brain and then deeper, creating a more visceral emotional response. Awe is the dominant response that I want. Awe is produced by great beauty and by power—by pounding surf, by boundless panorama, and by intimate detail. The sensation of awe can be enhanced by drawing on the rational strengths of the left brain. Even more amazing than the bright blue feet of a booby is the reason it needs them and how it uses them. And why is it that a bird of the open ocean can't swim, and how can it be that an island might sink?

I've granted myself quite a bit of license because this is not a science book, although the science is accurate to the best of my knowledge. This is a book of experience and response. Without apology I mix myth and metaphor with science and history. I speak of the character that we insist on applying to any animal as its *persona,* for lack of a better word. This approach is frankly anthropocentric, and there is the risk that a reader might lose touch with the fact that these are not little people with scales or feathers—even though that idea has resonated with us throughout our history.

Each of us responds to the shapes and colors of animals in ways that are partly innate, partly cultural, and partly a product of our individual experiences. Of these three, only our experiences are unique, so we all are inclined to respond to an eagle in a similar way—we see it as "noble." A part of our reaction is innate, largely the response we would have to a human with the same suite of facial characters. We perceive the fierce visage of an eagle as "stern," "noble," or "decisive," imbuing the bird with a persona based on how we interpret a bony extension of the skull that serves to protect the eye. It tells us nothing about the bird's mental state. Even though we know better, we respond to that bony extension anyhow. All of us. Meanwhile, a penguin shuffling by on its short legs is comical, cute, and possibly adorable. Isn't it.

However whimsical are the personas that we project onto animals, they are of consequence. Such characterizations are a substantial factor in determining whether we, the public, can be motivated to prevent the extinction of a species. People care about polar bears, wolves, eagles, and seal pups. "Cuddly" is a more positive stimulus than "dangerous"—although polar bears somehow manage to strike us with both qualities at the same time—but at any rate, it clearly helps any animal's popularity among humans if its persona tickles our innate responses.

So I take pleasure in responding to the persona of this bird or that sea lion, and I enjoy applying myth and metaphor to them, because real or not, the animal's persona is a major bridge between humans and the natural world. It is a vehicle that enables us to extend our powers of empathy to very different and yet kindred life forms. There is great pleasure to be found here.

This book will be a valuable resource for those who anticipate a trip to the Galápagos and hope to lay some foundation for the experience, which can be overwhelming. It will also serve returning travelers who want to hold on to those encounters, learn more about this special place, and further enrich their experience by placing it in a larger context. Finally, it is presented as an exploration of the visual delights of the islands. The Galápagos is a place to celebrate evolution itself—the achievement of Darwin, Wallace, and those who followed—and the solution of a profound mystery at once simple and complex.

Acknowledgments

I've had a lot of help with all facets of this book. My wife, Regina, has been a tremendous support in this lengthy undertaking. She has contributed some of her own photographs, used her artistic flair to broaden my world, and served as chief editor and portable thesaurus. She has been an endless source of the encouragement and flattery that are the necessary fuels for an undertaking of this sort.

I have been delighted with the generosity of scientists in the Galápagos research community—experts by any standards. Kate Huyvaert, Colorado State University, made time for my questions, edited several chapters for me, and in general has been an invaluable source of refined information on the birds of the Galápagos, especially the waved albatross. I am indebted to Peter Grant, Princeton University, Patricia Parker, University of Missouri–St. Louis, and Sarah Huber, Randolph-Macon College, for confirming and where necessary correcting my identification of finches and, most important, for taking the time to explain why they made their identifications as they did. John Faaborg, at the University of Missouri, made constructive criticisms throughout the text and brought me up to date on the Galápagos hawks after long conversations years ago. Earl Meseth, at Elmhurst College, kindly shared his hard-won knowledge of the terminology of albatross behavior.

I also owe a great deal to Dale Hess, Kendy Hess, and Jeanne Kern, who have graciously given me the benefit not only of their sharp-eyed editing skills but also of their insights and experience—gifts that were happily given and are deeply appreciated.

The Archipelago

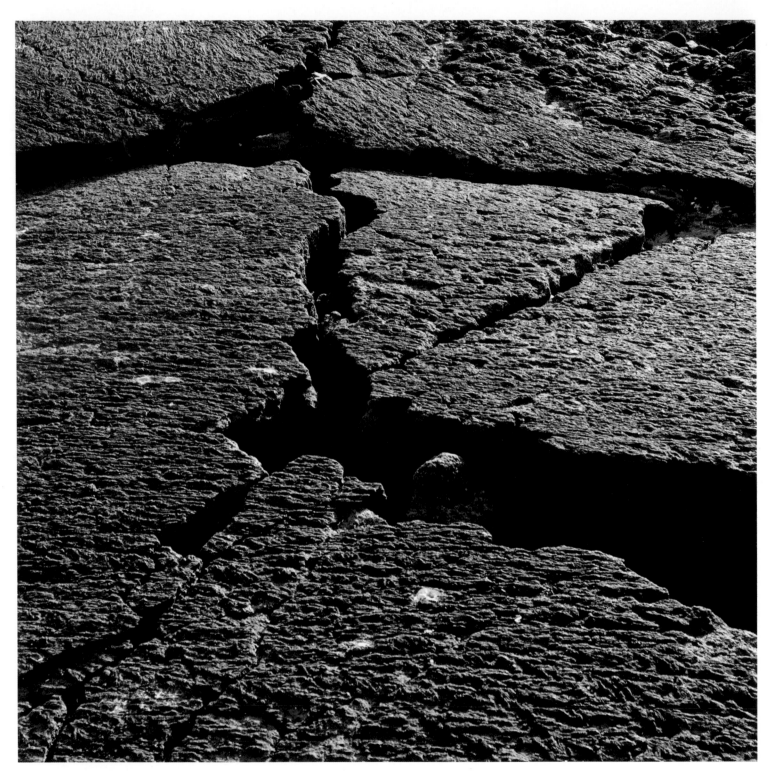

1.1 A flow of smooth lava of a type called "pahoehoe"—limited to islands formed over a hot spot—has broken into plates that serve as a fine visual metaphor for the tectonic plates on which the island rests.

1

Physical Forces

The sublimity, the majesty, the terrific grandeur of this scene baffle description and set the powers of language at defiance.—Benjamin Morrell, on witnessing a volcanic eruption on Fernandina

Every story begins somewhere. Usually the beginning, the "once upon a time," is lost in the obscure past, but we do know exactly when the Galápagos story began. It was during the high point of the age of dinosaurs, about 90 million years ago. One could haggle about the use of the terms *exactly* and *about* to describe the same event, but it is a matter of perspective, and the largest part of the Galápagos experience is the gaining of perspective.

The Galápagos archipelago had its beginning when a magma plume rose from deep in the earth's mantle and began dribbling lava onto the ocean floor. It had already been dribbling for 25 million years by the time an asteroid crashed into the earth just fifteen hundred miles north of it, incinerating enormous regions of the world and precipitating the disappearance of the dinosaurs. Soon the birds and mammals, with all their extravagant diversity, assumed the niches vacated by the dinosaurs and created more. The lava kept on dribbling, as it does today, building the landscape that supports the species that fired the imagination of Charles Darwin.

Darwin's experience here was instrumental in focusing his research along the lines that became evolutionary theory. From our position in the present, we can now ask questions and develop answers that Darwin could only dream about, and he was an astute dreamer. Standing on his shoulders and those of many more, we have the wherewithal to appreciate the rich understanding that their discoveries made possible.

The earth's surface is formed of a large number of enormous crustal segments called tectonic plates. They are hundreds to thousands of miles across but less than ten miles thick, and they cover the planet like a much-cracked shell covers a hard-boiled egg. But unlike eggshell fragments that are locked in place, tectonic plates drift about, pushed by the movement of the viscous magma upon which they float. They cannot move freely because they are constrained by their neighbors, but they do move, slowly and powerfully, driven by immense and incessant forces well beyond our imagination. They jostle each other at faults, and in some places—zones of subduction—the thinner oceanic plates slip beneath the continental plates and are thrust deeply into the mantle.

The Nazca Plate, upon which the Galápagos Islands ride, is one of these oceanic plates. It is moving east at about three inches per year—unusually fast for a tectonic plate. It is six miles thick, but its eastern edge is buckling under the weight of the South American Plate, causing volcanic activity and earthquakes, perhaps hundreds of miles beneath the surface. The levels of energy released are far beyond our powers of comprehension. Even though we know something of the mechanics of this activity, its incredible power forces upon us a new appreciation of our fragility.

In 1825, about ten years before the arrival of Charles Darwin, Captain Benjamin Morrell had anchored the HMS *Tartar* in Banks Bay just ten miles north of Punta Espinosa. From that vantage point he witnessed an eruption, and his eloquent words provide a rare glimpse into the fearsome forces at play:

The flames shot upward from the peak of Narborough [Fernandina] to the height of at least two thousand feet in the air. . . . A

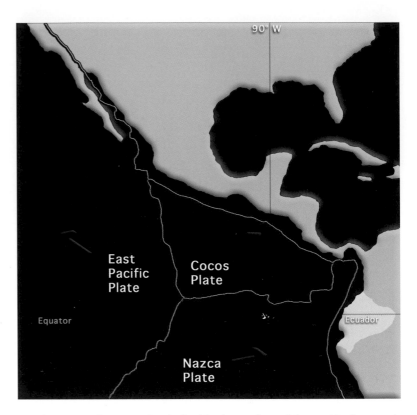

1.2 The tiny Galápagos Islands freckle the surface of the Pacific due south of St. Louis, where they straddle the equator in benevolent isolation.

river of melted lava was now seen rushing down the side of the mountain pursuing a serpentine course to the sea, a distance of about three miles from the blazing orifice of the volcano. This dazzling stream descended in a gully, one fourth of a mile in width, presenting the appearance of a tremendous torrent of melted iron running from the furnace. Although the mountain was steep and the gully capacious, the flaming river could not descend with sufficient rapidity to prevent its overflowing its banks in certain places, and forming new rivers, which branched out in almost every direction, each rushing downward as if eager to cool its temperature in the deep caverns of the neighboring ocean.

. . . The heat was so great that melted pitch was running from the vessel's seams and tar dropping from the rigging. . . . The *Tartar* slid along through the almost boiling ocean at the rate of about seven miles an hour. On passing the currents of melted lava, I became apprehensive that I should lose some of my men, as the influence of the heat was so great that several of them were incapable of

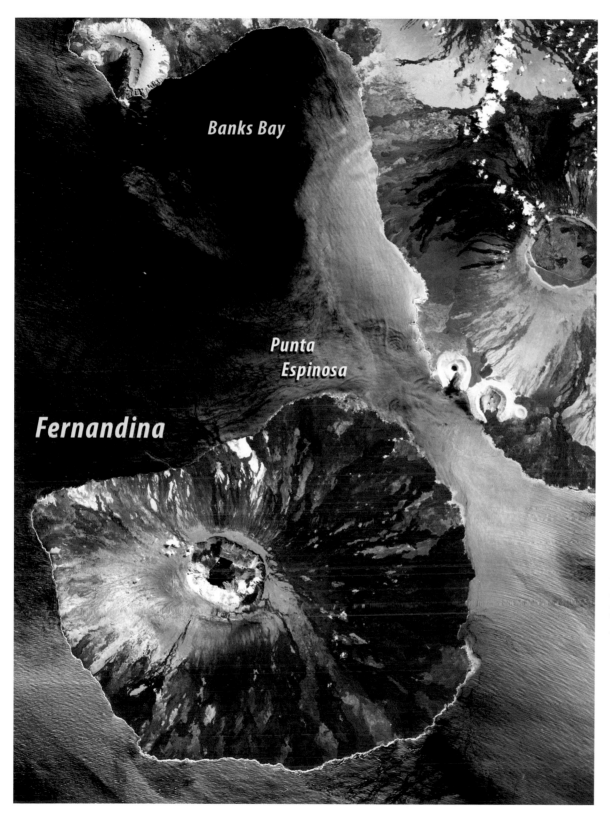

Banks Bay

Punta Espinosa

Fernandina

1.3 Fernandina is said to be seven hundred thousand years old, but much of the island is younger. The northern flows near Punta Espinosa were laid down less than two centuries ago. *NASA/GSFC/MITI/ERSDAC/JAROS, and U.S./Japan ASTER Science Team.*

standing. At the time, the mercury in the thermometer was at 147 degrees, but on immersing it in the water it instantly rose to 150 degrees. Had the wind deserted us there, the consequences must have been horrible.

The curious thing about tectonic hot spots is that they remain in fixed positions on the sphere of the earth, even as the oceanic plates drift by overhead. Maybe referring to a "dribble" of lava does not do justice to the magnitude of the flow, but that, too, is a matter of perspective. From time to time hot spots release magma onto the ocean floor and create submerged mountains called seamounts. If the seamounts grow enough to breach the ocean surface two miles above, an island appears. But there is more to it. The active geology of this spot has created a bulge in the Nazca Plate known as the Carnegie Ridge. It is like a local inflammation or a blister raised by the hot spot. The Galápagos Islands of today (brown in Figure 1.4) sit atop the western edge of the ridge where the youngest and tallest islands—Isabela and Fernandina—mark the location of the hot spot with their active volcanoes.

Because the Nazca Plate keeps moving to the east while the hot spot is stationary, the islands eventually lose their connection with it, and as those parts of the Carnegie Ridge cool and contract, the ridge begins to subside. The islands atop the ridge are both eroding and sinking, and eventually they slip below the surface to become seamounts once again.

The whole scenario, compressed into a time frame that we can comfortably grasp, is like the chuffing of a nineteenth-century steam locomotive. Puffs of smoke erupting from the stack are dark and substantial, but each "chuff" dissipates as it drifts away, becoming less and less substantial until it disappears altogether. Islands arise from the hot spot in much the same way, and as they drift with the plate, they leaving a spattering of seamounts to the east of the islands, as seen in Figure 1.4. Well to the east of this area lies an eight-million-year-old seamount. Its summit now lies nearly a mile below the surface, and yet it carries surf-tumbled lava. As far back as the age of the dinosaurs, there has been a flotilla of islands sailing off to the east in stately fashion and gradu-

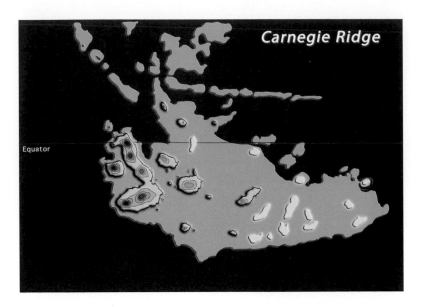

1.4 The Carnegie Ridge (light blue) is shown here at a depth of one thousand meters. To the east of the islands, scattered seamounts (white) ornament the ridge.

ally slipping below the surface. The oldest of today's islands, Española and San Cristobal, are but five million years old. They lie on the eastern edge of the archipelago, and they too will eventually become seamounts.

Five million years may seem insufficient for the evolutionary showcase of the Galápagos to have evolved. It is hard to form any meaningful concept of such large spans of time, but five million years was adequate for chimpanzee-like primates to evolve into humans, and the ancestor of the thirteen species of Darwin's finches that inhabit the Galápagos, arrived only 2.3 million years ago.[*] Still, one wonders what happened before. Some residents could be the survivors of tens of millions of years of island-hopping as new islands rise in the west and old ones slip beneath the waves to the east.

The organisms that live here today are an eclectic bunch, those that have proven their ability to survive being blown or rafted

* A fourteenth species, the Cocos finch *(Pinaroloxias inornata),* is found on Cocos Island, about four hundred miles northeast of the Galápagos.

over saltwater for long distances. It is a fortunate but exclusive group of waifs.

The most influential forces that permit remote islands to acquire residents are oceanic currents and prevailing winds. They differ from each other but are thoroughly intertwined. Their interplay not only determines where the immigrants come from but also establishes the climate of the islands and the fertility of the surrounding waters. They initiate and terminate the dramatic El Niño and La Niña events.

The strongest of these forces is the Humboldt Current, an invisible river that moves past Chile and Peru on its way to the equator at the pace of a leisurely stroll, warming as it goes. It draws very cold water from the floor of the Pacific near Antarctica and turns west as it approaches the equator, bathing the Galápagos in cool water before becoming the Equatorial Current. The water temperature near the islands is critically important, because no matter how much water is available, it cannot rain there unless air masses cool as they move over land. Baking in the equatorial sun, temperatures on land remain about ten degrees warmer than the Humboldt Current, so unless the land cools or the water warms, rainfall will be minimal and local. This is why the islands remain desert.

Besides its effects on temperature, the Humboldt Current creates an upwelling, an ecological bonanza produced when a deep ocean current collides with a landmass. In this case the landmass is the South American Plate, and the collision forces vast quantities of water to the surface—water that is not only cold but also nutrient rich. The nutrients fertilize the plankton that forms the base of the food chain and thus stimulate diversity and abundance at every level of the ecosystem all the way to the top, benefiting the largest predators. This upwelling creates the most productive marine ecosystem in the world, and even though it is a thousand miles from the Galápagos, it figures prominently in the lives of the seagoing birds that nest there.

By the time the Humboldt Current reaches the Galápagos, its productivity is spent and there is not much left in the water but the chill, but there is another current, the Equatorial Countercurrent. It is colder, smaller, and slower than the Humboldt, but it

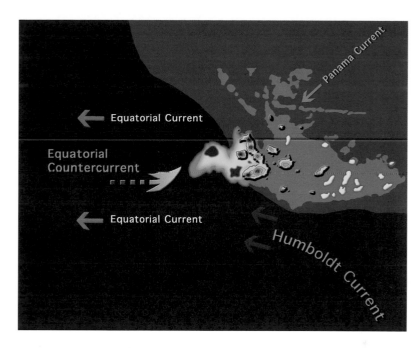

1.5 Ocean currents figure prominently in the ecology of the Galápagos. Satellite measurements of chlorophyll mark the location of an upwelling, its most productive regions shown in red.

is of direct importance to the islands because its upwelling is so close. The current flows east along the floor of the Pacific and is forced to the surface by the Carnegie Ridge and the western islands perched on it. There it creates its own upwelling and sustains the richest feeding area near the islands.

Finally there is the Panama Current. It is warm but small and it has only a minimal effect on the climate of the archipelago, even combined with the effects of the southwesterly trade winds that overlie it. Yet the combined action of wind and current provides a significant force directing Caribbean and Central American species toward the islands.

About every seven years or so, the trade winds fail, ushering in a potentially catastrophic event called El Niño. The causes of this failure are obscure but the consequences are not. When the trade winds fail, the upwellings do too, and the ecology of the islands is turned upside down. Water temperatures rise and nutrient levels plummet. Nesting seabirds abandon their colonies to save

themselves for another season, and thousands upon thousands of young perish. Members of species that cannot escape see their populations crash. Only a quarter of the Galápagos penguins survived the 1982–1983 El Niño, the strongest on record.

El Niño lasts about a year and is commonly followed by La Niña. When the trade winds return to their normal patterns, very cold water returns to the upwellings along with a pent-up supply of nutrients. La Niña produces exceptional bounty for the animals that are directly dependent on the sea, but the colder water temperatures generate extreme drought for terrestrial forms. Eventually the waters of the upwellings warm a bit, the influx of nutrients drops to normal levels, and the deserts once again receive their normal scant rainfall. Crippled populations begin to recover, and life on the islands returns to normal until the next event.

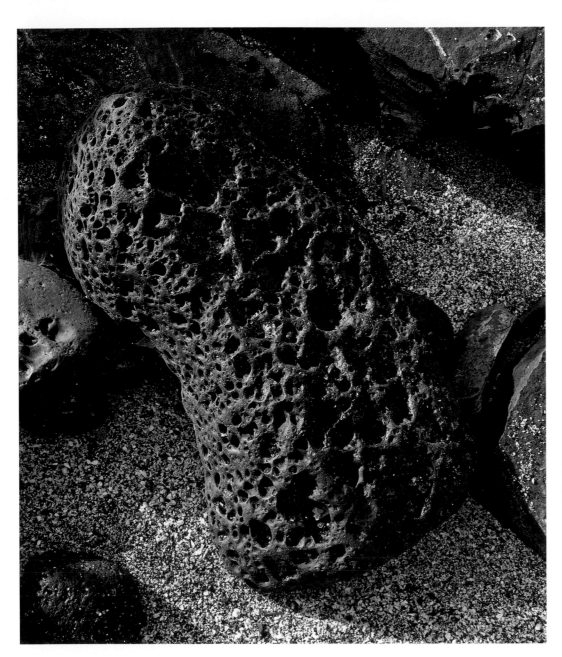

1.6 Surf-tumbled rocks are pounded until every hard edge is gone. This lava rock—riddled with gas pockets formed during a violent origin—is testament to the effects of the surf.

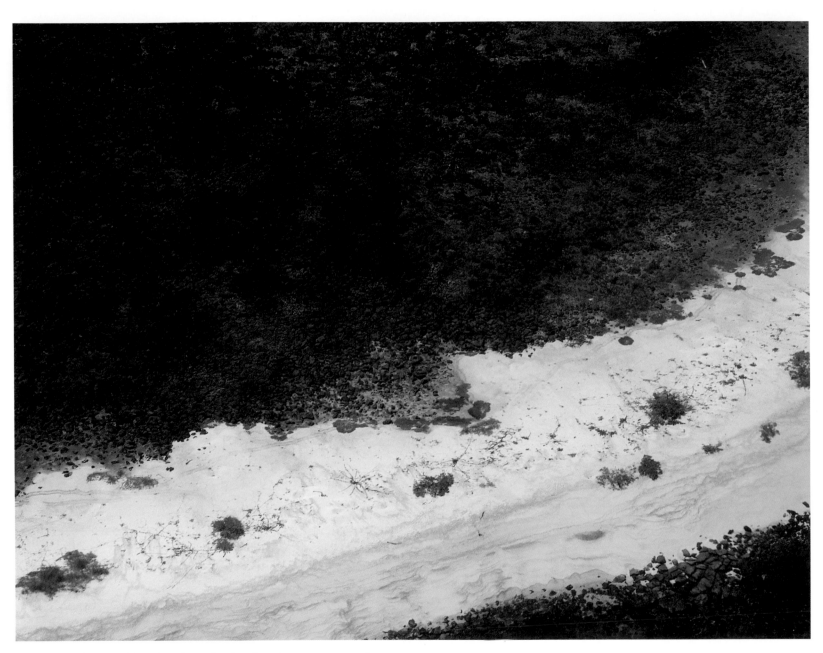

2.1 An aerial view of the shoreline of Baltra has the appearance of a tapestry
with the colors and textures that predominate on the Galápagos.

2

————— Weaving an Island Tapestry —————

The Galápagos have a malign spell which repels all efforts at colonizing . . . where life is hard and existence precarious.—Sidney Howard, in *Isles of Escape* by R. Bristow

Metaphor is a powerful way to grasp complex ideas. The best thing about metaphor is that it allows us to bypass forbidding scientific terminology to grasp fundamental relationships. Using metaphors, we can make complex relationships seem natural and large ideas tractable. Yet the nuts and bolts of science are necessary to probe deeply and with precision into the details of these relationships, and to keep it grounded in reality. Without the scaffolding of science, metaphor is bled of its promise and becomes an exercise in fantasy.

The ambition of this book is to illuminate the relationships among the most prominent plants and animals and their environment without getting lost in the technical aspects of the science. Both the ambition and the subject cry out for a metaphor, and I have one here. The Galápagos archipelago can be seen as a vast tapestry—a tapestry that engulfs the ecologist's term *ecosystem* and at the same time adds warmth and a wealth of intuitive connections. It is a magic carpet from which to experience the physical beauty of the islands, their inhabitants, and the elegance of their interactions. Even a small grasp of this complexity opens us to admiration of both the beautiful and the

grotesque, and so broadens and enriches our world. It is a worthwhile ambition and rewarding undertaking on many levels.

Like a tapestry, an ecosystem is woven of life forms that create a fabric of interdependence—an intimate meshing of parts that function only as a whole. It is the color, size, and texture of the fibers that make up the tapestry and that determine what kind of tapestry is woven.

Every place with living things is covered with a tapestry, an ecosystem that drapes the contours of the earth, covering the landscape with interdependent lives. Some tapestries are thick and rich in color and texture—others are thin monochromes that barely cover their substrate, like that of the Galápagos seen in Figure 2.1. It is fair to call this ecosystem Darwin's tapestry in honor of the man and his contribution to our understanding of how such tapestries are put together, how they function, and how they change. Of course, living things are fundamentally different from dead fibers—they reproduce and they evolve from within, so like any metaphor, it must fail eventually. It is precisely these changes, however, that make Darwin's living tapestry vastly more exciting than the metaphor. A living tapestry grows and changes itself from minute to minute, adjusting its colors and textures in response to the other sections of the tapestry that are themselves evolving. A living tapestry can even patch a hole here and there, making do with the colors and textures of the fibers at hand.

The upheaval on the floor of the Pacific Ocean and the accumulated lava created the mass of barren rock we now know as the Galápagos archipelago. Its tapestry did not arrive whole from another place; it was built a strand at a time through chance and necessity. It was the first of many patterns that have since been destroyed by submergence or volcanic eruptions, but new islands form and new components keep arriving to reclaim the barren surfaces and renew the tapestry. The new arrivals are driven to expand their ranges and colonize remote locations despite the most formidable barriers. Plants and animals are always pushing their boundaries.

The Galápagos tapestry that we are privileged to witness today is only the most recent of many tapestries represented in the historical record. This fabric has color and texture, but on the Galápagos its colors are somber and in places it is threadbare and tattered. It is riddled with holes, some of which have been ingeniously but crudely patched. Every hole and patch provides insight into how this living tapestry functions. Its range of colors and textures—its biological diversity—have been greatly enhanced by favorable winds and currents that nudge lost and likely doomed travelers toward the Carnegie Ridge. Even with its diversity so enhanced, it is simple—even plain—and that is what makes it priceless. Its simplicity exposes relationships that are lost in the plush weave of the far richer, thicker, and more complex tapestries of the mainland from which most of these living fibers were taken. Its simplicity permitted Charles Darwin his insights and has allowed scientists to build on his theory ever since.

From within this grand arrangement of threads, where we will spend most of our time, the overall pattern is hard to keep in mind because of the beauty and complexity of the individual threads. The small section of landscape in Figure 2.1 lies on the north end of Baltra, and it is indeed threadbare. What looks like a plush forest of rich brown fibers is in fact mostly bare rock with scattered brush. The rock is volcanic tuff, and it is rich in iron that bleeds rust onto the washed sand of the beach. Below the sand lies a lava substrate, broken and tumbled smooth by the surf.

The plants and animals that have survived the voyage to the archipelago to take their part in these tapestries have faced substantial barriers, and their presence tells us much about the nature of the whole. Any successful immigrants have been, beyond all else, lucky—lucky to have landed on these bleak desert islands at all, for their landfall here was their last chance before disappearing in the vast Pacific. But luck was not enough. They must also have been delicate enough to ride the wind, or strong enough to fly or to swim great distances, or they must have been very tough—tough enough to withstand weeks at sea in the equatorial sun without fresh water.

At the very least, in order to begin a population, two individuals must arrive at the islands within a few years, and then they must find each other. They must be of different sexes, fertile, and interested in mating. Then they must successfully nest in vegetation

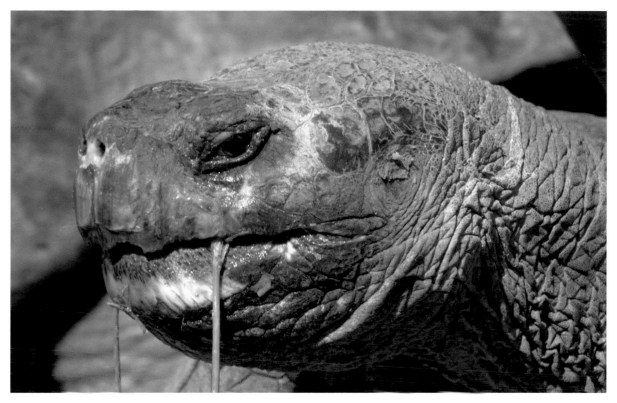

2.2 A Galápagos tortoise *(Geochelone nigra)* tears at the coarse feed in the Charles Darwin Research Station. Not being a powerful swimmer or flyer, nor delicate enough to ride the wind, his ancestors must have been tough enough to have survived a long rafting ordeal.

that is probably strange to them and feed themselves and their young from a menu that can be supported by this impoverished ecosystem. Should all of these challenges be met, the next reproductive cycle will bring the genetic problems of inbreeding, unless an equally lucky stranger arrives at just the right moment to lessen their isolation and diversify the gene pool. After all of these events have occurred within the proper time frame, there will soon be an El Niño, probably followed by La Niña. As Sidney Howard observed, "On the Galápagos . . . life is hard and existence precarious." If, against all of these odds, these survivors flourish, their bits of color and texture will become more prominent, influencing the tapestry-in-progress. This tapestry is always in progress.

Island populations are invariably more fragile than mainland populations. They live closer to extinction for a number of reasons, and the risk is cumulative. The greatest vulnerability lies in having a very small geographic distribution. Often an entire species is confined to a single island—maybe to just one ecological zone of that island. Small distributions often mean small populations as well, and any one of several extreme but quite normal events—a volcanic eruption, a typhoon, a severe drought, or even a strong El Niño event—could push them to extinction in a single blow. Even if 10 or 20 percent of the species survive such a catastrophe, the population loss nibbles at their store of genetic diversity and so weakens their ability to respond to future challenges. The ecosystems of islands, it seems, are brittle and easily damaged.

Then there is the vulnerability to novel infectious agents, like the West Nile virus or a bird flu, that can be brought to the island by migrating birds. Such an agent—bacterial, viral, fungal, or parasitic—may attack the population directly or may decimate a primary food source, leading to a protracted, less violent, but equally final exit.

The introduction of alien species is a problem everywhere, even on the continents, but it is especially devastating to island tapestries. Humans are usually the first to arrive, and hard on their

heels are the rats, cats, dogs, chickens, goats, pigs, cows, and horses that are a normal part of the retinue. All of these animals are liberally sprinkled about the Galápagos, and they literally chew up the tapestry. Some are direct predators of adult animals; some eat eggs or young; some are direct competitors, nibbling the lowest morsels and leaving the rest beyond the reach of native species; and some of the aliens simply overgraze, overwhelming the capacity of native plants to reproduce. The ways in which introduced species can sew a pattern of discord into the harmony of the tapestry are legion.

These results, however destructive to the fabric, are predictable. Without exception, these alien species evolved in a tough neighborhood and now find themselves in a garden of naive and innocent marks. Island populations may have evolved in Spartan environments, but threats of predation and stiff competition are new to them; they are invariably slow, usually too slow, to develop an appropriate response. Books have been written about the naïveté of animals that never encountered humans, our retinues of animals, and our increasingly invasive technologies. These encounters can be tracked from the introduction of humans using the innovative Clovis spear point, which coincided with a tremendous wave of extinctions that swept the Western Hemisphere twelve thousand years ago, to the beachfront condos and strip malls—individually benign but collectively malignant—that are now advancing on the surviving enclaves. All of these events change the environment—*suddenly,* in terms of the ability of most species to respond—and the changes render time-honored and successful behaviors obsolete.

Animals that can survive in a terrestrial environment make use of the islands in different ways. We see three overlapping groups worth recognizing. First, there are the pelagic animals—animals that live on the open ocean and have no particular use for land at all except for the demands of reproduction; they require a safe place to put their eggs. For green sea turtles—females only—that means several hours on a sandy beach; otherwise they are at sea like the males, who never have occasion to come ashore. For red-billed tropicbirds, it means a place for courtship, then nesting,

2.3 The green sea turtle *(Chelonia mydas),* a pelagic species, was photographed just off the shore of Fernandina near the upwelling but in the shallows.

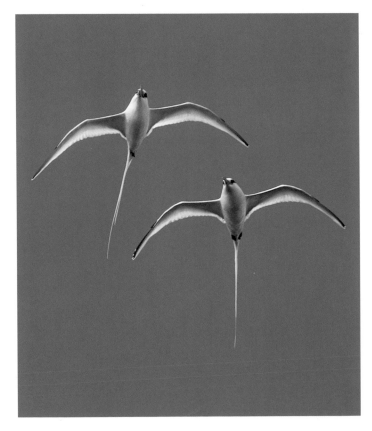

2.4 The red-billed tropicbird *(Phaethon aethereus)* is a pelagic species that mixes the sturdy body of a plunge diver with the ethereal qualities of an angel.

and finally a secure place to leave their chicks while they gather food for them. All of their other needs—food, water, and rest—are satisfied at sea. Albatrosses model the truth of this assertion by spending five years or more on the open ocean before they return to begin courting on the island where they hatched.

A second group of animals, shoreline species, are land-based, but their food comes from the sea, generally within a mile or two of shoreline. They may nest with pelagics and appear similar, but they belong to the islands, not to the ocean, and so they are more at risk. One prominent shoreline species is the marine iguana. Their lifestyle requires that they enter the sea to graze on sea lettuce but return to the beach to rest and warm themselves. They never venture far from the land-sea interface.

A third group, the terrestrials, are the most vulnerable of all. They are entirely dependent upon the land and require fresh water, often in short supply. The land is the source of all they require—food, nest sites, and nesting materials—everything except for the occasional scraps scavenged from the colonies of the pelagic and shoreline species.

Visitors to the islands are distracted by the beauty and abundance of the birds that feed in the ocean and might not quite realize what an exclusive group of animals is woven into the Galápagean tapestry—until they begin to notice what is "missing." The list of terrestrial mammals is short: Two bats that must have flown to the islands and a handful of rice rats, all endemic, that likely evolved from a single arrival. There are no other native terrestrial mammals. There are no amphibians. Nearby South America has more bird species than any other continent, but very few have made their way to the islands and survived. There are no sparrows, no blackbirds. No thrushes, orioles, wrens, or jays. No vireos, no woodpeckers, no hummingbirds.

The exclusivity of the Galápagean ecological community means that there are many niches—ways of making a living—that remain unexploited. These are the holes in the fabric of the tapestry.

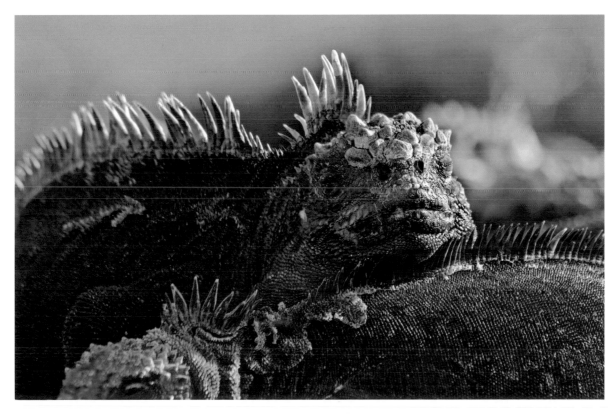

2.5 Marine iguanas (*Amblyrhynchus cristatus*) are creatures of the shoreline and as such are among the first residents to greet visitors.

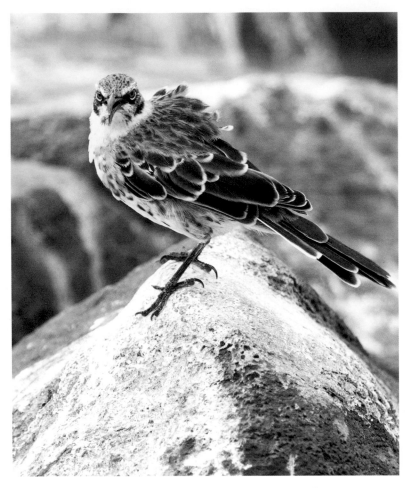

2.6 An Española mockingbird is one of those terrestrials that suffer the hardships of the desert, but living within a seabird colony, a good pilferer can make a living.

Evolutionary theory recognizes that unexploited resources are likely to be tapped. New species may arrive that are suited for that deficiency, or, more intriguing, a species already there will evolve to tap the resource, to "patch the hole."

Losing the power of flight is common among birds that find themselves without terrestrial predators, a frequent happening on islands. There are flightless ducks, flightless rails, flightless parrots, even flightless wrens found here and there on islands all across the Pacific. Flightlessness in small birds is always an island phenomenon that is a consequence of hole-patching. Suppose a small, wrenlike bird that feeds near the ground finds resources

that would ordinarily be monopolized by a rodent—but there are no rodents. It is hard for rodents to reach distant islands, so their niches are often vacant—holes left in the tapestry. The bird evolves to exploit those resources, but as it becomes more mouselike, it is likely to find itself flightless (we will explore the reasons for this in the chapter on the flightless cormorant). The loss of flight is of no consequence so long as there is a corresponding hole in the fabric—the absence of a ground-based predator. If cats are introduced to the island, the corresponding hole is no longer there, and the survival of the bird is in question.

Darwin's finches present a classic example of hole-patching here in the Galápagos. Their ancestors were seedeaters when they arrived at an archipelago where there have never been any birds that lived by probing in wood for insects. That absence may be thought of as a hole in the tapestry—a "woodpecker-shaped" hole, which presented a golden opportunity for a species that could find some way to access those insects and that could use a few extra calories. In this case, the entrepreneur was one of those ancestral finches, a bird who now warrants the name "woodpecker finch" (*Cactospiza pallida*). It is one of the jewels of evolution. Finding their world crowded with seedeaters, the ancestors of today's woodpecker finches made insectivores of themselves by using cactus spines and other sharp objects as a prosthesis and eventually came to adopt the ecological role of woodpecker. Today it is one of the few known instances of tool use by a bird. A woodpecker finch could never compete with a true woodpecker—woodpeckers have evolved very sophisticated anatomy to probe for and to extract insects. But then woodpecker finches don't have to compete against bona fide woodpeckers: They are good enough, lacking a competitor, and natural selection will continue to refine their abilities.

Each of these groups—pelagics, shoreline species, and terrestrials—include some endemic species, meaning that they evolved on the islands and are found only here. Endemics are at high risk for all of the reasons already enumerated, and their dance with extinction is more intimate. The waved albatross is one of these. Nesting only on the Galápagos, the species numbers about twelve thousand but is vulnerable nevertheless. Its continued survival

depends on the continued bounty of the upwellings, the security of their nesting colonies, and their safety while foraging on the open seas, where they are currently threatened by large-scale fishing operations.

In spite of the inherent vulnerabilities, the Galápagos animals have fared well compared to those on many islands. The Galápagos are distant from the major trade routes that connected Europe to the New World and to the East Indies. Other than the depredations of pirates and whalers, abuses were unusually mild until late in the twentieth century, when our culture was just beginning to recognize the value and fragility of life on this planet. The Galápagos Islands have retained an extraordinary 96 percent of their endemic species—another reason why the islands have acquired an almost sacred aura.

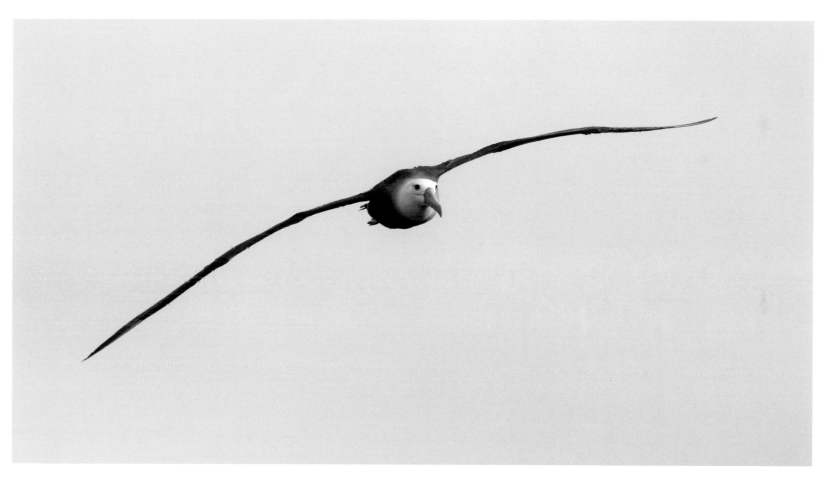

2.7 It is hard to imagine a bird more gracefully efficient in flight and so completely at home in the air as an albatross.

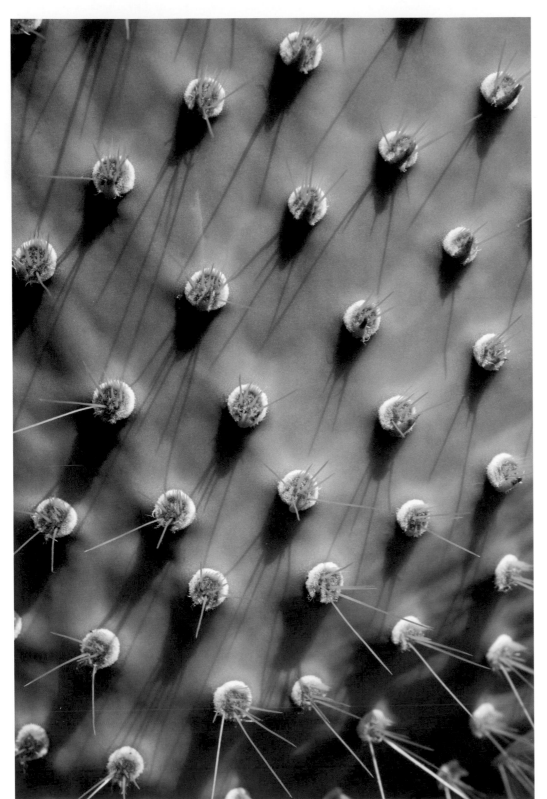

3.1 The prickly pear of the genus *Opuntia* is a major player in the productivity of the Galápagos tapestry; with its waxy coating and its spiny armament it is well defended.

3

The Nature of Desert

The finest quality of . . . this desert landscape is the indifference to our presence, our absence, our coming, our staying or our going. Whether we live or die is a matter of absolutely no concern to the desert.—Edward Abbey, *Desert Solitaire*

Weavers in medieval times had access to fewer than twenty dyes extracted from plants and insects. The hues were muted, as if taken from a desert landscape. Darwin's tapestry is colored by sand and rock as well as by plants and animals, so the parallel is robust. The desert is of course inhabited by terrestrials—animals of the land. Animals of the sea use the desert too, but they are not of it. This forbidding place is ideal for albatrosses, boobies, and frigatebirds. They require almost nothing of the land but a small bit of solid ground, the more impoverished the better, so that it will support fewer terrestrials to nibble at their nesting success. These birds of the sea gather their wealth offshore.

Deserts are poor because there is too little precipitation to cover their nakedness with vegetation. Among the ecological "facts of life" is a little-appreciated but far-reaching truth: the productivity of terrestrial ecosystems, measured by the growth of plants, is a direct consequence of the precipitation they receive. All terrestrial ecosystems depend on green plants because they are the source and the conduit of all good

things. The larger the diameter of the conduit—the amount of vegetation created by precipitation—the more food is produced and the larger and more complex the populations of animals that can be sustained. The higher the rainfall, the higher the productivity. Always. If the bore of the conduit is small, food will be scarce and plants will be thinly spread about the landscape. There are few situations in ecology so simple and in which the chain of causation is so short.

The character of the Galápagos desert flows from these truths. Exclusive of El Niño, the precipitation amounts to only ten to fifteen inches per year, much like Santa Fe or Tucson in the American Southwest. Precipitation is scant because the islands are washed by the cold Humboldt Current. The Galápagos will remain desert so long as the trade winds blow and the great currents run their courses.

Figure 3.2 makes this point eloquently. The gray matplant is widely spaced or absent on the steeper slopes and more crowded and vigorous in places that benefit from the pattern of drainage. Its spacing reveals the surface area required to gather water for one plant. The spacing is policed by the root systems of individual plants that are battling silently beneath the surface, competing for the few drops of water that fall into the contested territory between them. The absence of new plants to fill the in-between spaces confirms their inability to wrest water from the established plants.

Green plants are both the foundation and the conduit of nearly every ecosystem, and naturally they have adapted. Evolutionary theory confidently predicts that desert plants, living in the most severe conditions of heat and drought, will have evolved structures and behaviors—strategies—to survive in this challenging environment. These strategies are on display in deserts everywhere and have evolved independently many times around the world, but here in the Galápagos, the simplicity makes it plain.

Water is, of course, the key. Having drawn it from their surroundings as effectively as they can, desert plants spend it on the essential and the unavoidable—photosynthesis and evaporation—and they do it in miserly fashion. Each leaf is covered with a waxy surface that allows light to pass but blocks evapo-

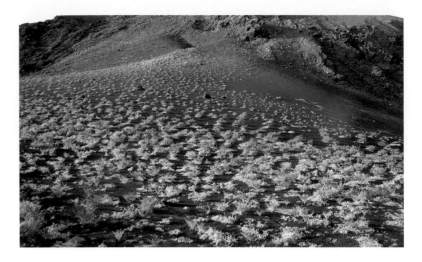

3.2 A drape of gray matplant *(Tiquilia nesiotica)* cloaks a slope of cinders on a shoulder of Bartolomé. The size and spacing of the plants map the moisture in the soil. *Regina Hess.*

rative loss; it is as if each is fitted with its own Spandex greenhouse. Immobile and holding both food and water, succulent plants like prickly pear cacti defend their wealth from herbivores (who need those precious commodities, too) by deploying rank upon rank of infantry with fixed pikes. This defense evolved long before prickly pears arrived on the Galápagos, and it is a formidable defense against large herbivores with fleshy lips. But on the aboriginal Galápagos there were none of those. Instead, the large herbivores were tortoises, which have no lips; indeed, they find the cactuses quite edible.

Figure 3.3 catches Lonesome George, a saddleback Galápagos tortoise, as he appears to be eyeing the pads of a giant prickly pear like a small boy intent on a cookie jar. This variety of prickly pear has evolved to heights of forty feet and has a "trunk" that superficially resembles that of a ponderosa pine. It's a poignant moment, because one of the forces that pushed this species of cactus to become so tall was the extensive browsing by tortoises. With its spines no defense against an herbivore lacking sensitive lips, the plant was pushed to move the pads out of reach. Denying the tortoises access in this way had an added benefit: It also elevates their pads above the dense acacia canopy.

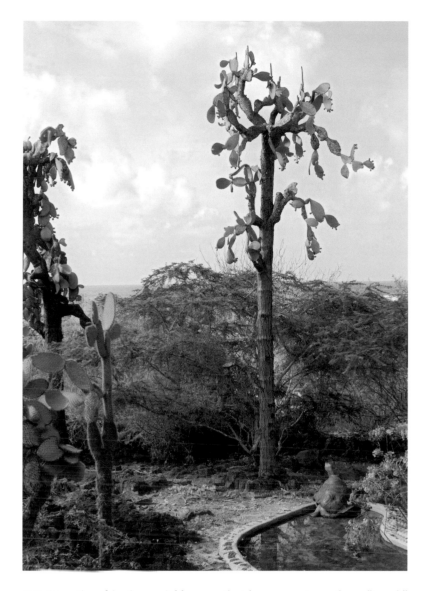

3.3 *Opuntia echios* is a prickly pear that became a tree whose "trunk" could be easily be mistaken for a ponderosa pine from the western United States.

Another conservation strategy is to produce very small leaves that minimize direct loss by evaporation. Some species forgo leaves altogether and do the work of photosynthesis with green stems. Bristles are also common in the desert. They provide shade and can lessen water loss by evaporation, if distributed in dense patches, or they can defend against herbivores if scattered but straight and stiff. Among the commonest gambits of the evolu-

tionary process is the use of anatomy that originally served one function and modifying it in some way to serve another. A prickly pear with a halo of spines on heavy pads is not exactly what it seems. The spines were originally leaves but are now reassigned by natural selection from the "Department of Energy" to the "Department of Defense." The thick green pads are stems, originally for support, but now functioning as the primary photosynthetic organ.

Another strategy, especially successful for trees and shrubs, is to drop their leaves during the dry season and pass the most difficult months quiescent, husbanding their water stores while they wait to live again. Palo santos trees are a case in point, and they create an eerie wintry feel amid the heat.

To a visitor from the temperate zone, who is used to bare trees only in the coldest season, it seems that the forest must be dead or nearly so. Darwin described this grim appearance when he first witnessed the Galápagos shoreline at San Cristóbal (Chatham) in September 1835, well into the dry season. "Nothing could be less inviting than the first appearance," he wrote. "A broken field of black basaltic lava . . . is everywhere covered by stunted, sun-burnt brushwood, which shows little signs of life." This is a pretty good description of a well-adapted and healthy desert ecosystem.

With green plants established as the sole conduit of food and energy, the low level of precipitation that defines the desert ecosystem assures that most vertebrates will be reptiles. That is because of the particular talents of reptiles—talents that we sometimes regard as a failure to have evolved in our direction. Foremost among these talents is a temperature regulating system called ectothermy—often called cold-bloodedness— where body temperature is regulated from outside by solar input and the ambient temperature.* Body temperature can fluctuate widely but it is often regulated within a narrow optimum band by behavior—the animal simply controls its exposure to sun and shade. An ectotherm

* Biologists prefer the terms *ectothermic* and *endothermic* because they are more precise. "Cold-blooded" animals regulate their temperatures behaviorally and occasionally have higher temperatures than "warm-blooded" animals.

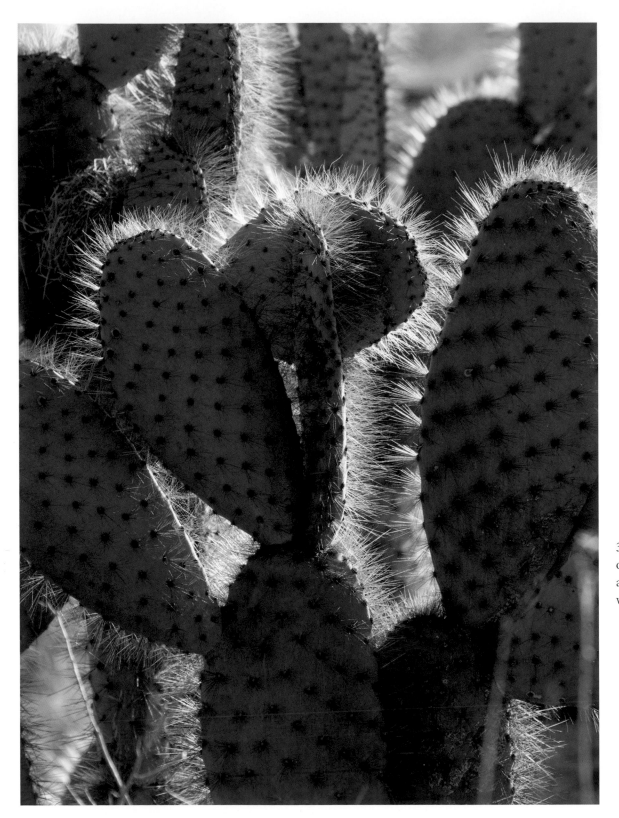

3.4 This prickly pear, one of the dozen or so endemic species of *Opuntia*, has a very high concentration of spines, which provide both shade and defense.

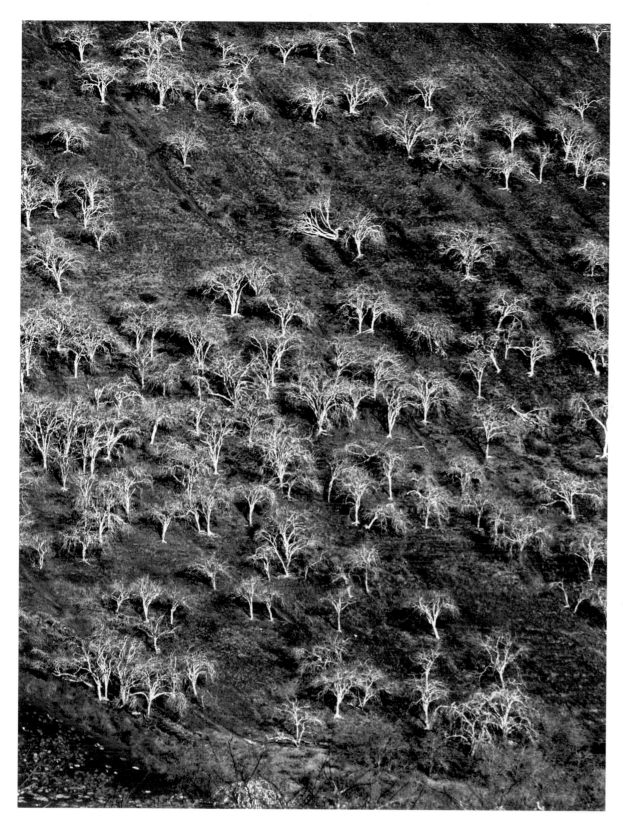

3.5 Palo santos trees *(Bursera graveolens)* stand out against the lava rock and dried vegetation like giant spears of white broccoli.

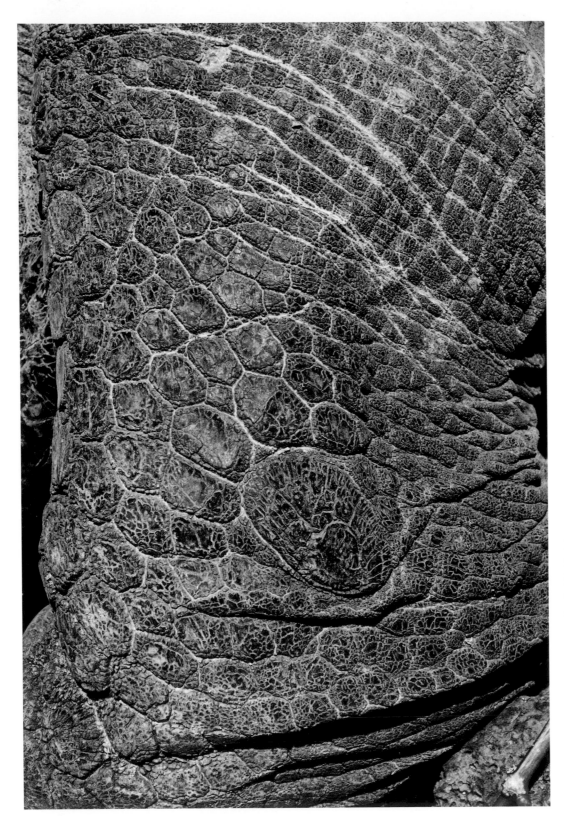

3.6 The left forelimb of a Galápagos tortoise at the Charles Darwin Research Station (CDRS) is covered by skin that is a mosaic, obscuring the upper arm, elbow, lower arm, and wrist that would be clearly defined in most terrestrials.

that can drop its temperature by twenty degrees for the twelve-hour nights at the equator has a distinct fuel-saving advantage, which is of prime importance in the desert.

The alternative to ectothermy is endothermy—"warm-bloodedness"—which evolved only in the birds and mammals. We endotherms regulate our body temperatures internally to be consistent and high, near one hundred degrees Fahrenheit and often warmer. We are high-performance machines, and we use a lot of fuel both day and night; thus, where it is dry and food and fuel is scarce, reptiles are superior competitors. We are the hare and they are the tortoise that wins this race.

Reptiles have other talents that are more visible. Their tough scaly skin, equivalent to the waxy leaves of plants, minimizes their water loss and protects them from the rocky, spiny, thorny world they inhabit. The elephantine skin of an old tortoise is wrinkled, its armor plates abraded and burnished by a century of wear. The Galápagos teaches us that "old and worn" can be beautiful—a trophy honoring the success of the wearer.

Aside from the Galápagos tortoises, which we will consider in depth later, the land iguanas are the largest terrestrials. These reptiles, weighing up to twenty-five pounds, are much less common than the marine iguanas of the shoreline. It wasn't always that way. When Darwin went ashore on Santiago (James Island) in 1835, he reported difficulty in "finding a spot free of their burrows to pitch a single tent." In the same breath he noted that when cooked they "yield a white meat, which is liked by those whose stomachs soar above all prejudices."

Land iguanas are part of the breeding program at the Charles Darwin Research Station (CDRS) that has successfully reestablished populations on islands like Santiago, from which they have been eliminated. I'm sure the CDRS did not purposefully select the most attractive of the iguanas as a base of their breeding program, but the few iguanas I saw in the wild were of dull color, probably due to the incomplete loss of shed skin, regional variation in coloration, and quite likely some dirt. The magnificent male in Figure 3.7b has the appeal of a golden dragon. The mainstay of the iguanas' diet is prickly pear—pads, flowers, and buds.

They also favor tender young leaves of trees, and they have been seen browsing several feet above the ground.

There are seven species of lava lizards, which vary a bit in size and coloration. They are sprinkled about the archipelago, but no island has competing species. They are lower on the food chain than the land iguanas, for their small size makes them more vulnerable to predation. Figure 3.8 shows a male and a female from Española, home to the largest species, in which males exceed ten inches in length. Males are a bit bigger than females, a characteristic of species in which males compete for females. They also have dark throats that they use for territorial display, the most common of which is a series of quick push-ups. For the challenging male, the black markings on the throat of his opponent create a more forceful display. Españolan females show red markings on the head and neck that are more brightly colored and much more extensive than on the sibling species. They are omnivorous lizards, lying in wait for insects and other invertebrates hidden by their immobility, colors, and textures, but they are also known to eat the flowers as well as the insects that come to pollinate them.

Most predators on the islands eat lava lizards, but chief among them is the Galápagos hawk, another endemic species. The presence of an aerial predator suggests why the strong markings on both male and female are positioned so as to be largely hidden when they flatten themselves against the rock. If the hawk were part of a rich tapestry like the mainland, it would eat mostly mice and shrews along with a few snakes and lizards. Those are the foods of similar species, like the red-tailed hawk of North America, but on Española the menu is impoverished. There have never been shrews anywhere in the Galápagos and never any rodents on Española, not even introduced rats, so the hawk makes do as island species have done for millennia. This raptor broadened its "idea" of prey to include the available—giant centipedes, locusts, snakes, and lava lizards.

The Galápagos hawk also takes young marine iguanas along the shorelines. That's what was on the mind of the hawk in Figure 3.9. From its position, it could see thousands of them spread like a buffet across the sand and lava rocks. In addition to their

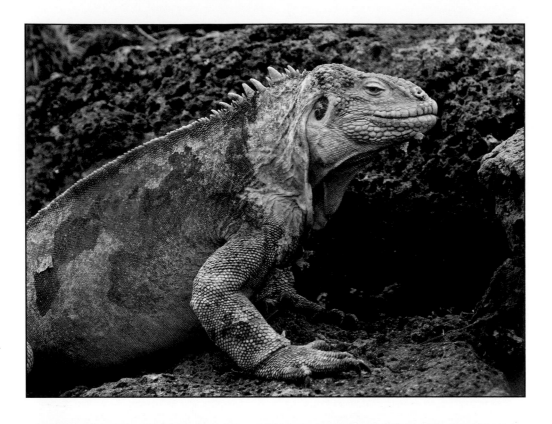

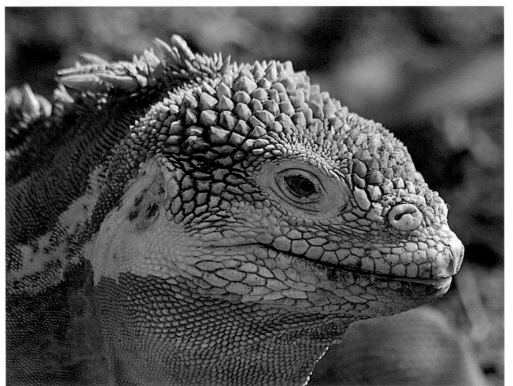

3.7 Land iguanas *(Conolophus subcristatus)* are found on the largest islands. *Top*, a wild iguana resting along the shore of Santa Cruz. *Bottom*, a captive of the same species at the research station (CDRS).

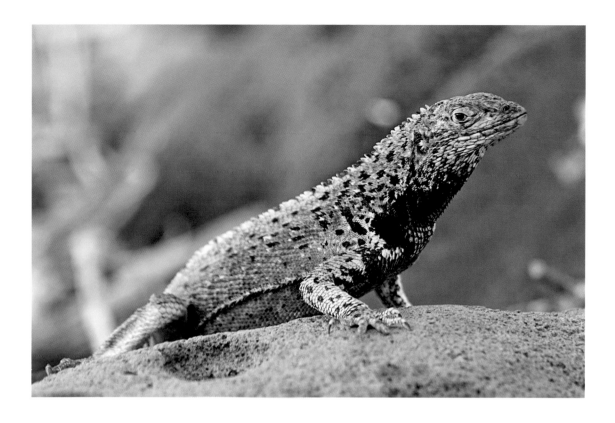

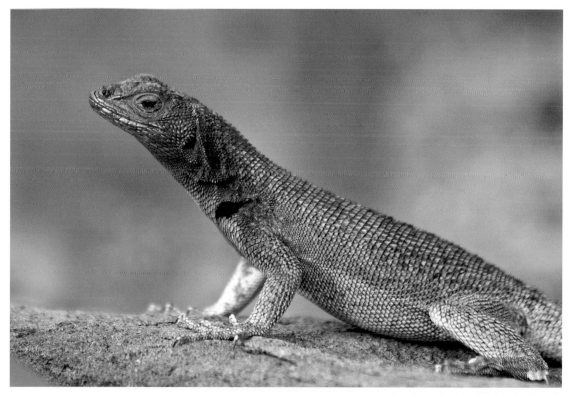

3.8 Male (*top*) and female (*bottom*) Española lava lizards (*Microlophus delanonis*) from the island that boasts the largest of the seven endemic species and the most brightly colored females.

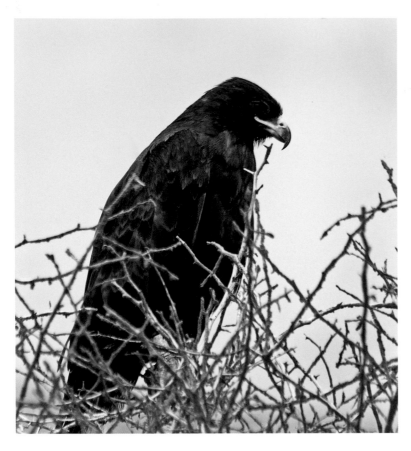

3.9 A Galápagos hawk *(Buteo galapagoensis)* surveys the shoreline looking for an opportunity.

normal desert fare, hawks patrol the colonies of nesting seabirds during the day in collusion with short-eared owls, who work the night shift. They readily take carrion provided by the richer ecosystem of the shore, and they are said to have a knack for noticing when people come ashore to clean their fish or to hunt for goats. Clearly it requires an alert jack-of-all-trades to succeed in this Spartan natural economy.

Another consequence of the spare resources of the desert is the adoption of polyandry, a rare mating system where a single female is tended by more than one male; in the case of Galápagos hawks, even three or four males. Theorists argue that productivity is so low on these islands that a female requires several males to assist her in feeding her brood.

Birds of the desert tend to be small and inconspicuous. Generally speaking, there needs to be a good reason for bright colors, for making oneself highly visible, and these birds haven't found it. In rich and diverse ecosystems, it is overwhelmingly males who adopt such coloration and then—like flashy, fashionable, but uncomfortable clothing—it is shed just as soon as the mating season is past. Such flamboyance is much less common in deserts generally and never occurs among endemic terrestrials of the Galápagos. Instead, they so perfectly cloak themselves in their environment that one might suspect their colors were all from a single palette, with just a few pastel shades. The photographs of animals in this chapter were not selected toward this end, but each is a masterpiece of color compatibility with the subtle hues and the soft colors that abound in the desert. These soft tones belie the fact that the desert is a hard place to make a living.

While desert creatures must live on the produce of the desert, they do not miss opportunities at the seams of the ecosystems. Where the desert meets the sea, there are great colonies of nesting birds that bring the riches from the sea to the land, and there is cleanup to be done: eggs fail to hatch and young birds die, fish and squid fragments are disgorged and abandoned, the occasional carcass washes ashore. They are just crumbs, really, that are swept into the seam, but it is a banquet of protein for the animals of the desert, and they don't miss much.

The mockingbirds of the Galápagos figured prominently in the education of Charles Darwin. It was not the finches that "first thoroughly aroused" Darwin's attention to the provocative distribution of species on the Galápagos; it was the mockingbirds. They are a simpler puzzle than the finches and make a much better primer on evolutionary theory. There are only four species of mockingbirds on the islands, all evolved from a common ancestor from the Ecuadoran mainland and all endemic, but no two species occur on the same island. How this distribution could occur is obvious once the key to the mystery of origins is in hand, but at the time, Darwin didn't have the key.

Visitors usually see only the two species of mockingbirds shown here because they are the most accessible. The Galápagos

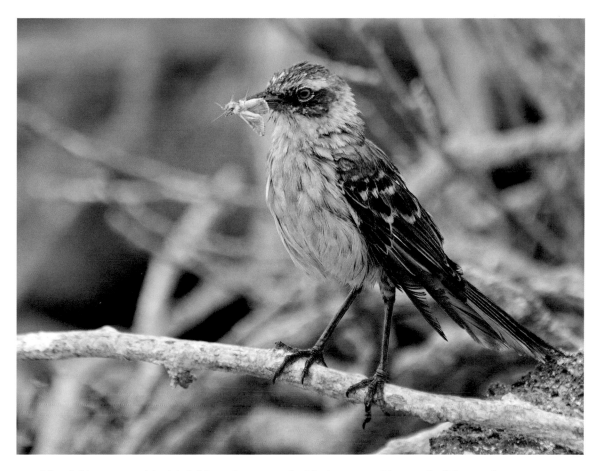

3.10 The Galápagos mockingbird (*Nesomimus parvulus*) is the most widespread of the mockingbirds. This one has found a moth among the booby nests in the saltbush of Genovesa.

mockingbird is the most widely distributed of the four species, but the Española mockingbird (formerly the Hood mockingbird) is unique to the desert tableland of Española. Its bill is longer and more strongly curved, and individuals tend to be assertive, forever alert for food or water that might be coaxed from visitors. It is amazing that terrestrial birds can survive at all on these islands with no fresh water, but there are isolated pools in the rocks that last for a while after a rain. There is moisture in the prey they capture, and dew can be collected from the exposed plants near the shoreline. It seems a tenuous existence, but their very presence speaks of an unbroken line of success over many thousands of years.

Unlike the brash and even sassy mockingbirds, the Galápagos dove has a gentle, even shy demeanor consistent with the blush of pink iridescence on the breast and the blue eye shadow. It is in the same genus as the mourning dove of North America, whose flight is also fast and straight, but it looks and acts more like the ground-doves of the American Southwest. The strong behavioral and physical similarities of related species like these is a compelling substantiation of evolutionary theory that requires no technical knowledge, only casual observation. Like their mainland counterparts they eat seeds, seeming to prefer those of prickly pear, but like most birds they will take invertebrates—caterpillars and

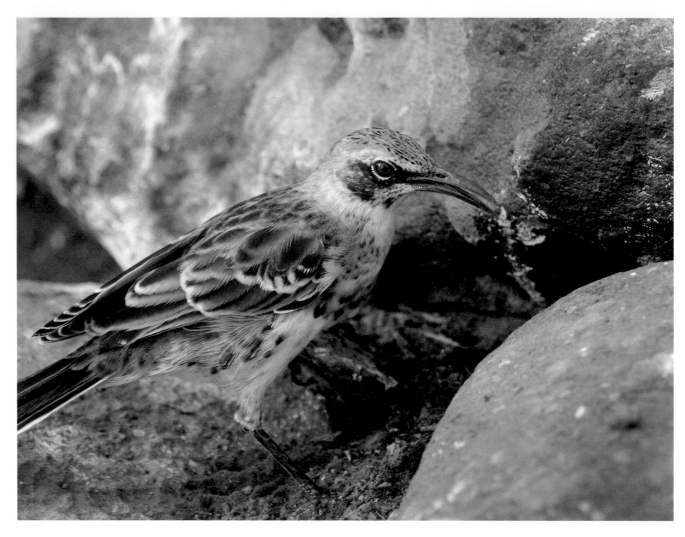

3.11 For the Española mockingbird *(Nesomimus macdonaldi)*, every day is a hunt for treasure in the nesting colonies of albatrosses and boobies.

such—if the opportunity presents itself. The bird in Figure 3.12 was foraging in the highlands of Santa Cruz, but this species may be seen regularly on most of the islands.

Taken as a whole, the plants and animals that wrest a living from the desert are a Spartan bunch—there is little water, a fact that shapes and colors everything. Their bodies are armored with thorns, scales, or feathers, or they are otherwise covered with tough surfaces to live in an abrasive environment and to minimize water loss. That

they will lose water is unavoidable—even though their bodies are engineered to minimize that loss, animals must breathe and plants must exchange gases as a part of photosynthesis. An acquaintance with desert life is a fine introduction to the many ways a living thing can evolve to conserve water in subtle, incremental ways. Even the pastel palette of the animals is in keeping with the severe economy of the desert—light-colored skin or feathers is another small way to lessen heat gain and so minimize water loss.

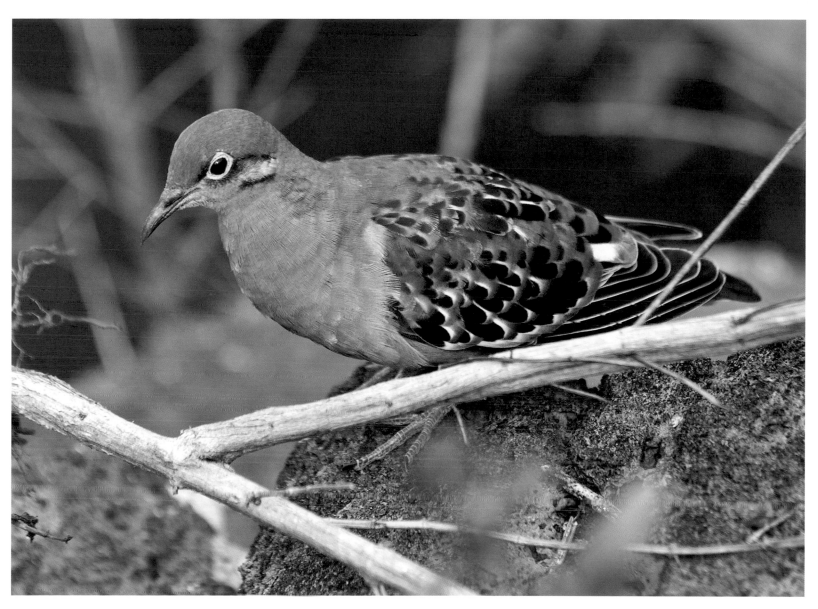

3.12 The Galápagos dove *(Zenaida galapagoensis)* is another widely distributed endemic, especially on the older islands on the eastern part of the archipelago.

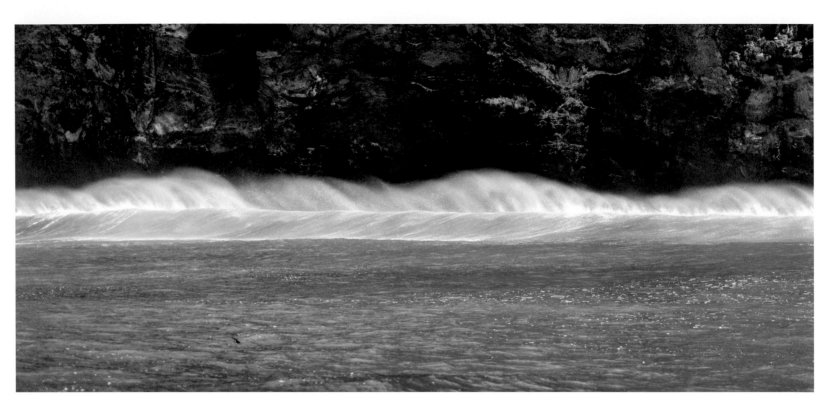

4.1 On the northwest shore of Isabela, swells sweep in from the open
Pacific where they huff and puff and blow against the volcanic rock.

4

Cliffs and Rocky Shorelines

In this difficult world of the shore, life displays enormous toughness and vitality by occupying almost every conceivable niche.—Rachel Carson, *The Edge of the Sea*

Another axiom of ecology is that the greatest diversity of life is found at the seams of the ecosystems—those places where two fundamentally different environments abut. Each habitat is quite different from the others, with its own textures and palette of colors, yet with all of this variation they are stitched together to make a single harmonious unit.

The most clearly defined of these seams is the shoreline, whether rocky, sandy, wetland, or mangrove. Each seam brings into proximity the residents of the two neighboring ecosystems—and add a smattering of species that belong just to the seam. A hawk living near the shore has a range of prey from the desert nearly as great as a cousin that lives far from the shore. In addition, it has access to prey that live at or near the seam—marine iguanas, the young of seabird colonies, crabs, hatchling turtles, and carrion—plus whatever might wash ashore from the sea.

Prey species living at the juncture of two ecosystems enjoy greater options for escape. They can skip from one medium to another, while making use of the resources of both. For instance, a marine iguana can evade a Galápagos hawk by dropping into the surf

from an exposed position on a rock. The iguana is making use of the fact that it is functional in two mediums, on land and in the water, one of which is forbidden to the hawk. It is like a game of tag where there are safe bases—only what appears to be a safe base is just the beginning of a different game. When the iguana jumps from the first medium into the second where the hawk cannot go, it is indeed safe from the hawk, but now it has dropped blindly into a new game with different antagonists. Furthermore, when the iguana surfaces to breathe, as it must, it becomes vulnerable to attack from the air by patrolling frigatebirds working in a third medium.

The shore is a complicated place, and there is a lot of it on the Galápagos. Most of it is rocky, trimming these islands like lace on a petticoat. This habitat is similar throughout the islands, so animals of the shoreline appear uniformly distributed. The islands also have beaches, and there are a few mangrove forests, but the shoreline is mostly a place of violence, where powerful waves crash with concussive force. From a safe, dry location, its great beauty can be enjoyed with impunity.

Of course there are not cliffs everywhere; there are areas of shelf rock where the surging surf is confined to channels, and between the channels there are tide pools as calm as a lily pond. These pools have their own visitors, such as the oystercatchers shown in Figure 4.2. Oystercatchers are not common on the Galápagos because most of the shoreline is poorly suited to their needs, and favorable areas are small and scattered.

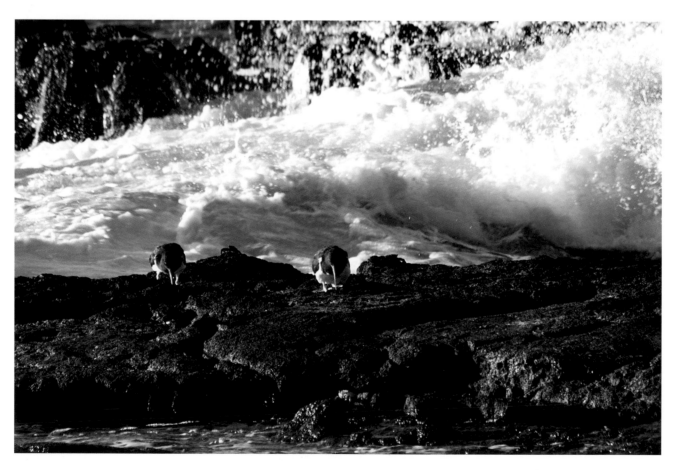

4.2 A pair of American oystercatchers *(Haematopus palliatus)* busily forage for invertebrates, apparently unconcerned with the tons of water crashing just feet away.

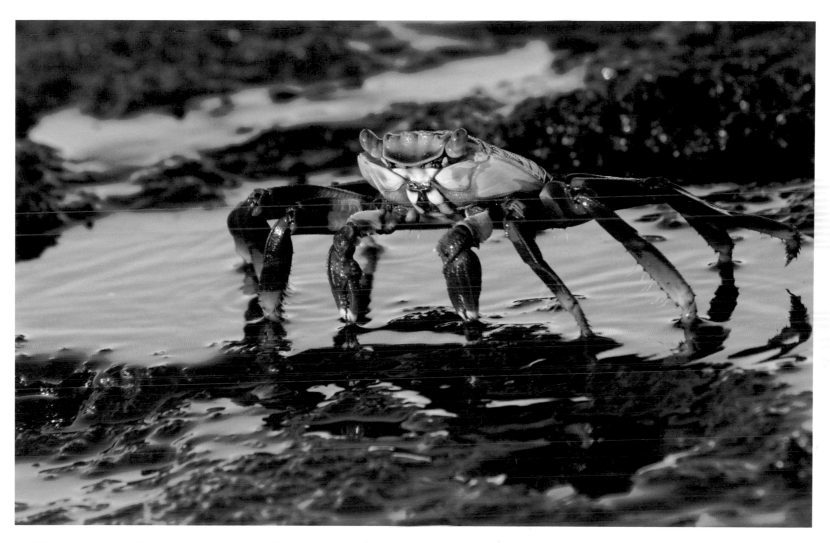

4.4 The crab is able to feed and still resist the surf's assault by adopting
a stance that calls to mind the entire defensive line of a football team.

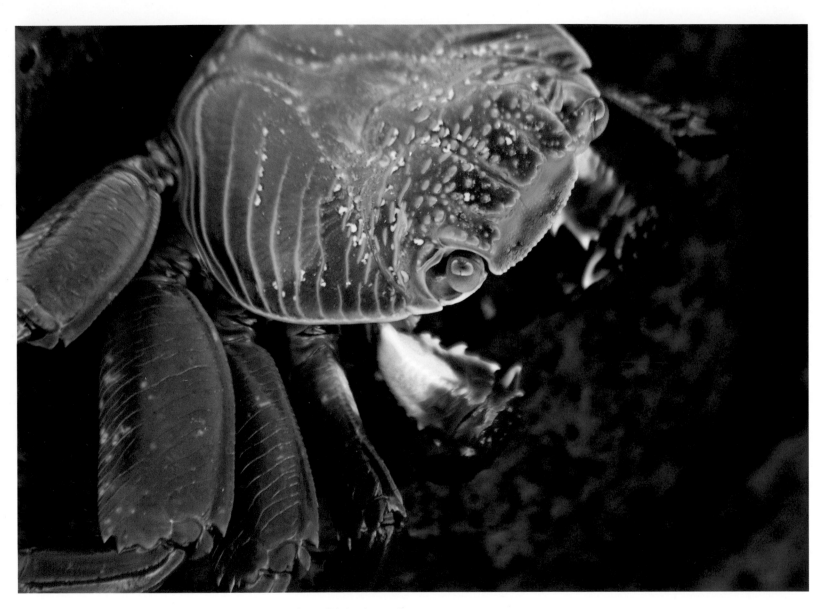

4.5 The body shape of these crabs is admirably suited to a life in the surf.

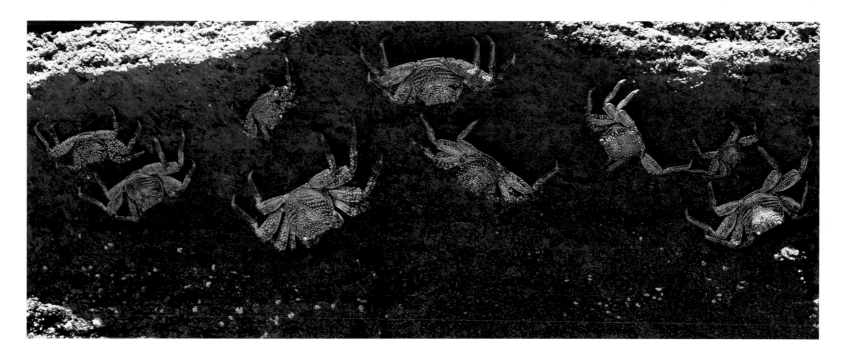

4.6 Immature Sally Lightfoot crabs demonstrate the posture that allow them to cling successfully to the rough rock even as the heavy surf washes over them.

4.7 Time for lunch. Never has the phrase seemed so intimidating.

but they appear adept at bobbing in the surf, and after a few failed attempts where they are thrown against the rocks by the surf, they eventually snag some irregularity on the rocks with their strong claws and pull themselves slowly to warmth.

The hundreds of marine iguanas warming themselves on the rocks need to make the commute several times a day. Endemic to the Galápagos, the marine iguana is the only marine lizard in the world, and that makes them truly exotic.

There are two more surf creatures found only on the Galápagos—and both are birds: the flightless cormorant, and the Galápagos penguin. Birds don't ordinarily have to deal with the surf, but then neither of these birds can fly. Their difficulties with the surf are less than those of the iguanas because they are endotherms—their consistent internal temperatures allow them to retain their muscular dexterity—and because they are exceptionally strong swimmers. Both eat fish that they capture by pursuit, so their pas-

sage through the surf is controlled—more like an aircraft making a carrier landing, and less like the crash landing of the iguanas.

Surely there can be no place less suitable for a penguin than the youngest islands of the western Galápagos. We think of penguins as birds of the ice—and of course they are, as several species nest on ice or amid glacial debris—but more properly they are birds of the Southern Hemisphere. There are penguins of forested shores, desert shores, and shores made of lava still sharp from the violence of its birthing. The last of these is home for our penguin. It is the most northern of all, and it has fashioned a life here on the equator.

The Galápagos penguin evolved from the Humboldt penguin that still works the rocky coasts of Chile and Peru, feeding on the bounty of the great upwelling forced by the South American Plate. Long ago, an ancestral group of penguin "pilgrims" was carried by the Humboldt Current to the Galápagos, where they discovered the upwelling on the west side of the archipelago. Today we find

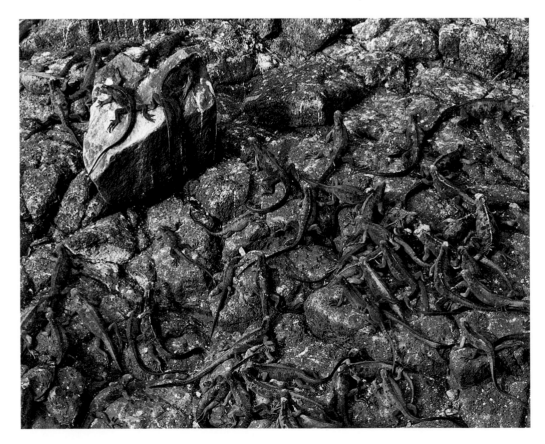

4.8 Basking in the sun in large numbers, hundreds of marine iguanas warm themselves on the lava rocks of Española, in preparation for another feeding foray.

their descendants, still living on the western edge of the archipelago, still feeding on the bounty of this upwelling, and still dressed in puritan style.

In the tropics, penguins have pushed the limits of their engineering. Evolved for cold climates, here they nest on equatorial lava. They can't thin their insulation drastically because they still must forage in the cold water of the upwelling, so they nest in crevices, take advantage of the shade of mangroves, stand in the shade of rocks, take to the water to cool themselves when necessary, and generally avoiding exposing themselves to the heat of the day. And when that is not enough, they pant like dogs.

Penguins generally look like they are equipped with a wetsuit, and it is easy to forget that since they are birds, they must be covered with feathers. When the light is just right, one can see not only the feathers, but also the echo of a reptilian origin revealed by their

arrangement. Figure 4.11 shows a juvenile, its youth proclaimed to penguin society by its gray back, white cheek patch, and pale eye color. It will assume adult plumage at about six months of age.

The rich food supply that sustains the penguins is attractive to many species of birds, and the nearby cliffs and isolated tablelands create ideal nesting sites for pelagic species like shearwaters and boobies. Off the extreme northwestern corner of the islands, twenty miles north of the equator, lies Roca Redonda. It is of volcanic origin and is often shrouded in a thick fog that obscures detail and creates mystery. As in a tapestry, everything is connected, so it is not surprising that this fog comes from the upwelling. It is as if the cold torrent rises from the floor of the Pacific with such momentum that it cannot be stopped at the surface, and it washes like a weightless surf over the island. As pelagics, albatrosses, shearwaters, and storm-petrels forage over the open ocean out of the

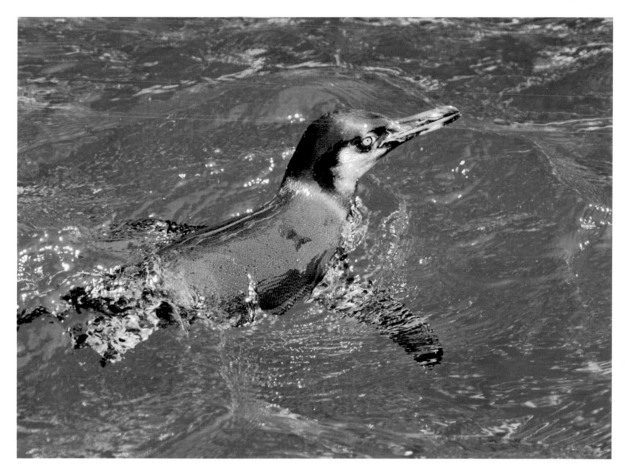

4.11 A juvenile penguin, already an expert swimmer, takes to the water with the gusto of opening day at the pool.

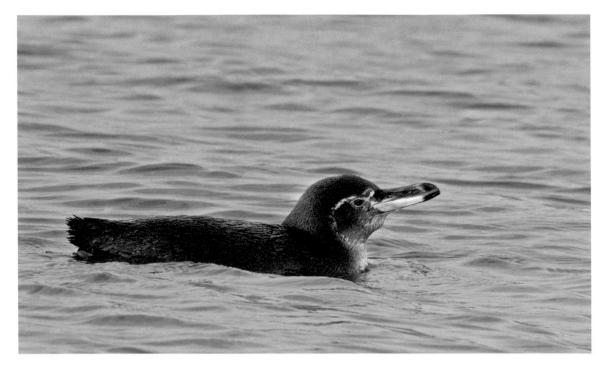

4.12 Galápagos penguins are inclined to swim at the surface, which seems unusual for a penguin. When they swim like this, they ride high in the water, much like a duck.

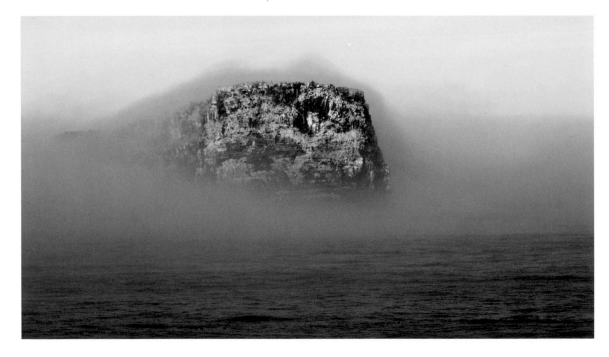

4.13 Roca Redonda, here bathed in a morning fog, is isolated and inaccessible, its cliffs riddled with crevices and crossed by ledges, making it a haven for nesting seabirds.

sight of land. They must nest on land, of course, but they choose remote and inaccessible islands like Roca Redonda that are difficult to reach. Traveling about the islands by boat provides a rare opportunity for visitors to experience pelagic birds in their natural habitat over deep water. Even if visitors could gain access to such a place, the birds themselves would remain out of reach, as they are inclined to nest in crevices or even burrows, some traveling to and from their nests in the dark.

The Galápagos shearwater, formerly a subspecies of Audubon's shearwater, has recently been recognized as a distinct species. They are as at home in the air as the albatrosses to which they are related, and like the albatrosses they feed on fish and squid, especially when those dietary staples are forced to the surface by tuna or dolphins. The shearwater in Figure 4.14 is riding the cushion of air squeezed between the surface of the swells and the wings of the bird. They climb the crests and dip into the troughs with consummate skill.

Compared to most other groups of birds, shearwaters are long-lived. One study confirmed that a Manx shearwater, a close relative from the North Atlantic, began her fiftieth year of life in the wild by preparing a nest. A Darwinian understanding of the world

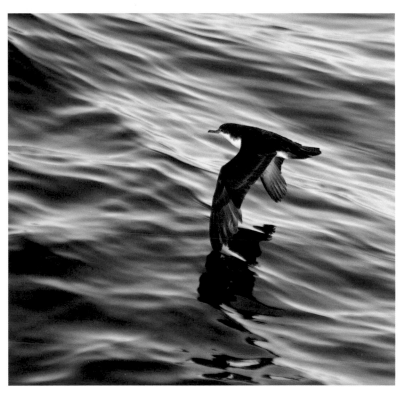

4.14 The Galápagos shearwater *(Puffinus subalaris)* is one of those pelagic birds that populate Roca Redonda.

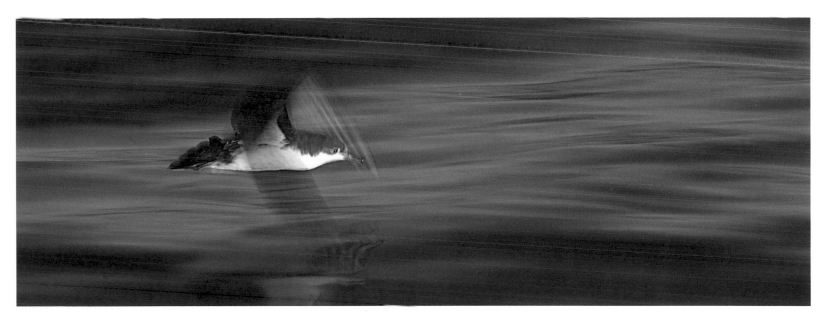

4.15 Smooth water early in the morning means that shearwaters must labor in inefficient, powered flight rather than sail the wind.

tells us that, given the genetic similarities assured by their close evolutionary ties, we can expect that a similar lifespan is enjoyed by the Galápagos shearwaters.

Storm-petrels are kin to shearwaters but are smaller. They are in fact the smallest of the oceangoing birds. They are about the size of the purple martin of North America, and with their nimble and erratic flight patterns, they can be mistaken for martins by those unfamiliar with storm-petrels. They have perfected a unique foraging technique called "foot pattering" that marks them immediately. Unlike the graceful soaring and tacking of shearwa-

ters, storm-petrels flit from place to place among the waves like a butterfly that can't quite commit to any particular flower. Their flight is buoyant and hovering with abrupt changes of course and speed. It is a technique that suits their search for small prey—fish, squid, and invertebrates—near the surface of a vast ocean. Having once seen the skip and dabble of storm-petrels, one is unlikely to confuse this bird with anything else—except, perhaps, for another storm-petrel.

Three species of storm-petrels may be seen in the Galápagos— similar in size, color, and foraging technique. All three have a white

4.16 Elliot's storm-petrels *(Oceanites gracilis)* fly slowly, almost hovering, as they scan the surface for minute invertebrates.

4.17 An Elliot's storm-petrel *(left)* approaches the surface. A fraction of a second later *(right)* it dabbles its feet in the water and moves on, apparently finding no prey at this spot.

patch on the rump. Elliott's storm-petrel is the species named *gracilis*—"thin" or "slender." It is not the most abundant of the three, but because it feeds inshore it is the most likely to be seen.

The old mariners chose names to describe the animals they knew, but the origins of those names are frequently lost in the past, so there are often several explanations for the names of creatures. One of these suggestions is so perfect that it really ought be true. According to some sources, *petrel* refers to the disciple Peter, who walked haltingly on the surface of the sea, nearly sank, but in the end remained on the surface.

About twenty miles south of Roca Redonda on the extreme western shore of Isabela, the cliffs of Punta Vincente Roca rise from the waters. The shape of the island bears a striking resemblance to a seahorse (see Figure 1.4), and Punta Vincente Roca lies on the seahorse's lower lip. The geology of the two areas is similar and thus present similar nesting sites for seabirds, but Roco Redonda is the summit of a great underwater mountain positioned within the upwelling, and Vincente Roca overlooks the comparative shallows of Banks Bay, where the HMS *Tartar* was anchored at the start of the 1825 eruption on Fernandina.

Although its cliffs look the same as those on Roca Redonda, the inhabitants are different: Punta Vincente Roca is home to birds that work the shallows. It is a good place for the brown noddy, the only tern to nest commonly on these islands.

Noddies are quite tame. Like the dodo and the grouse called a "fool's hen," they were easily killed and so were considered "stupid."

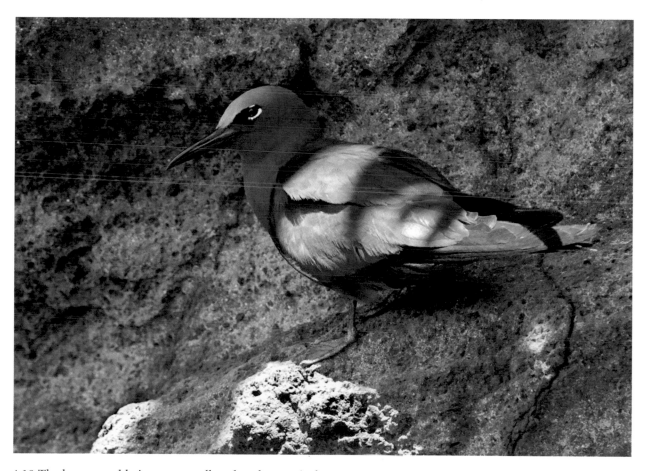

4.18 The brown noddy is an unusually colored tern—its bronze and gray plumage blends well with the palette of the Galápagos.

The noddy's scientific name (*Anous stolidus*) was assigned by Linnaeus in 1758 and reflected the attitudes prevalent in that day, so our elegant little tern was demeaned in two classical languages: *Anous,* from the Greek, means "silly"; *stolidus,* from the Latin, means "slow of mind." The common name "noddy" is the most respectful in centuries; it alludes to the reciprocal head-bobbing that occurs between mates.

The most unusual thing about the brown noddy is that it isn't white. Terns, like gulls, are predominantly white—they flash in the sunlight as they turn sharply, hover, and dive for small fish in the shallows, sometimes in just inches of water. Noddies behave like other terns, but even though they lack the flash and splash of their bright white relatives, they still are not "plain," as is apparent on close inspection. Theirs is a quiet beauty with the subtlety of brushed pewter under a mantle of weathered bronze, a frosted forehead, and functional black antiglare panels between the eyes and bill. It is a bird worth remembering. In the Galápagos, brown noddies number only a few thousand, but they are spread throughout the tropics.

Tropicbirds are true pelagics, seldom seen near land except as they approach or leave their breeding sites. They choose inaccessible places—crevices in cliff faces, caves, and sometimes burrows. They are rarely seen except on the wing, and they are strong flyers, so it is a rare treat to get a good look at any of them.

There are three species of tropicbirds, all of them found throughout the tropics and all similar in appearance, but only the red-billed tropicbird nests on the Galápagos; breeding colonies of the species are established at a number of locations. The red-billed tropicbird's most striking feature is a pair of slender trailing plumes. Constructed of the central tail feathers with a whiplike shaft, they are much more flexible than one might expect. The plumes' significance is not aerodynamic, however; their primary function lies in courtship displays. The absence of paired central plumes in juveniles serves to support this interpretation.

Since red-billed tropicbirds forage over warmer waters, the colder upwellings that are so productive for other pelagic species are less suitable for them, so they favor the archipelago's northeastern quadrant, which is influenced by the Panama Current. Foraging red-billed tropicbirds are found in association with whales, dolphins, and smaller predatory fish like mackerels that force their prey, especially flying fish, to the surface. Particular sorts of subsurface currents attract this association of predators, and tropicbirds have learned to locate and capitalize on these situations.

The stocky bodies and heavy bills of tropicbirds suit them for plunge diving. Many seabirds are plunge divers, harvesting fish at different depths. Tropicbirds begin their dive from forty feet above the water, entering the sea at high speed and striking perpendicular to the surface. A body designed to be tough enough for this kind of "contact sport" is unlikely to be an effective soarer, so when they fly, tropicbirds and other plunge divers must flap their wings frequently. Flapping requires more energy than soaring, so when they finish foraging, plunge-diving birds spend more time sitting and less time flying than the long-winged birds (such as albatrosses and shearwaters). They sleep right on the water, and with their shorter wings and strong flight muscles, they have no difficulty taking off, despite their short legs and small feet.

The shoreline, with its cliffs and pounding surf, is a forbidding place for most animals and requires special adaptations among the few species that call it home. With desert on one side and pounding surf on the other, there are few animals that can make use of it, but it is ideal for Sally Lightfoot crabs, marine iguanas, tropicbirds, penguins, and others that gather their wealth from the sea (or steal it from those who do).

Prominent among these animals are the pelagic species that gather into colonies to reproduce. The fabled fearlessness of these birds, well-known from before the time of Charles Darwin, allows for a remarkably personal interaction that is unlikely to occur elsewhere. In the Galápagos, a visitor can approach a nesting bird and study it at close range, while the bird appears unconcerned and maybe a bit curious about the human who entertains it during its long and uneventful incubation. The impact of intimate eye-to-eye contact with beautiful and enigmatic species like these persists in one's memory long after more subtle events have faded.

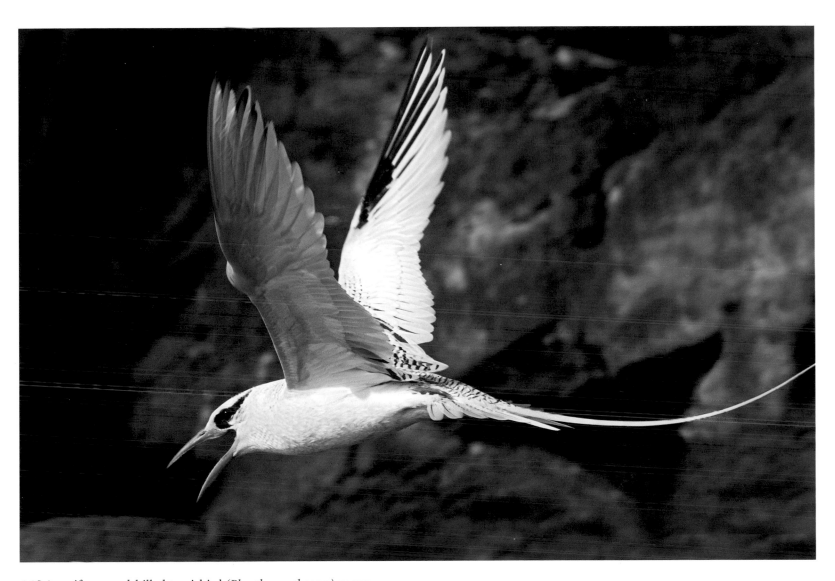

4.19 A vociferous red-billed tropicbird *(Phaethon aethereus)* passes
by the cliffs that rim the sunken caldera of Darwin Bay.

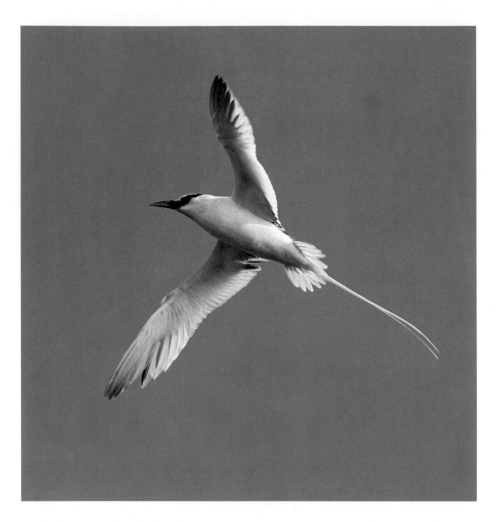

4.20 Red-billed tropicbirds are beautiful and boldly marked. Graceful in a manner more reminiscent of a tight end than of a ballerina, they nevertheless carry a well-defined "tutu."

4.21 A red-billed tropicbird takes a moment to bathe in the waters of Darwin Bay, ruffling its feathers and splashing droplets into the air.

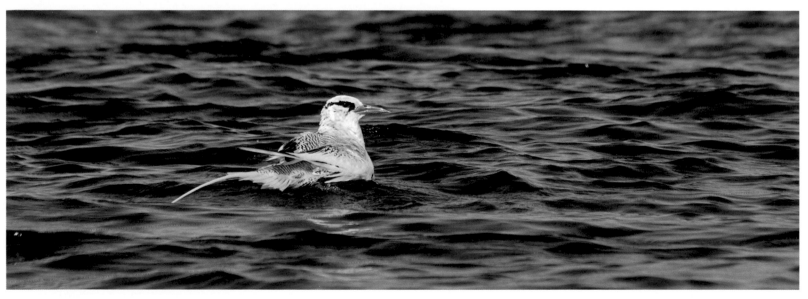

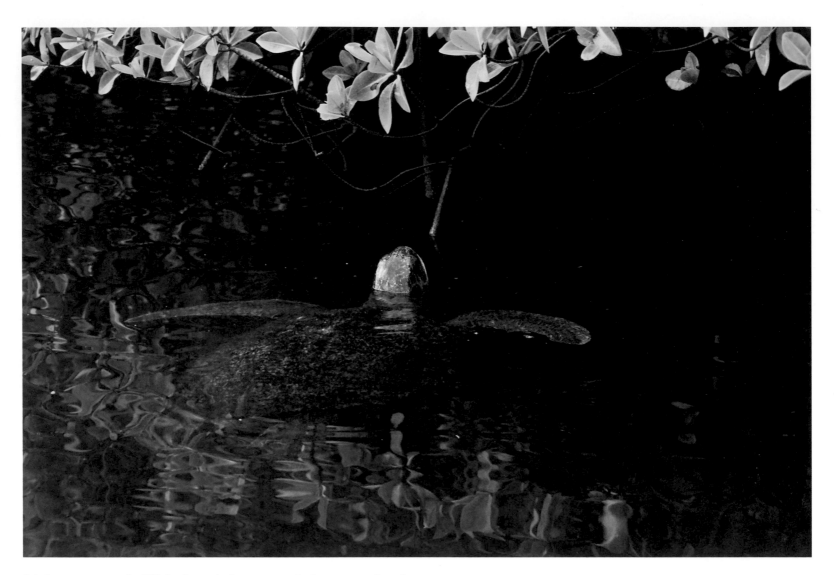

5.1 A green sea turtle *(Chelonia mydas)* enters a quiet lagoon to take advantage of the mangroves, browsing on leaves and scraping algae from prop roots.

5

―――――― Lagoons and Beaches ――――――

The shore has a dual nature, changing with the swing of the tides, belonging now to the land, now to the sea.—Rachel Carson, *The Edge of the Sea*

In addition to the sea-pounded cliffs and craggy rocks of the shoreline, there are also places where the land-sea interface is less abrupt and more benign. Extensive rocky shelves make peaceful tide pools when the tide is out, rocky coves escape the fury of the surf, and mangrove forests, with their toes in the water, create rich green gardens—rare in the Galápagos—and solitude. There are hidden beaches. Each of these places marks a change in the character of the Galápagos tapestry, but unlike the line of surf, these transitions are gradual.

The Vecia Islets are one of these less-abrupt places where past violence has created a moonscape of volcanic rock on the northern shore of Santa Cruz. The youngest lava is piled about in large chunks, as porous and rough as a torn loaf of dark rye bread—except that its surface is laced with sharp crystals—its origin too recent to have been dulled by the sea. Older volcanic rocks are weathered, have accumulated a soil of sorts, and support trees that provide well-placed lookouts for the frigatebirds to monitor the sea lanes. The tide rises and falls, and the water breathes in and out of the maze of lagoons swaddled in red mangroves. It is a quiet place, sheltered from the wind, and it has the feel of sanctuary.

One of the species that avails itself of this place is the green sea turtle, the only sea turtle common in the islands. It is a pelagic species, particularly when the turtles are preadults—a period that lasts for twenty-five years. By then they have become entirely herbivorous, and the serrated cutting edge of their beaks assists in tearing the tough vegetation—algae, sea grasses, and similar fare—into pieces small enough to eat. They are aquatic cows, ecologically speaking. They may be encountered almost anywhere about the islands, and visitors commonly see their bulky, three-hundred-pound bodies wallowing at the surface as they graze in the shallows or nibble at the mangroves.

Elsewhere in the maze of waterways, a school of cownose rays pass in total silence. Moving with ponderous wingbeats and with breathtaking grace, their wing tips occasionally break the surface to introduce a bit of reality into an otherwise surreal moment. Their "wings" are less than three feet from tip to tip, and they trail

a black whiplike tail the way a submarine tows a sonar array. A tail like that hardly seems necessary, but they live in a world that is alien to us, so their means to success is unlikely to be intuitive.

Cownose rays are bottom feeders, so they are not feeding as they sweep about the lagoon in a grand and silent promenade. So what are they doing? Biologists generally find that the waking activities of animals can be divided into the categories of reproduction, feeding, and loafing. The last is a superficial designation in which can be literally hundreds of subcategories. *Loafing* may seem an odd choice of terms, but there are times when a bird is not courting or feeding—it is simply "existing" between significant activities. *Loafing* is the term used to enter this activity (or apparent inactivity) into the time budget. Both feeding and reproductive activities require an appreciable expenditure of energy, while loafing does not. Since cruising cownose rays are spending energy in social activity but not feeding, it's a good

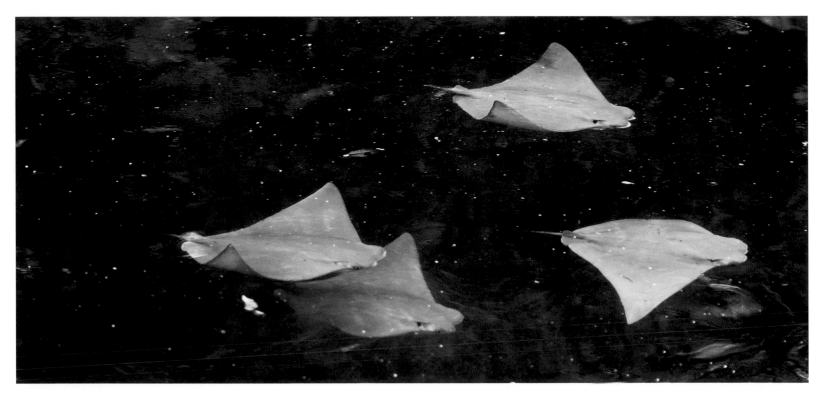

5.2 Four golden cownose rays *(Rhinoptera steindachneri)* moving in silence appear as a four-of-diamonds card come to life.

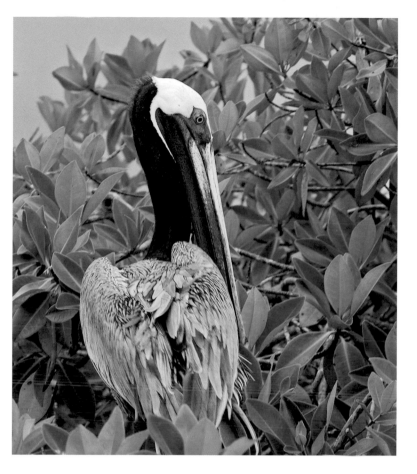

guess that their promenade will improve their reproductive success in some way.

One of the odd experiences a visitor can have in the Galápagos is an unexpected encounter, in this otherworldly place, with a bird from "back home." It is more than a little provincial, but it is hard not to think of these familiar birds as expatriates. Brown pelicans, so abundant along the southern coasts of North America, are often seen loafing in the mangroves. The bird in Figure 5.3 is an adult in breeding plumage, and while brown pelicans nest readily in red mangroves, this is not a nesting area. Adding to the sense of "back home," a great blue heron forages nearby, poised for a strike. Neither pelican nor heron is detectably different from North American birds, and either photograph could have been taken in Florida or Texas, except for the lava behind the heron.

To further unsettle the visitor who is not totally sure which reality he is experiencing, there are the long-term expatriates—birds with unmistakable relatives on the mainland (the "old country") that have clearly adapted to their new home. The lava heron is one of these. Lava herons look and act very much like the closely related green heron that summers in the United States and winters in Central America, so it is easily recognized as a variation on that

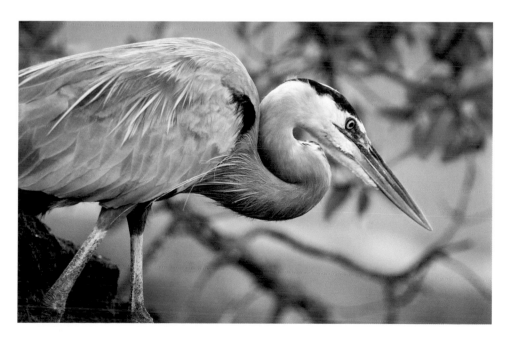

5.3 A brown pelican (*Pelecanus occidentalis*) with the gravitas of a philosopher loafs in the red mangroves.

5.4 A great blue heron (*Ardea herodias*), visually locking onto a target, prepares for a strike in the shallows.

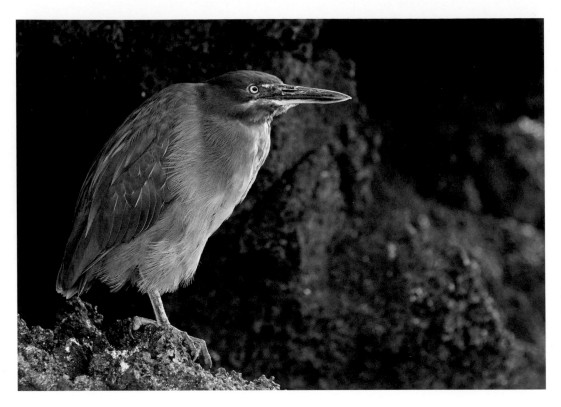

5.5 Lava herons *(Butorides sundevalli)* are so perfectly matched to the lava that one might imagine the lava dust has rubbed off on them.

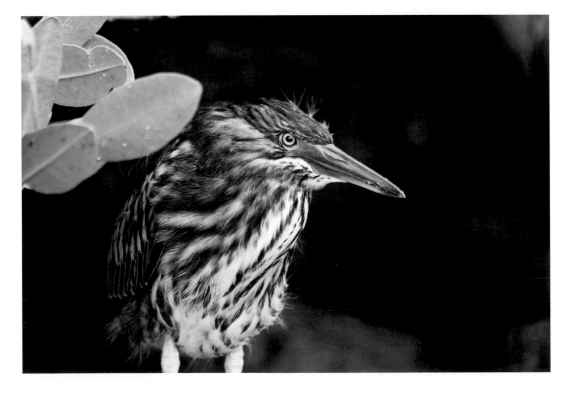

5.6 In the great scheme of things, this juvenile lava heron was not given a sense of humor and appears annoyed at having its prey disturbed.

theme, but it appears dusted with soot like a chimney sweep. That "dusted" look is more common about the islands than one might expect, which suggests the tremendous value of camouflaging for Galápagos species. The lava heron in Figure 5.6 is recognizable as a juvenile because it is striped, although it barely qualifies because it has not yet gotten all of its "underwear" out of sight. The striping on the breast of the juvenile is identical to that of both the juvenile and adult green herons from "back home." The dusted color of the lava heron adult likely resulted from pressure to be less alarming to a fish looking up through its ceiling at the shoreline—better for the heron to be dismissed as a chunk of lava or two than recognized as a predator. The juvenile plumage apparently has not responded to the new environment, retaining the streaked breast that is characteristic of green herons on the mainland, where it helps them blend in with shoreline vegetation.

One would expect islands with such extensive shorelines to support lots of gulls, but they do not. Gulls—seagulls—are not so much birds of the sea as birds of the broad seam. They favor estuaries, with their mudflats and extensive salt marshes and the human habitation that tends to expand those places as well. There are no estuaries here, so instead of diverse aggregations of gulls, we find only two, and both are endemic. The swallow-tailed gull is nocturnal and pelagic. It is so notable it will be treated later in its own chapter. The second is the lava gull, the rarest gull in the world: a solitary scavenger, feeding on small lizards and the eggs of ground-nesting birds.

The nature of the shoreline dictates that lava gulls are thinly distributed, so they are never seen in flocks—usually just one at a time. The four hundred pairs that make up the entire species may be the largest population the islands can support in this niche. While the population is stable, it is considered at risk because it is so small and because it is confined entirely to the Galápagos. Lava gulls take whatever they can from herons and pelicans that are foraging successfully, but without a mob of gulls for support, the theft must be done carefully, and "under the radar" of the omnipresent and ever-attentive frigatebirds.

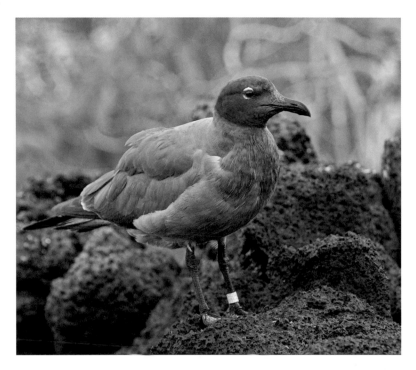

5.7 The lava gull *(Larus fuliginosus)* is another "dusted" species that makes its home among the lava beds of the shore.

The colors and anatomy of the flamboyant flamingos are so exotic that everybody knows a flamingo, even if few people have actually seen one in the wild. The intense gradations of pink in the flamingos of the Galápagos, reportedly the brightest colors of any, are luminous against the soft earth tones of their feeding areas. Since the pigment comes from their food, it says more perhaps about the brine shrimp of these lagoons than it does about the birds.

The characteristic feeding behavior of flamingos, which is fundamentally like that of the great baleen whales, is more exotic than their color. Likening a flamingo to a skinny, pink, flying whale is perhaps too great a stretch of the imagination to propose without explanation, so here is the justification. As they wade about the lagoons, flamingos swing their upside-down heads back and forth like a farmer cutting hay with a scythe. Indeed, they are harvesting food—sweeping the water for brine shrimp and other invertebrates. From the surface it seems that they are

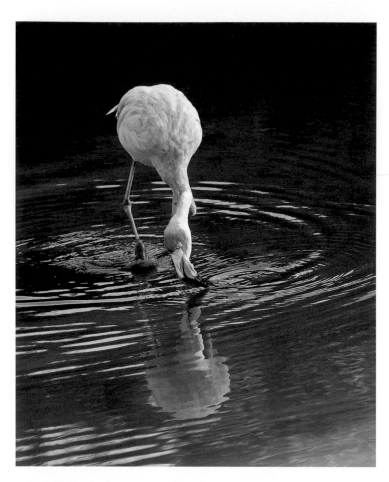

5.8 A greater flamingo *(Phoenicopterus ruber)* dabbles in the water of a brackish lagoon, its preferred habitat.

5.9 Flamingos sweep the salty water with their scythe-shaped bills, filtering out a potpourri of invertebrates.

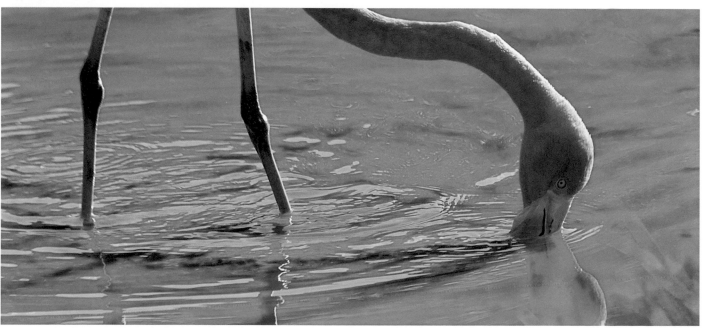

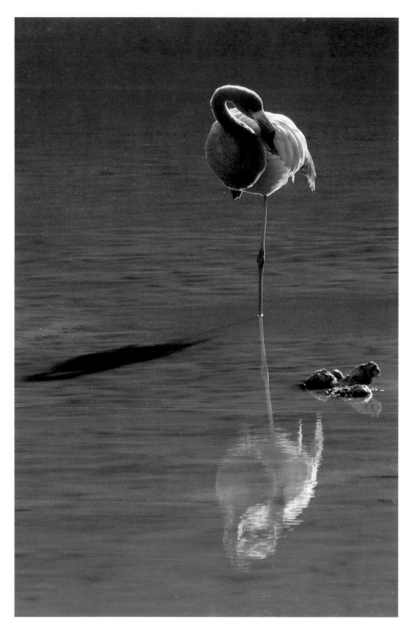

5.10 A flamingo spends some time preening; oiling and cleaning the feathers is an important and time-consuming chore.

aimlessly swinging their heads back and forth in the water, like a little boy dangling his feet from a dock. That is what we can see. What we cannot see is that they are using their muscular tongues like pistons to draw water into their mouths; then, they force it out again through thin, closely spaced plates on the bill to filter out invertebrates. This feeding activity has much in common with the action of whales using baleen to harvest krill. Like those of baleen whales, the tongues of flamingos have a rough surface that scrapes the plates clean of the accumulated food in preparation for the next cycle, but in flamingos, the pumping is rapid—up to several times a second.

Flamingos are sufficiently different that no one quite knows how they are related to other birds. At present taxonomists place them in an order by themselves. The flamingo of the Galápagos is a subspecies of the bird that reaches U.S. shores, but it is a resident, not a migrant, and colonies of several hundred birds make a living here. There are only a few places, particularly on the south of Isabela and nearby Floreana, where the quiet salty waters attract flamingos, which add a flash of color to the tapestry of the islands.

In the shallows outside the protected lagoons, the water is clearer and the colors are sometimes more vibrant. Just off the shore of Fernandina we happened on a stingray. This one is likely a diamond stingray, but its identy is less significant because this experience is about sensation, not taxonomy. The sensation is one of "batness" and is all the more eerie because in the brilliant blue waters of the Pacific it is surreal. Our culture has clothed bats in mystery, malevolence, and a touch of the satanic, and the batlike quality of rays, especially the dark-colored ones, plucks those cultural chords even with little else to make the association.

Real bats, when seen vaguely against a dark blue sky, present an observer with shadows and indistinct wings, a fleeting encounter busy with flapping even if the vocalizations are inaudible. An encounter with a ray like this one is vastly different. Small lapping sounds made by the water accentuate the ray's silence and enlarge an already strong sensation of deliberate power and grace—slow but without lethargy. It is a potent experience that photographs can never entirely capture, but the part of it that passes to the lens,

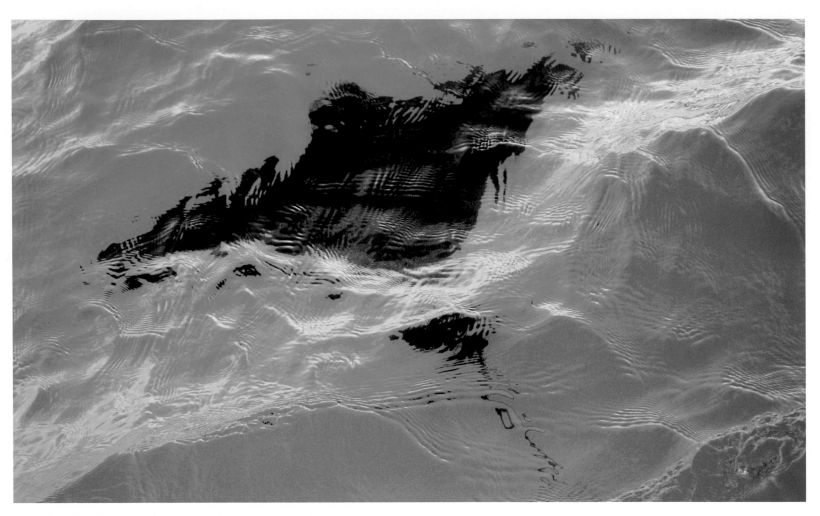

5.11 The ghostly image of a stingray (genus *Dasiatus*) is seen through a ruffled surface that only enhances the mystery.

through the water's shimmering distortions, offers a compelling glimpse of another world.

No one can give much thought to the denizens of the land-sea interface without considering the sea lions. The Galápagos sea lion *(Zalophus wollebaeki)* is now recognized as an endemic species, distinct from the familiar California sea lion, although a visitor is unlikely to notice a difference. We easily feel a kinship with sea lions, so we project our pleasures onto them as they loll on the beaches napping away the sunny afternoons. They have an inclination to aggregate on favorite beaches just as humans do, but sea lions are inclined to clump together—touching—as humans are not. They often act in ways that make it easy to imagine a familiarity with them—as though they were humanoid or perhaps a large, friendly dog. Of course they are neither, so part of the challenge of understanding sea lions is to keep in mind that they are wild animals, even if we still enjoy their antics.

They are favorites of the visitors, partly because the adolescent sea lions, who seem to have more than their share of high spirits, unflagging energy, and enthusiastic bonhomie, call to mind a pack of young Labrador retrievers. They body surf on the breakers and

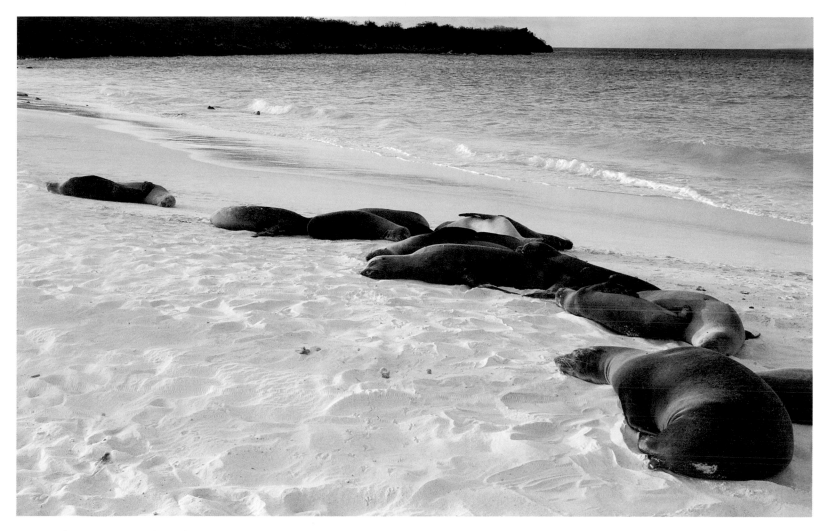

5.12 Sea lions nap in the late afternoon at Gardner Bay, Española—
one of the scarce coral beaches of the archipelago.

5.13 Usually clumsy on land, Galápagos sea lions are agile and graceful in the water. Even sleeping on the beach, their bodies hint at these extraordinary skills. *Regina Hess.*

5.14 Sea lions project a comfort in the presence of humans that can be interpreted as a sense of entitlement.

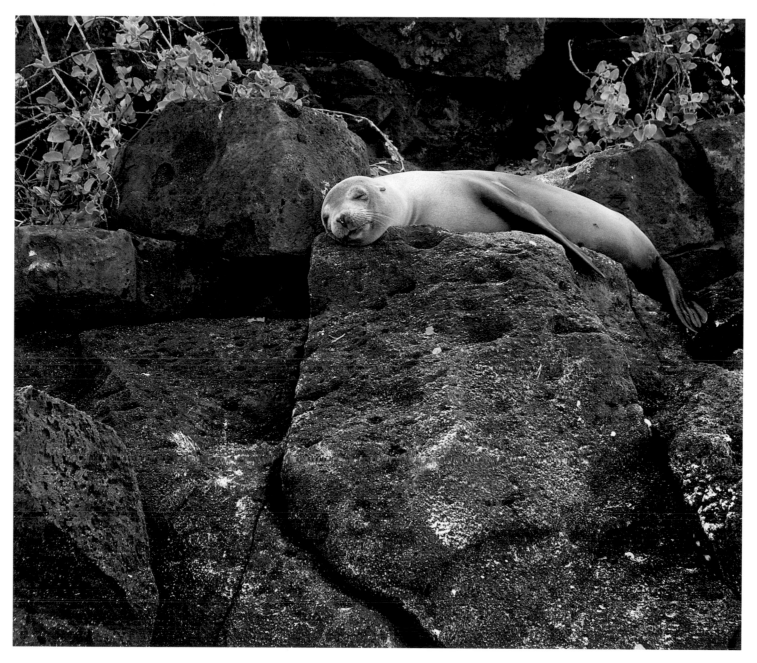

5.15 This pup went to considerable effort to leave the soft
sand of the beach and climb onto the hard, rough lava.

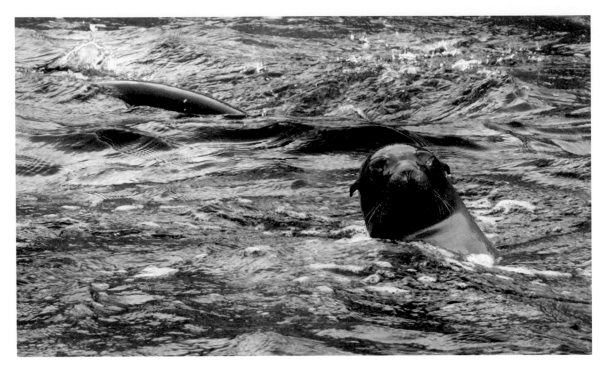

5.16 As the landing boats bring humans to the shore, young sea lions come romping through the waves to see who is visiting and how they might provide entertainment.

play a sort of "water polo," using an unfortunate marine iguana for an impromptu study in ballistics. The older and the younger sea lions, lacking such energy, lie about on the beaches and in less probable spots, sleeping away their nap times.

Underwater, sea lions are fast and agile and move effortlessly. They appear fascinated by humans and are especially entertained by snorkelers, but when snorkelers' aquatic inadequacies become apparent, they can find more excitement in a rock—which is not particularly flattering for the human. In Figure 5.17 a young sea lion has decided that a rock is more fun than his photographer. He picks a rock from the sea floor, carries it in his mouth like a dog with a toy, and races about with stunning agility and speed. Soon he will release the rock, watch attentively as it sinks to the floor, then recapture it to take it for another ride.

Lolling about at favorite haul-outs occupies a major part of the females' time, but it isn't really a spa. Carnivores spend more time sleeping than most mammals, and for diving mammals there are physiological specializations that maximize their time underwater. Those methods are beyond the scope of this book, but they require that the sea lions recharge the oxygen stores in their muscles in preparation for the next foraging expedition—like recharging a battery—and they do it during their beach time. Sleeping females are often also nursing, reminding us that a female must catch enough fish both to sustain herself and to produce milk for her young. The pups may nurse for two years or more, so females are nearly always lactating, sometimes feeding both a yearling and a pup. Yearlings can catch their own fish, but they still supplement their diets with the extremely rich milk of their mothers.

Then there is the pup nursery. By a week after the birth of her pup, the female takes to the sea again to feed. The pups are left in a sort of day-care arrangement, overseen by only one or two adults, but they are permitted to play in the shallows. Such experiences no doubt contribute to a degree of angst for the little pups. Though still sleek and wet from playing in the shallows, they always seem more than ready for their mothers to return.

The dense fur of the sea lions has two modes of appearance. When dry, it is short cropped and dense—it traps a lot of air and functions well as an insulator. When wet, it looks and functions

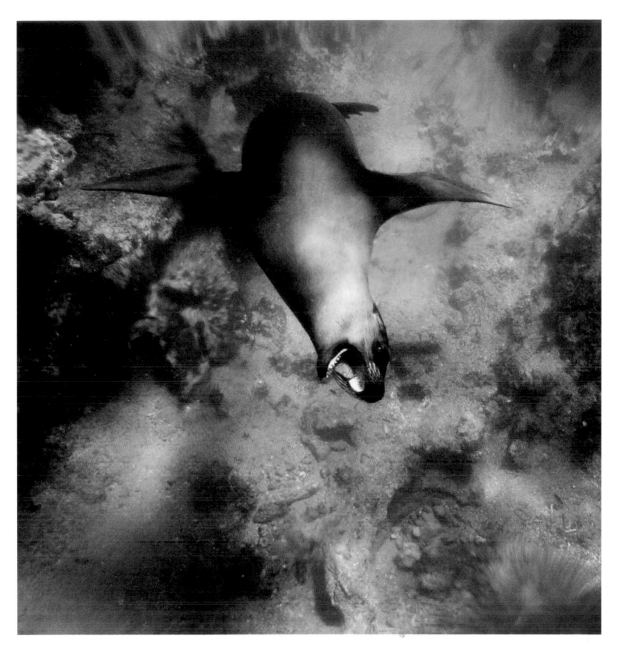

5.17 A sea lion zooms and soars like an underwater Blue Angel.
This one is playing the "rock game" in the shallows of Bartolomé.

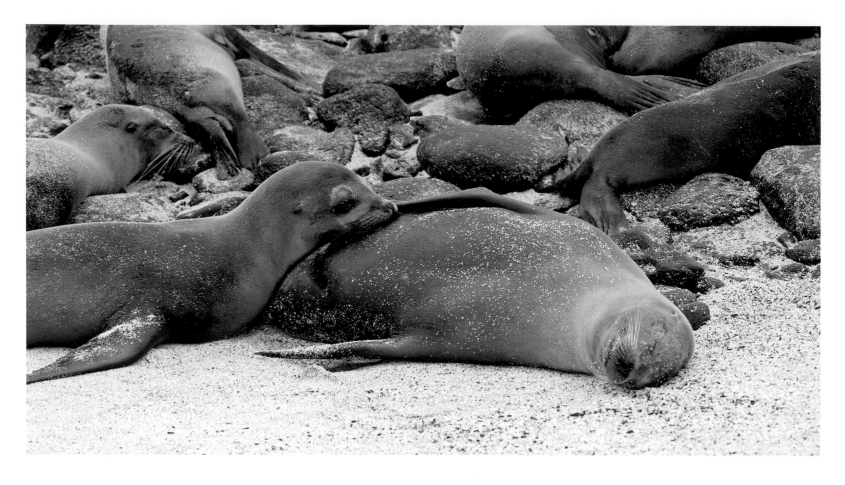

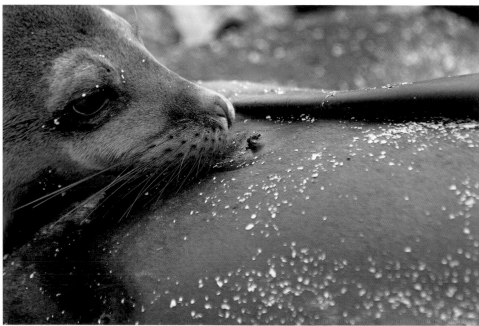

5.18 *Above,* sea lions are inclined to lie about in small groups, usually in contact with each other, but this pup is not sleeping, it is suckling. *Left,* the yearling pup takes a short break before it resumes nursing.

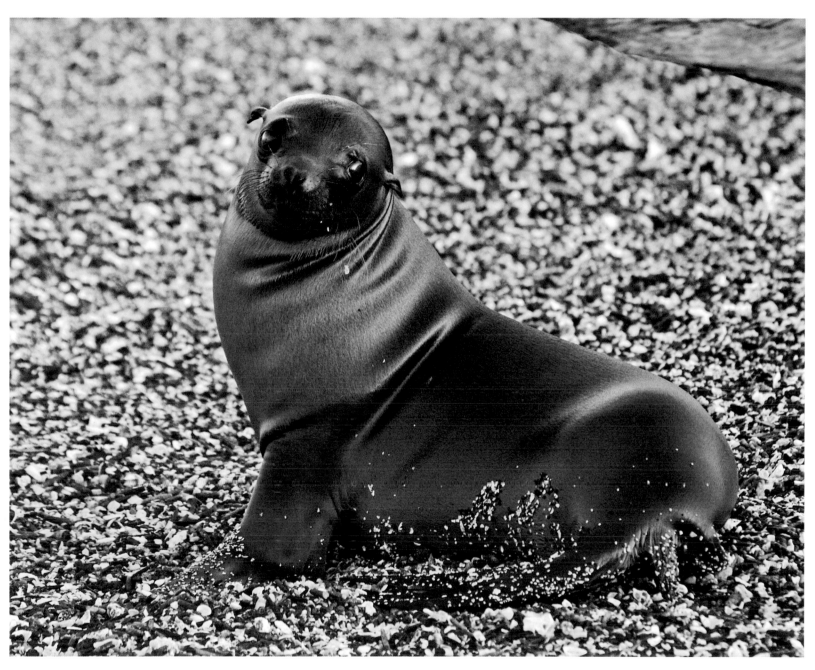

5.19 A sea lion pup several months of age has a pathetic abandoned look when its mother is not in attendance.

like a wetsuit. The hairs mat and offer virtually no friction against the water. The air is pressed out of the fur, eliminating a buoyancy problem, and the water remaining in the fur becomes warmed and remains next to the skin. Wet sea lions look very different from dry ones, and Figure 5.20 provides an unusual comparison. Apparently a sleeping sea lion was surprised by a larger than usual wave as the tide came in. Having moved to a higher perch, the sea lion presents a vivid image of the difference between wet and dry fur.

Most mammalian predators have long whiskers on their snouts and scattered about their heads that serve as sensory devices, like curb feelers on a car, but the bristles of sea lions are extremely long and richly supplied with nerves at their bases. Evolutionary theory predicts that greatly modified structures like these have been modified to serve some end, and so it is. Sea lions, with their great speed and extreme agility, pursue and capture fish. Their success is enhanced by using their whiskers to detect water currents created by the prey and to home in on the fish. The nerve channels feed directly into the brain, and the longer the whiskers the wider the separation of right and left "channels" and the more refined the information collected.

Diverse habitats attract biological diversity, creating a rich tapestry to exploit the resources. This diversity is increased by microhabitats within the seam—different textures that attract rays, turtles, flamingos, lava herons, and others, each to their special, preferred habitats. Seams permeate the Galápagean tapestry, enriching the whole. Before we take an extended look at the most prominent species on the islands—the species that I think of as Galápagos "royalty"—there are two more kinds of places to examine: the highlands, and those special places where human residents and wildlife interact on a day-to-day basis.

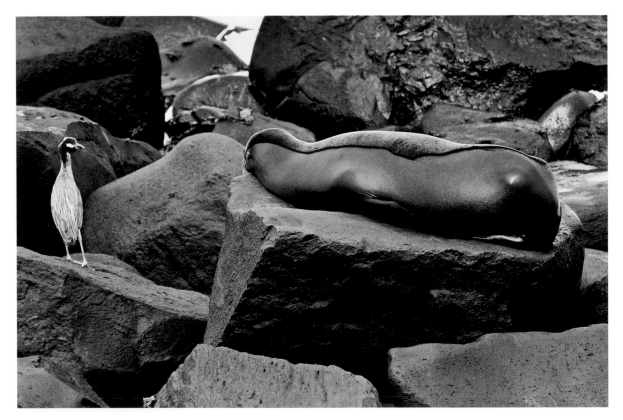

5.20 Surrounded by Sally Lightfoot crabs and skirted cautiously by a yellow-crowned night-heron *(Nyctanassa violacea)*, a half-wet sea lion has claimed a prime position on higher ground.

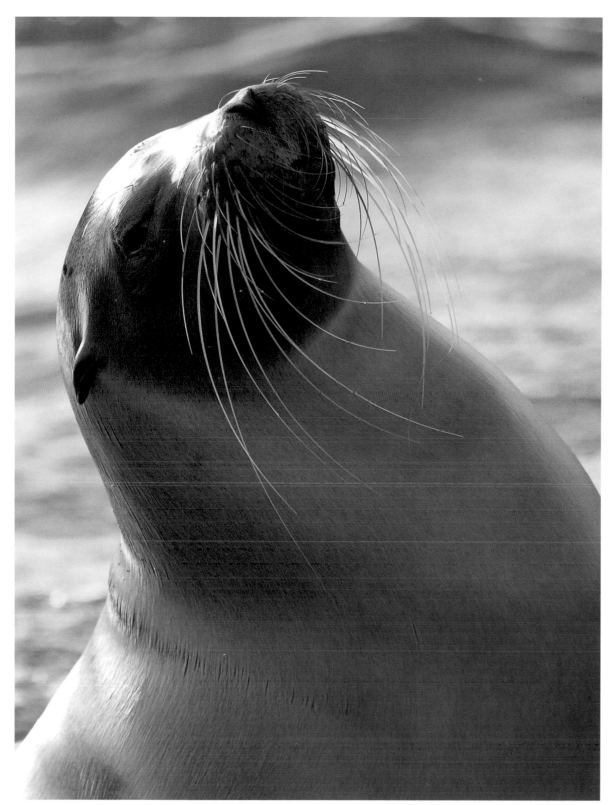

5.21 The long symmetrical whiskers are much more than a fashion statement for sea lions.

6.1 The white surf in this aerial photograph marks the abrupt seam between the desert and the sea, accenting the dominant hues of the tapestry.

6

——— Of Highlands and Humans ———

All things are connected.
Whatever befalls the earth,
befalls the sons and daughters of the earth.
Man did not weave the web of life;
he is merely a strand in it.—Ted Perry

In most places, the Galápagean tapestry is a blend of many hues of blues and browns, here and there blushed with the warm red tones of weathered iron and accented with black lava and white surf. There is not a lot of green in this tapestry, but there are places where islands of green float in a sea of desert.

Islands are the premier literary allegory for isolation. In the study of island biology, the isolation is literal, but there are many kinds of "islands," and they don't need to be surrounded by water—a cloud forest surrounded by desert is an island as well, because most life forms are marooned there by an arid landscape as surely as Robinson Crusoe was marooned by the sea. Ecologists look at the Galápagos as a series of nested islands, each smaller and more fragmented than the one below. Figure 6.2 shows the nested islands as understood in the broader context. The shallows of the Carnegie Ridge (light blue) define the largest "island." It functions as an island because its residents are isolated. Leaving aside the seam species, plants and animals that live

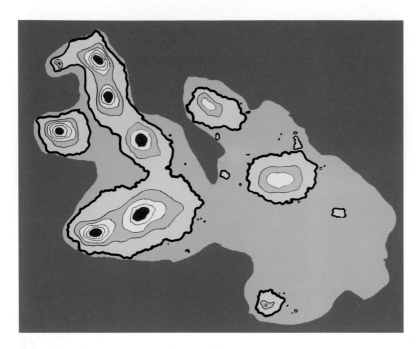

6.2 Islands on islands. Medium-green hues mark the 1,000–2,000 foot elevations that encompass the bulk of the scalesia zone. Light greens and dark reds identify higher elevations whose habitats are even more severe, more isolated, and smaller (contour interval = 1,000 feet).

in the shallows dare not venture out into the deep, nor can they move ashore. Life in the desert is similarly confined—here, to a series of circular habitats. The green areas are clearly a cluster of islands perched on a sea of desert. They mark higher elevations that deflect the trade winds upward, where they cool and drop some of their moisture as fog or rain. The inhabitants of the green zones are also confined—marooned on their small plots of land. It is a perfect situation for speciation to occur.

Seasonal changes in the ocean currents create wet and dry seasons that are more meaningful at higher elevations. From May to December the higher elevations are granted a heavy mist called the garua. It envelops the higher elevations and favors seasonally lush green vegetation reminiscent of a rain forest, where a canopy is formed and the trunks of the trees are rich with epiphytes. These epiphytes capture water, filtering it from the mist like a barnacle filters detritus from the water.

Where ecosystems abut, their seams can be abrupt, as at the

surf line, or the transition can be so gradual as to be imperceptible—brown threads gradually and grudgingly surrendering to green ones. Ecologists like to call this sort of transition an ecotone. In an ecotone, there is no point where a person can say that he has stepped from one ecosystem to the next—unlike a beach, where the transition is easy to recognize.

In mountainous regions, ecotones are common—desert brush gives way to pine parklands, pine to spruce forest, and spruce, eventually, to alpine zones. These colors and textures are not available to the Galápagean tapestry—there are no cone-bearing plants on the islands. Instead the naked landscape is draped with the limited selection of species that have managed to reach the islands by hook or by crook. Prominent among these are plants of the genus *Scalesia*. They belong to the daisy family, and they tell the story of arrival and diversification as well as Darwin's finches. Of the fifteen species of *Scalesia* now distributed about the islands, all have evolved from a single ancestral stock. They are primarily small shrubs in the arid zone, some only a foot high, but a few reach heights of fifty feet at elevations where the wetter conditions that accompany the garua permit more luxuriant growth. This enormous range of size and habitat preference, from a single parent species, could only have happened on an island where the tattered ecological fabric presented an enormous range of opportunities.

It is such a successful genus that one of the ecological zones is recognized as the scalesia zone, and it may be found between 800 and 2,500 feet in elevation. In it one will encounter the unlikely—ferns, mosses, and orchids—and the incredible: a forest of daisies.

The daisy forest is a cloud forest, so named because during the garua, it is regularly shrouded in fogs or mists that supply the water necessary to support it. It is named for the largest of the scalesia species, *S. pedunculata,* an endemic found on only three islands. The whole is perfectly structured for its function. Since the productivity of terrestrial ecosystems is directly proportional to the water input, the major part of that function is trapping water.

The canopy is thick with flat leaves pointed downward to shed water toward the interior of the forest, where it can be absorbed.

6.3 Like cracked peppercorns on a salad, the spent flowers with their loads of seeds freckle the canopy of the daisy forest. Here and there, a few late bloomers are still accepting pollinators.

That canopy is lofted like a circus tent on legs that are spindly and crooked, creating a surprisingly open and breezy subcanopy. The ambiance of the daisy forest calls to mind the Gulf coast of the southeastern United States, where coastal scrub oaks are draped in Spanish moss. The water droplets of fogs that drift through this subcanopy are harvested by a scruffy netting draped from the crooked stems of the scalesia. Even the crookedness of the stems is adaptive, as it provides horizontal supports for the true mosses that cluster on their upper surfaces as well for as the Spanish moss that dangles. In the six months between garuas, the epiphytes find ways to minimize their use of water or become dormant.

The largest remaining stand of scalesia forest is accessible at Los Gemelos, "the twins." Los Gemelos is a pair of pit craters, the result of subsidence, at a moderate elevation on the island of Santa Cruz. For the romantically inclined, Los Gemelos can be translated—with just a bit of stretching—as "soul mates."

Comparing the extravagant diversification within *Scalesia* to the more widely known radiation in Darwin's finches is revealing because it highlights the way in which two vastly different life forms evolve in parallel. Both appeared on the islands probably as a single event, and each managed to survive the jarring insertion into an alien landscape and the hazards associated with having very small, inbred, and localized populations. Both then found success by reiteration of the formula "expand, isolate, diversify, and specialize." Both forms have successfully parlayed this practice into more than a dozen species.

Darwin's finches are among the most studied finches in the world and certainly the most celebrated. They are frequently linked to Darwin's understanding of the evolutionary process, but in fact he never really said a great deal about them—and wisely so. They are a complex group, and it was not until 1947 that David Lack made sense of their evolution. It was Lack who popularized the name for these birds that have collectively become an icon of evolution.

The finches are widely distributed about the islands, but several species occur in the scalesia zone. The ancestral finches arrived about 2.3 million years ago from the American tropics during the upheaval that nudged Central America above sea level. Their closest living relative is the dull-colored grassquit. Except for *gooney bird* and perhaps *dodo*, that must be among the worst labels ever affixed to a species—but it accurately describes an important characteristic of this ancestor of Darwin's finches: it was already suffused with the palette of the desert when it arrived.

The finches are difficult for visitors because there are so many of them—thirteen species in all (plus a fourteenth species on nearby Cocos Island). Of course all are derived from a common ancestor—that is, after all, the point of their celebrity—so it cannot be surprising that they appear similar and that identifying them can be difficult. All of them are sparrow-sized and brown with various amounts of streaking on the breast. Among the ground finches, males tend toward black as they become adult, but the females and young retain the "finchy" brown and streaked coloration. Other finches are brown regardless of their age or sex.

6.4 In the daisy forest, the tough, crooked network of branches makes a perfect architecture to hold Spanish moss *(Tillandsia insularis)*, which traps moisture wafting through the understory.

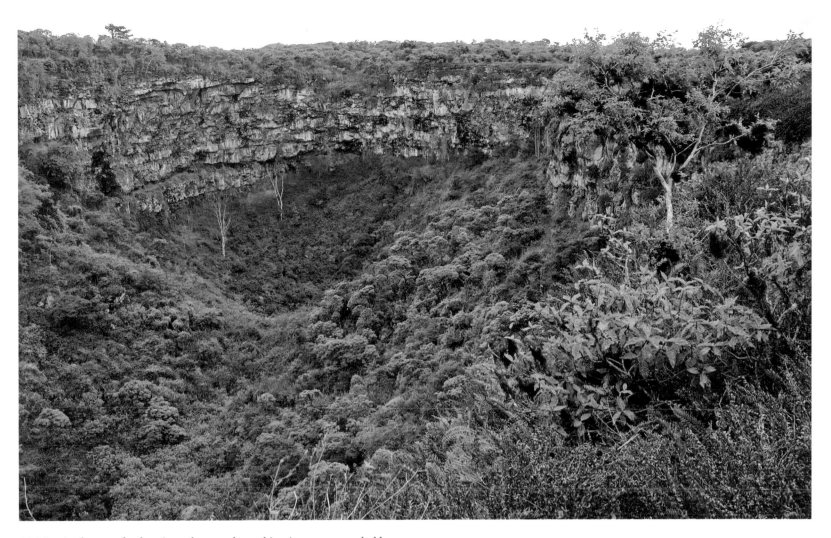

6.5 Massive layers of volcanic rock, now draped in vines, are revealed by a local subsidence called Los Gemelos in the scalesia zone of Santa Cruz.

The most important feature among them is the size and shape of the bill, true as a point of ecology as well as for purposes of identification. The diet of a species generally directs the evolution of the bill or teeth of an animal—sharp teeth for cats, flat, grinding teeth for horses, and serrated bills for boobies, who can't make teeth but need them anyway. Natural selection pushes species toward specialization to minimize competition for food. While it is an oversimplification, it is generally true that finches of different species living on the same island gather their food from different sources. Natural selection has modified their beaks accordingly.

Beyond any doubt, bill size changes from year to year among the ground finches. It is driven up and then down in small amounts, as the food sources change under the influence of the El Niño and La Niña cycle. It is also influenced by location. The bill of the medium ground finch in Figure 6.6 is nearly as large as that of a large ground finch in other places. The range of sizes from smallest to largest is remarkable, but all of them began with their ancestor's seed-cracking bill. Their evolution has made them more efficient, but not easy to identify because of the individual variation. To paraphrase Abraham Lincoln, an experienced naturalist can

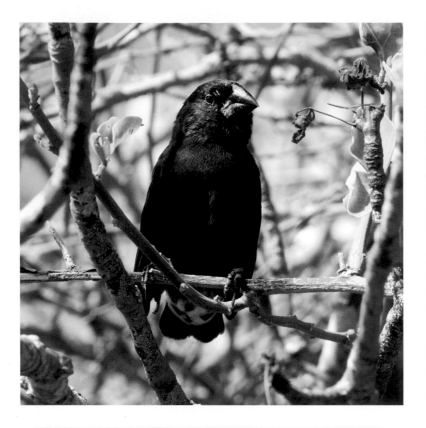

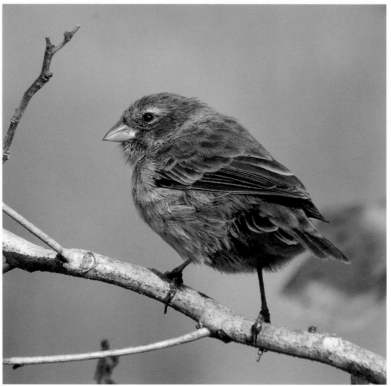

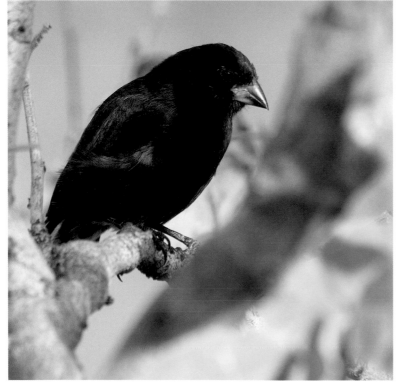

6.6 (*top left*) A male medium ground finch (*Geospiza fortis*) makes his living at the Charles Darwin Research Station on Santa Cruz.

6.7 (*bottom left*) A male small ground finch (*Geospiza fuliginosa*) studies his prospects in the Galápagos Tortoise Reserve on the west flank of Santa Cruz.

6.8 (*top right*) The female small ground finch has a smaller bill than the male—bill size is another variable that complicates any attempt to identify the finches.

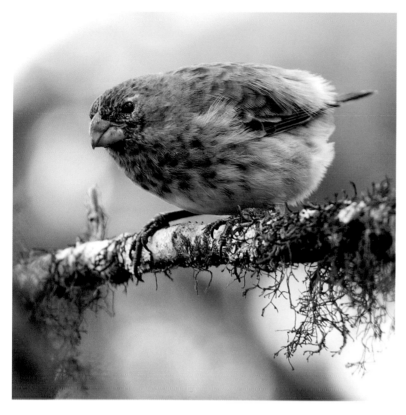

6.9 This vegetarian finch *(Platyspiza crassirostris)* pauses amid the epiphytes in the daisy forest.

identify most of the finches most of the time, but very few can identify all of the finches all of the time.[*]

Both medium and small ground finches use their crushing beaks to open seeds. The large, reinforced beak of the medium ground finch favors the high energy content of the larger, tougher seeds that they have the strength and leverage to open. The small ground finch has a smaller bill and prefers the smaller, more delicate seeds that it can open—grass seeds and such. There are more seeds of this kind available, but each has less nutrient value than larger seeds.

[*] Apparently the exceptions to this rule are Peter and Rosemarie Grant, whose research was the subject of *The Beak of the Finch*, a Pulitzer Prize–winning book by Jonathon Weiner. The notorious difficulty of identifying the finches has led some to say that "only God and the Grants can tell them apart for sure." A bit of trivia: Abraham Lincoln was born on the same day as Charles Darwin—February 12, 1809.

We might grasp the difference more clearly if we imagine making a meal by shelling peanuts rather than sunflower seeds.

The vegetarian finch is one of the residents of the daisy forest. Instead of sticking to the usual finch diet of seeds, it has taken to eating buds, young leaves, and fruits, and its bill has become more parrotlike. There are no parrots here, and surely, with the foods available on the Galápagos, it is likely that the vegetarian finch's bill, constrained by finch ancestry, will never reach the extremes of those of parrots.

In many ways the finches provide a summary of the island experience: A novice arrives at a strange land, a classic "fish out of water." Life is hard, but above all it is different. There are few predators, but the foods are strange, sometimes not recognizable, and tucked away in odd places. The nesting materials that their DNA tells them to seek may not be available, and even if they are, there may not be a suitable place to build. On the Galápagos one has to make do. A new way of life needs to be learned, and new skills developed. Eventually, through the failures of less-adapted siblings, their bodies change over generations and their lives become more livable. Few survive the transition, but that is the way of evolution, and those who survive embark on a new path to an unpredictable destination.

Humans in the Seam

Human activity has had an enormous impact on the tapestry of the islands. Whole sections have been stripped and alien animals introduced, some intentionally and some not. Many species have been reduced to populations that are ecologically insignificant, and some have been pushed to extinction. In the language of the tapestry, unique colors and textures have been stripped out (think of tortoises), and the fabric has been patched with generic replacements (feral goats). Large areas of unique fibers have been reduced to threadbare patches, the elegance of the tapestry compromised by the loss of colors and textures. It is the way things are on islands—islands seen in the broad sense as by an ecologist.

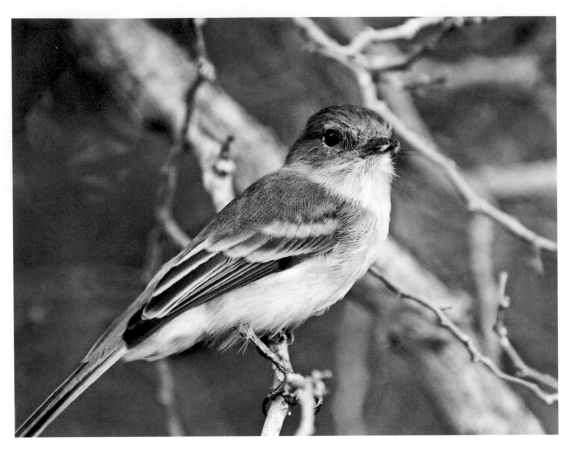

6.10 The large-billed flycatcher *(Myiarchus magnirostris)* is another endemic—one of only two flycatchers on the islands.

Humans choose to live in the seams for the same reason many other creatures do: there are greater resources there. A harbor is erected where food from the sea can be brought to land and joined with the agricultural harvest. The desirability is further enhanced if a substantial source of freshwater creates a junction of three habitats—a three-way seam. A characteristic of human communities is the concentration of large amounts of resources. Freshwater is available to the uninvited in a thousand ways, and food can be taken from the markets and anywhere else it is not tended. Then there is the stream of waste, a veritable feast for carrion eaters and opportunists of every stripe, from mockingbirds to pelicans. So a new sort of community is formed around humans that, like all communities, must abide by the rules of ecology.

Here is just one case in point. At the edge of Villamil, a large-billed flycatcher (Figure 6.10) has found a prime spot over tortoises in the Captive Tortoise Breeding Centre on the southern shore of

Isabela. The normal habitat for these flycatchers is the arid lower elevations, but the tortoise center has become an oasis. It is a good place: Humans feed the tortoises, which produces an abundance of fly-attracting debris. There is plenty of water, too: besides the pools maintained for the tortoises, there is always a leaky hose or a pan of water set out for the dog. The flycatchers wait for insects to buzz nearby, as flycatchers are wont to do. It is an artificial oasis—a synthetic irregularity in the tapestry that is richer than a seam. Humans generate waste in a much more profligate manner than the seabirds in the nesting colonies, and insects abound.

Most of the original residents of the seam eat fish in one way or another. When the supply is endless, it is worth waiting for, so fishing operations in the harbor or at sea are interesting places to look for birds and to watch their activities. At the harbor the flow of food and water reaches industrial proportions. Animals that normally inhabit the seams are presented with a rich supply

6.11 Fresh yellowfin tuna wait in an open-air market at the harbor of Puerto Ayarta.

6.12 A diverse clientele evaluates choice items in the daily catch at the market, but the great blue heron is more likely to settle for smaller items—a chance at the endless supply of fresh fish parts.

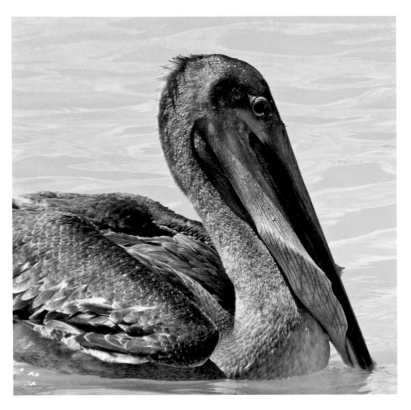

6.13 A juvenile brown pelican has purloined some large, probably discarded food item from the market—it apparently doesn't know quite how to deal with it and seems more interested in carrying it than eating it.

of food, but as the flycatcher demonstrates, they must adapt their behaviors to capitalize on it. They must be tolerant of proximity to humans, and they must not take enough to antagonize them—or else they must be clever or fast enough that humans can't do much about it.

Magnificent frigatebirds present a case of the first strategy: not taking enough to antagonize. Pirates by nature, they are always alert and waiting for an opportunity to present itself. This often requires sitting and waiting at the seam where good things are likely to happen. In this case, it is a fishing vessel. There is substantial waste. Fish are injured but escape the net, species undesirable to humans are discarded, and more. This leads to a frenzy

of feeding frigatebirds, but their "take" of the harvest is of little consequence to the fishermen.

Sea lions present a case of the second type: "can't do much about it." While it is easy for visitors to be amused by the sea lions, they are less entertaining, I am sure, to fishermen who must watch the fox take its pick of the "chickens" in the coop. There is a "cottage industry" among sea lions popping in and out of the net over the floats. Inside the net is an unbelievable selection of fresh fish that have no chance of escape, free for the taking—a fish market without compare, and all fresh!

The interplay of physical and biological forces that created and now regulate the archipelago are simple at first glance, but as these fundamental rules of ecology are applied, first here and then there, the consequences begin to unfold and interact with one another. The pattern of interactions becomes increasingly complex, even baroque in its intricacy. As Immanuel Kant saw it, "Creation is never over. It had a beginning but it has no ending. Creation is always busy making new scenes, new things, New Worlds." That was the view from 1755. Nearly a hundred years later, Charles Darwin would have been in total agreement with those sentiments—and he knew how it was done.

6.14 The net presents no challenge to sea lions; they casually pop in and out of the net by jumping over the floats.

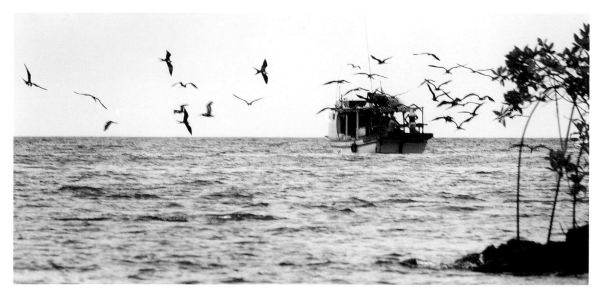

6.15 Magnificent frigatebirds *(Fregata magnificens)* engage in a scrum, each angling to be the first to capture a prize.

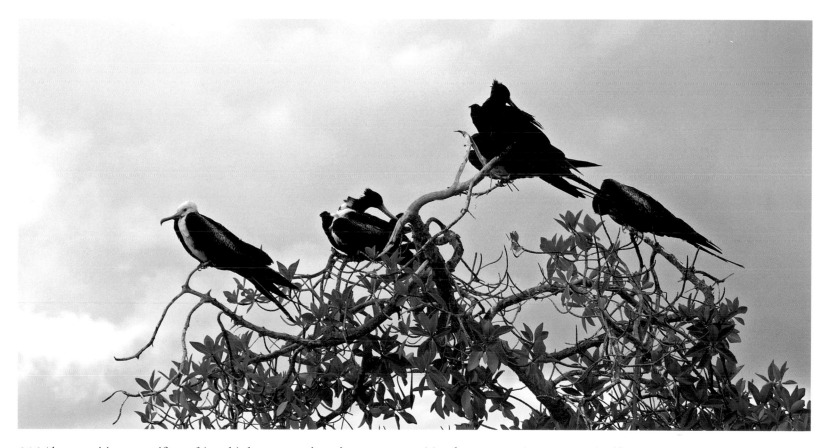

6.16 Always waiting, magnificent frigatebirds roost on the red mangroves, waiting for opportunity to present itself.

Galápagos Royalty

The animals I have chosen as the "royalty" of the Galápagos are evolutionary suc-
cesses—but then so are we all. When the last of a species dies, that species becomes a
failed experiment, or an obsolete model in a changing world, but until then, every liv-
ing thing qualifies as an evolutionary success. Every bloodline, including our own, can
be traced back to a time before there was blood. So while "success" is a necessary pre-
requisite, it does not solely define Galápagos royalty. These animals resist easy group-
ing. Some of them are spectacularly beautiful; others are not. Some are endemic to
this archipelago; others are not. Some of them number in the hundreds of thousands,
others are very rare, and some may soon become failed experiments.

Clearly, some Galápagos residents have a greater impact on visitors than others,
and I have elected to declare them royalty and to present them individually. They
deserve special mention because of the permanent impression they make on the vis-
itors who experience them. They are accessible to the public and occur in predict-
able places that permit the approach of humans in ways that do not put either of us
at risk. All of them have a charismatic presence that makes it easy for us to project
human traits onto them, sometimes in a comedic way, sometimes with deep respect,
always with awe. In the Galápagos, visitors can experience these royalty up close—
look into their eyes and see another living being, largely alien, looking back with curi-
osity rather than fear.

On leaving the Galápagos, and reflecting upon the experience, one is eventually
led to the conclusion that the wren nesting on the back porch is royalty, too. It is just
that we have been unable so far to make the connection. This is a lasting impact of the
Galápagos experience.

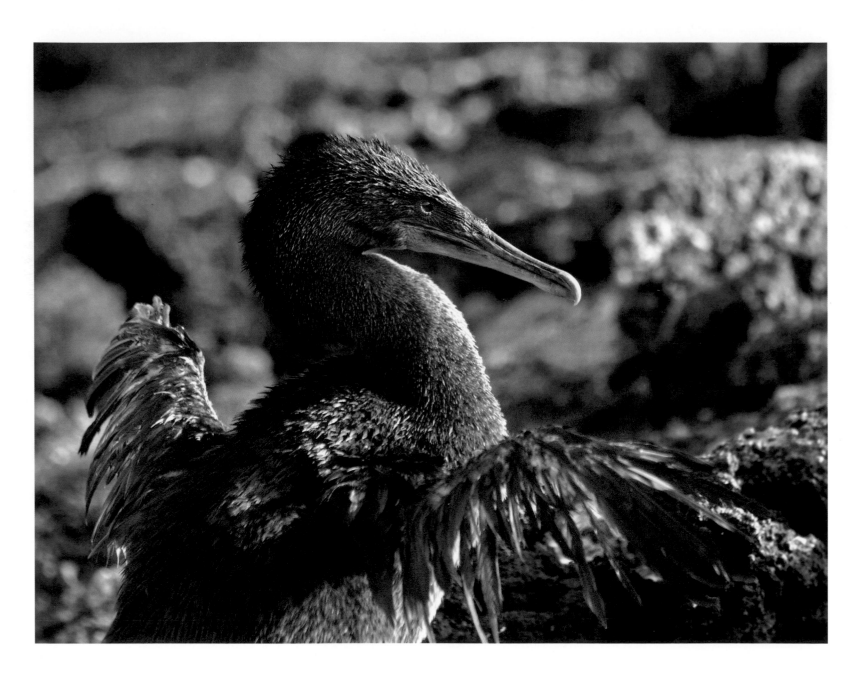

7.1 The flightless cormorant has a presence that lends it to the realm of mythology.

Phalacrocorax harrisi

7

Flightless Cormorant

I was surprised to find that so many men spent their whole day, ay, their whole lives almost, a-fishing. . . . Better go without your dinner, I thought, than be thus everlastingly fishing for it like a cormorant.—Henry David Thoreau, *Cape Cod*

The flightless cormorant, with its hopelessly tattered wings and its habit of flaunting them, is one of the icons of the Galápagos. Tapestries are often devoted to myth, so here is a suitable story, freshly minted: Long ago, a cormorant flew to the archipelago with his powerful and beautiful wings. He was so proud of his wings that the gods chose, as an appropriate punishment, to strip him of the power to fly and to make tatters of his wings, exiling him to these remote islands forever. As further punishment, the gods cursed him with the compulsion to display his affliction to all passers by. . . . But this story is a fantasy. The real story, as we can piece it together, is much more interesting.

The ancestors of today's flightless cormorants really did fly to the islands on wings very much like those of all the other cormorants of the world. Once here, they discovered a private oasis where they had struck it rich: a prolific upwelling with an abundance of fish next to an island totally lacking in terrestrial predators. The ability to fly

7.2 This bird, bobbing in the surf at the base of a rock, is an archetypical cormorant: half submerged and listing with the slosh of the seas, it is equally comfortable on land and at sea; unlike a duck, it is wet.

immediately lost much of its value, and over the years, this group of cormorants became better swimmers, at the expense of their capacity for flight.

For cormorants, "swimming" is much more than paddling about on the surface; it is the pursuit and capture of fish in their own element. The two activities, flying and swimming, are so different from each other in the demands they place on a bird that any evolutionary change that improves one will almost certainly impair the other. Flighted birds distribute their weight judiciously, their muscle mass apportioned to place the balance point of the body about the shoulders. The breast muscles of flighted birds are by far the heaviest and have the most bulk, so that is where they must be positioned, but they remain an aerodynamic impediment. Furthermore, these muscles are physiologically expensive to build and operate, requiring fully one-fourth of the blood supply and thus up to one-fourth of the energy consumption.

It turns out that the best swimmers are the poorest flyers. The superior swimming abilities of loons and grebes are accompanied by labored flight, presumably because the entire pelvic girdle and associated muscles are oversized. The migratory loons and grebes cannot optimize their swimming apparatus because they must remain flighted. The changes that can be seen in our cormorant show us what would happen if that limitation were removed.

Our cormorant is the heaviest of all the world's cormorants. It is a predictable change since there is no penalty for increased muscle mass in flightless birds. More mass generates more thrust, more heat generation, and at the same time it improves heat retention. The feet are enormous, fully webbed, and shifted to the rear, an ideal position for the same reason that a torpedo has its propeller there. By virtue of their location, the muscles that drive these feet can grow without either their size or weight compromising the hydrodynamics of the bird. The breast muscles are greatly reduced—a bonus in streamlining. The flightless cormorant's new, bottom-heavy figure can be admired in Figure 7.5. Finally, the lower legs of the best divers are laterally compressed and almost bladelike, further decreasing the turbulence. It is a fine distinction, mentioned here because depending on the point of view, the flattening can make the right and left legs look mismatched, an illusion that is particularly prominent in Figure 7.6. As in other flightless birds, the feathers have become more hairlike. It is a very dense plumage that traps air well, which in turn influences buoyancy and provides insulation.

All of these changes force the bird into an upright position on land, making it more than a bit clumsy, which is of little consequence in the Galápagos, where there were no land-based predators when the bodies of these birds were being rearranged. The upright posture also creates a vaguely humanoid persona which, along with ungainly, childlike movements, we interpret as "cute." Being cute is vitally important to animals in today's world: It influences the ability of people to care about them.

There is of course a down side: having lost the ability to fly, the species can't get it back. This Faustian bargain was clearly a good one in the short run, and for as long as those conditions that favored it remain stable. In the long run, though, conditions never

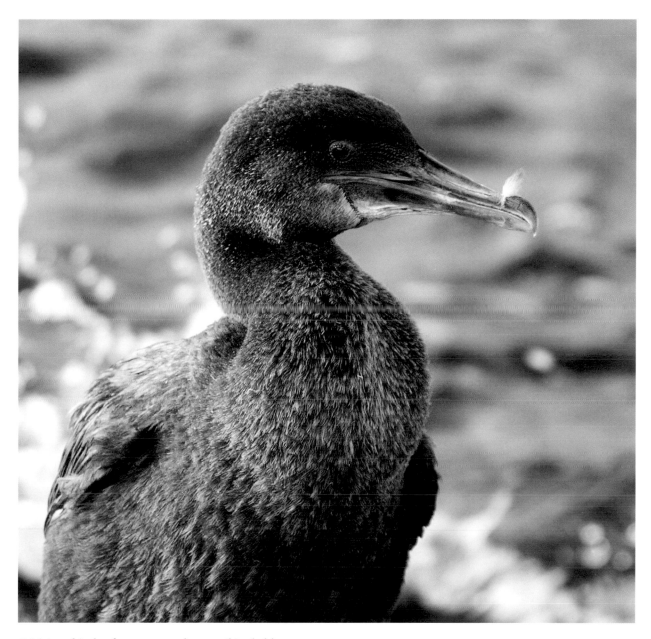

7.3 Many kinds of cormorants have strikingly blue eyes.

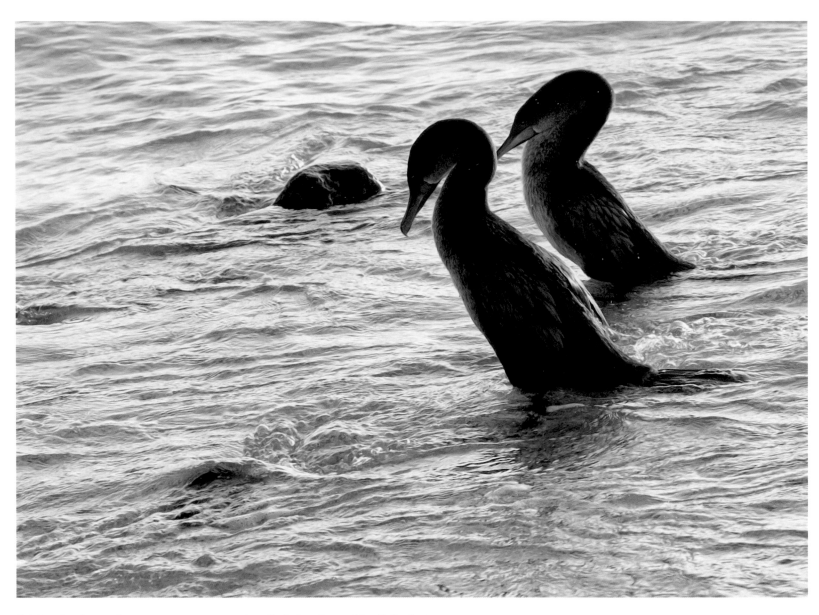

7.4 A pair of courting cormorants engage in a little "snake-necking," displaying the slender chest and large hindquarters that make them master divers.

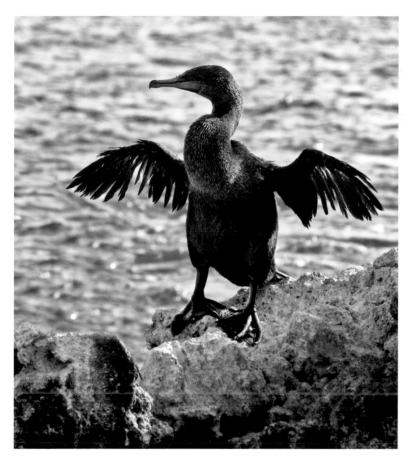

7.5 A flightless cormorant adopts the traditional posture of "drying its wings" after a fishing expedition.

All cormorants have a habit of spreading their wings after they emerge from the water. It is our good fortune that they habitually display, like a gap-toothed grin, the most remarkable aspect of their anatomy. They are described as "drying their wings" when they assume this posture, and maybe they are, but they have been seen holding their wings the same way in a light rain, which raises the question of what they are really doing. Acknowledging that birds don't think in intentional ways as we do, we might suppose that wing spreading is simply an action that cormorants do after leaving the water—a relict behavior that these birds share with all of the other cormorants of the world. Most often it is helpful, but it is simply a part of the genetics of cormorants in the same way that the emotional shedding of tears is uniquely human.

I photographed a flightless cormorant on Fernandina. As if to display his uniquely adapted body, he hopped out of the water and began walking toward a mate a short distance away. As the bird crossed a level section of pahoehoe lava with his peculiar rolling waddle, he paused to shake off some saltwater, the droplets highlighted by the setting sun. The bird aligned his body along an axis to achieve the best shaking action and thus the best water removal. This posture (seen in Figure 7.6) displays the underwater pursuit shape and shows clearly the reduced breast size and massive thighs that are permitted by relinquishing the ability to fly. It also showcases the enormous feet and the bladelike "mismatched" lower legs.

The cormorant passed by me only a few feet away. With wings spread for balance as he prepared to hop-waddle down a slight incline, he made a shabby angel, wandering off across the lava to join his mate for a bit of pair bonding. Part of the magic of the Galápagos lies in moments like this, where my presence was of so little consequence to this bird's life that he did not deflect his route by even a couple of feet to separate us. These are priceless moments, easily missed by those not paying attention to the unfolding drama.

It is usually apparent when a bird (or a fish, or a lizard, or a mammal) is courting: it behaves peculiarly, and that is exactly the point. Courtship activities must be distinct from everyday

remain stable, especially on islands. That is the genesis of David Quammen's observation in his marvelous book *The Song of the Dodo:* "Islands are where species go to die."

The entire species consists of only fifteen hundred cormorants, and that number drops precariously during El Niño years. Flightless cormorants perfectly model the tenuous position of many island species. They are flightless and endemic, and they inhabit only the western side of the western islands, where they depend on the abundance of prey sustained by the upwelling. When El Niños occur, as they do with regularity, the upwelling fails, and the cormorant population crashes. Given the precariousness of their situation, it is astounding that they have clung to existence through thousands upon thousands of years.

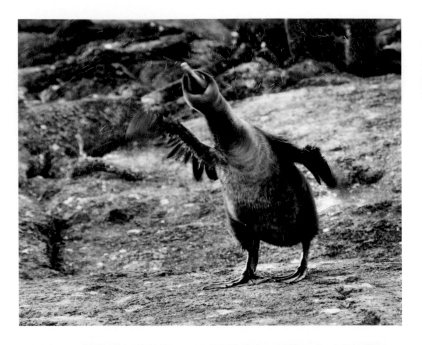

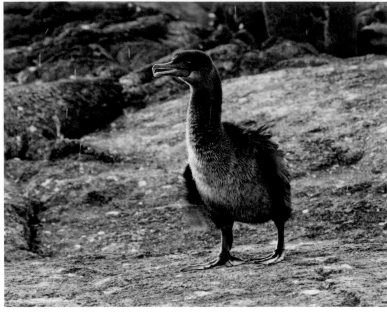

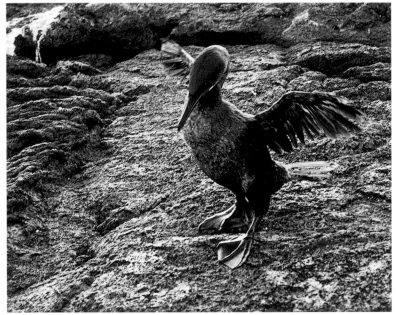

7.6 (*top left*) Its torso shaped remarkably like a bowling pin, a cormorant pauses to shake off saltwater after a swim.

7.7 (*top right*) With its feet positions unaltered and a scattering of droplets still in the air, the cormorant refocuses its attention and resumes its walk, its reptilian ancestry unmistakable.

7.8 (*bottom left*) The extended wings assist in balance while negotiating rougher terrain with an anatomy poorly suited to locomotion on land.

postures and vocalizations so that the meanings are clear. The elaboration of this simple rule (along with a few others) has shaped the evolution of the most spectacular displays in the world, mostly among the birds.

Our cormorant's displays are not spectacular. He and she amble about as a pair, swimming or walking, and they do strange things with their necks. Most frequently they assume a strong flexion of the neck called a "snake-neck" posture. The pair in Figure 7.9 took a stroll along the beach with the solemnity of a bride and groom approaching the altar. It was mid-May, and they were either creating or strengthening their pair bond in anticipation of nest building.

Cormorants build their nests of detritus: seaweed, shells, sticks, and other debris, mostly brought by the male as gifts. They contain two or three large white eggs that require a month of shared incubation to produce a clutch of helpless young. Usually just one survives to approach maturity, and that one is left with the male while the female finds a new mate and begins a second nest. Among cormorants as with humans, it takes a village.

The chick in Figure 7.11 is proof of the improbable. He is part of an unbroken chain of reproductive success from the day the first cormorant flew to the islands on strong wings—even before Isabela and Fernandina rose from the sea. Rubbery, helpless, and vulnerable, he represents the new generation—the tenuous hope for the future. He is one of the frayed threads of life that link the generations. This young bird must be tougher than he looks—I wish him well.

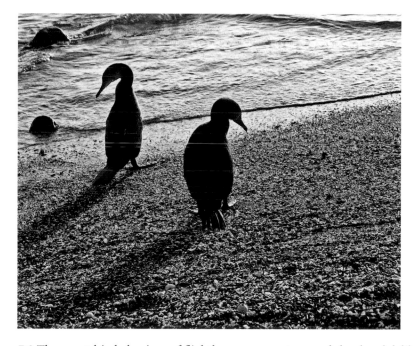 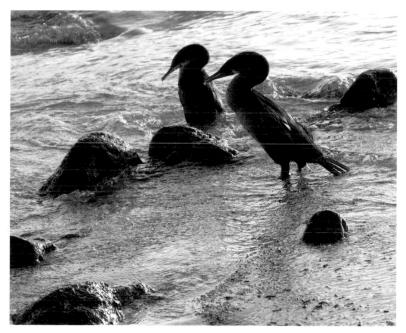

7.9 The courtship behaviors of flightless cormorants are subdued and deliberate, but the meaning of their movements is clear.

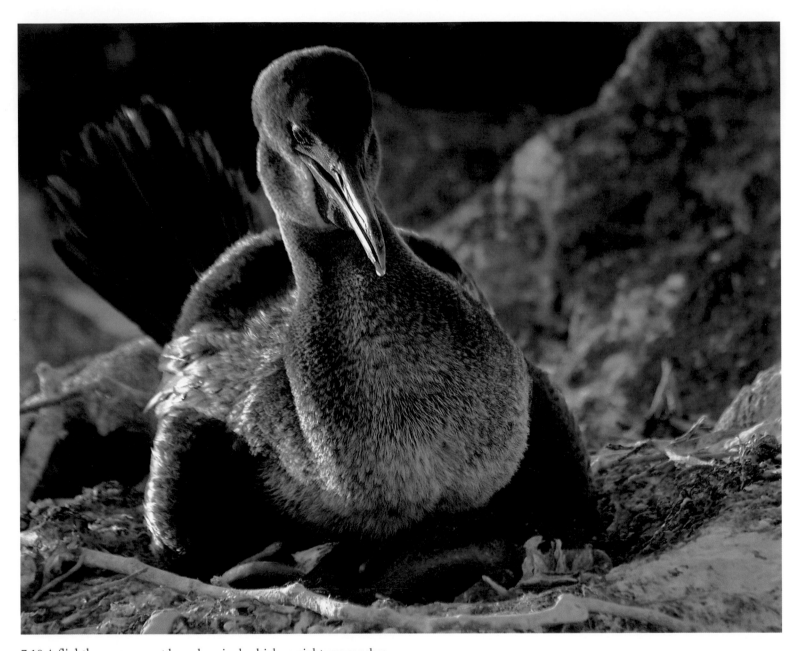

7.10 A flightless cormorant broods a single chick as night approaches.

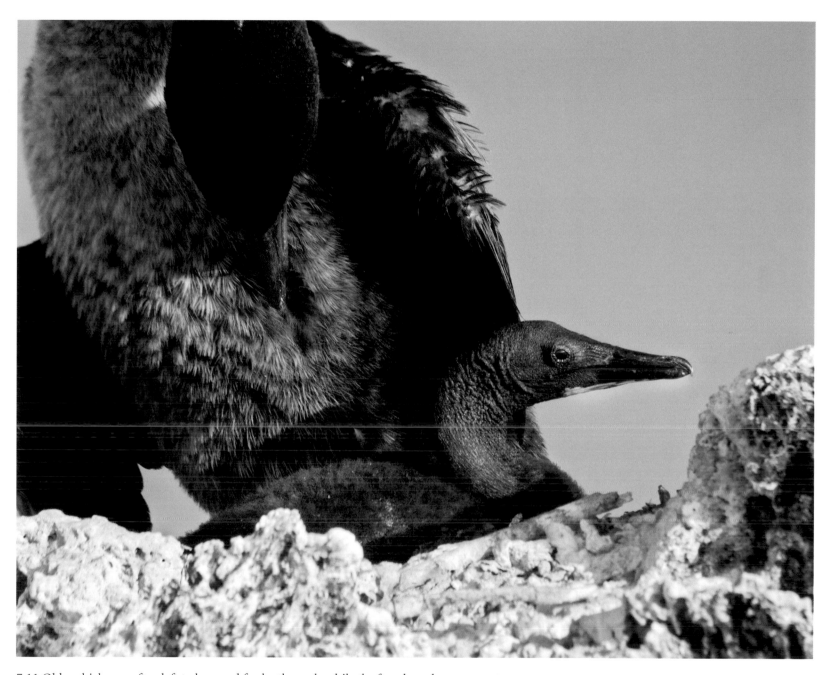

7.11 Older chicks are often left to be cared for by the male while the female seeks a new mate.

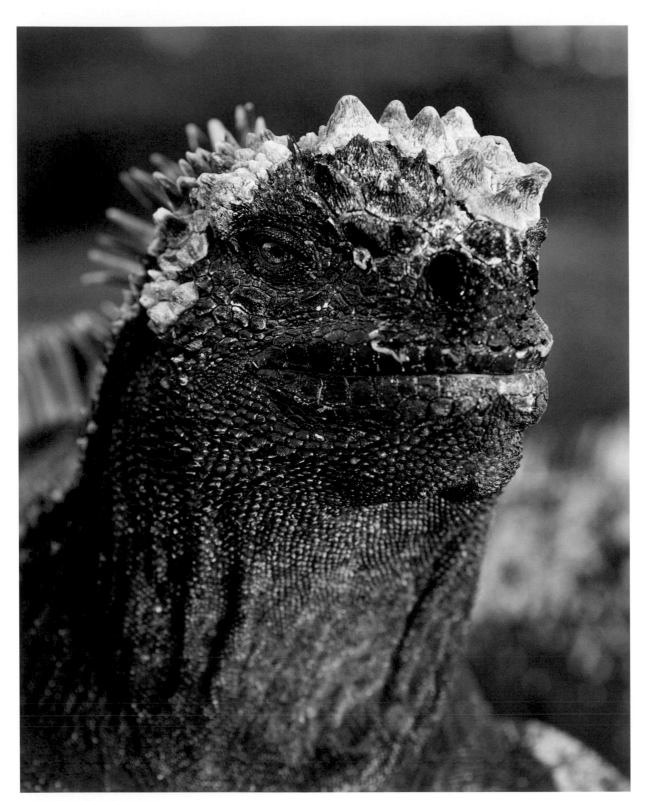

8.1 A marine iguana presents a fearsome facade as sentry of the rocks but, as it turns out, is a vegetarian.

Amblyrhynchus cristatus

𝔏

———— Marine Iguana ————

They are like the alligator, but with a more hideous head, and of a dirty sooty black colour, and sat on the black lava rocks like so many imps of darkness. Notes from the Voyage of the H.M.S. Blonde *to the Sandwich Islands, in the Years 1824–1825*

The marine iguana is another icon of the Galápagos, but it is hard to respond to them without allowing our penchant for visual metaphor to take us to the dark side. That was clearly the response of Charles Darwin and the naturalists who preceded him. Darwin described the iguanas as "most disgusting clumsy lizards," and the diaries of earlier travelers speak of "the ugliest living creatures we ever beheld" and "imps of darkness." It is easy to understand their responses to the gargoyle-esque and cadaverous ambiance of these iguanas, even in our time of growing understanding of the natural world—an enlightenment made feasible by the insights that flow from Darwin's idea. Nevertheless, these "imps" are commonly the first greeters of visitors arriving by boat, as they number in the hundreds of thousands and are spread about the shoreline of all the islands.

Their appearance is spellbinding. Having gotten a good look, it is difficult to turn away. There are of course reasons why they look this way. As with all migrants, it is the consequence of their genetic endowment colliding with the new and challenging

environment of the archipelago. They provide us with a chance to admire their remarkable evolutionary achievements and to appreciate a species superbly adapted to a severe environment. They are beautiful in a way that is sorely underappreciated. They are absolutely memorable and truly belong to the Galápagos royalty.

Eight million years ago, before tectonic plate movements raised the Isthmus of Panama from the ocean, the omnivorous ancestors of the marine iguana lived along a floodplain on the South American Plate. Floods broke loose a mass of vegetation from the bank of the river and it floated out to sea with a few unfortunate iguanas clinging to the impromptu raft. Eventually the prevailing currents brought the raft to islands of the archipelago that have since disappeared below the surface. The accidental tourists found themselves in a land that must have appeared as forbidding to them as it did to Darwin millions of years later. The new landscape had almost nothing in common with the floodplain from which they were torn and offered little in the way of vegetation or invertebrate prey. They were able to ingest saltwater, but only marginally. Survival seemed impossible, but for at least a few, it was not.

Today we find that their descendants are entirely vegetarian, subsisting largely on sea lettuce, a green alga (genus *Ulva*) that grows abundantly on the rocks in the lower intertidal zone and rocky shallows. All iguanas are adequate swimmers, but the marine iguanas now swim beyond the surf and dive to graze beds of algae at depths of forty feet or more. They have made many changes to accommodate this new world. Among them is the development of a very short face (*Amblyrhynchus* means "short nose") and remarkably tough scales on their lips. Both of these adaptations enhance their ability to use their very sharp, three-cusped teeth to shave the sea lettuce from the submerged lava. "Grazing" describes their feeding activity even as it conveys their ecological position as "surf cows," no matter how fearsome they look.

Watching the iguanas coming and going through the surf, I was struck by their ability to tolerate the thrashing they receive on their return to the rocks. Chilled and sluggish, they bob on the surf like driftwood and may be thrown repeatedly against the rocks by the surf. Eventually they find purchase on the lava while the surf

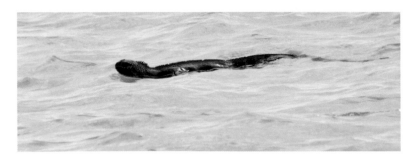

8.2 Iguanas swim by folding their limbs against their trunk and undulating their long thin bodies like snakes. Just a glimpse captures one's attention.

withdraws to pound them again as they slowly move to higher ground between surges. Their claws, enormous in proportion to other iguanas, and the muscular forelimbs that control them, permit them to cling to the lava in the face of active surf. Both structures are much larger than those of other iguanas, so we can add them to the list of evolved responses. Together they permit the iguanas to cling to the bottom while harvesting sea lettuce. Imagine a cow clinging to the meadow while grazing in a hurricane.

After millions of years, these castaways have made a home for themselves on the archipelago. Their population is robust, life expectancies are in the range of twenty-five to thirty years, the rocks are warm, the predators are limited, and the sea lettuce is plentiful. It is hard to look at that broad smile (Figure 8.4) and lopsided squint—the crumbs of sea lettuce around the mouth—and fail to see a really large and contented lizard well suited to its adopted home. Marine iguanas have come to terms with their environment.

Iguanas from the island of Española take on a unique red coloration during the mating season. The color comes from eating a kind of marine alga that is abundant in the shallows of the Galápagos during that period. The intensity of the hue, however, apparently has no effect on mate selection. This is unusual because often strong colors, particularly reds, serve to advertise the high quality of the bearer, and displaying the color is proof of a well-nourished and healthy individual. In this case, however, it is only a peculiarity of the locality, a coincidence of timing and

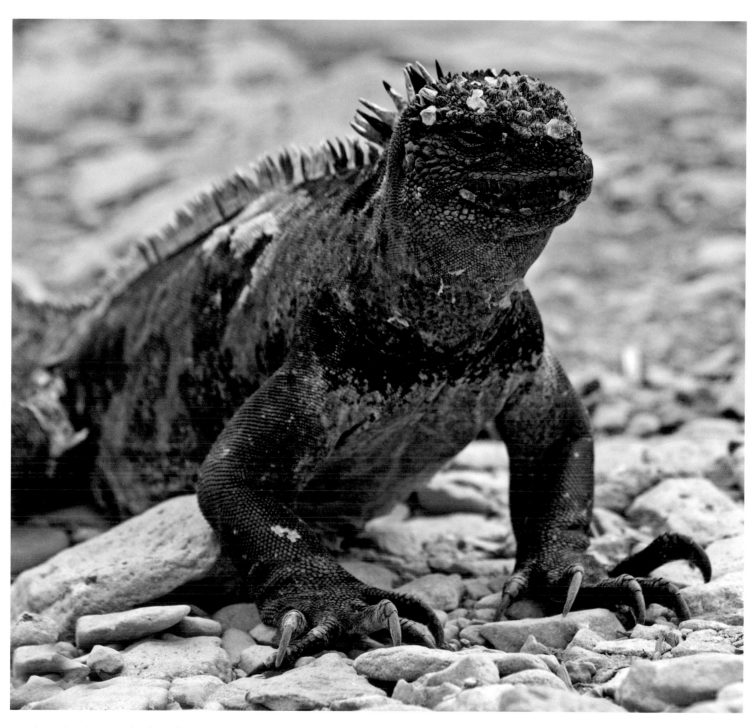

8.3 A marine iguana displays the extraordinary claws and stout forearms necessary to cling to the rocks in the face of active surf.

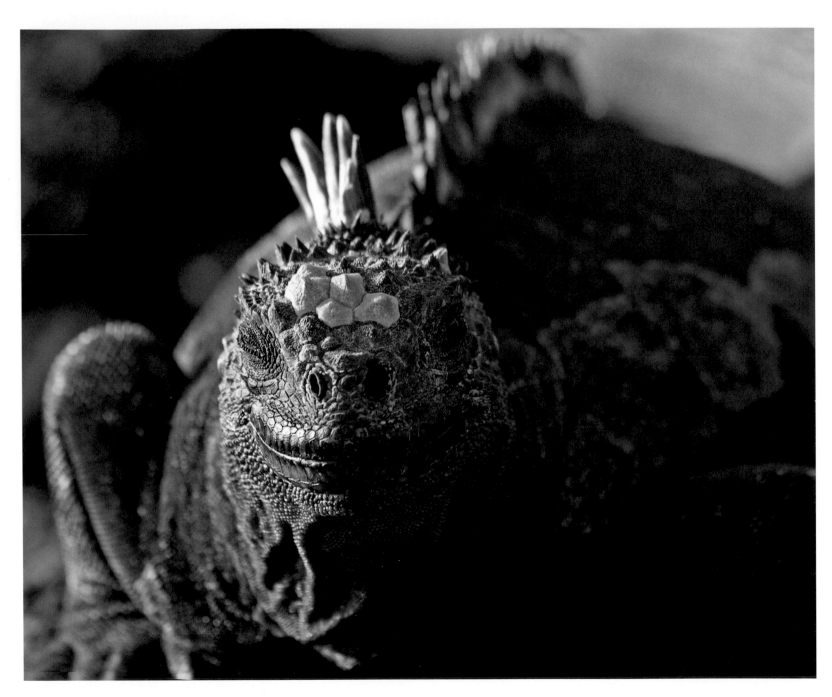

8.4 With a tight smile, a large marine iguana, resting after a day of grazing, keeps one eye on the humans who have intruded on its lava bed.

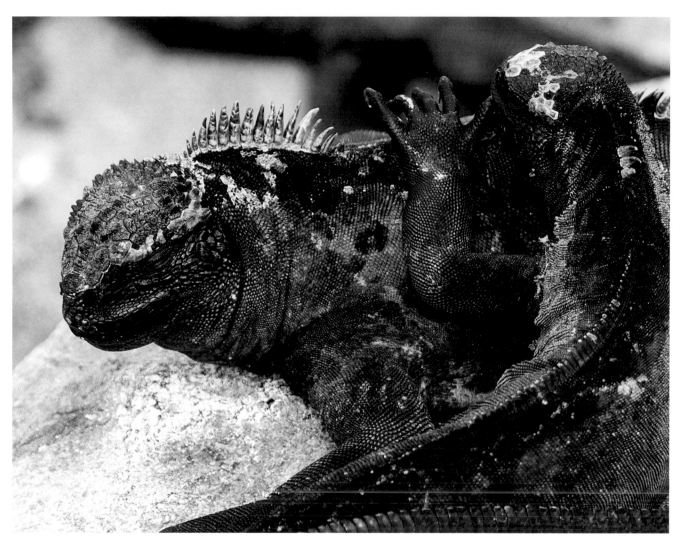

8.5 Españolan marine iguanas possess a unique red coloration.

the interaction of diet with seasonal changes. Apparently the color has no significance. Sometimes a cigar is just a cigar.

As night falls, iguanas aggregate in large piles, sometimes by the hundreds, to conserve heat. This piling-on and crawling-over creates the appearance of an "iguana junkyard," an illusion assisted by the somewhat battered appearance and limp postures they are prone to assume. It is mostly during this time that they sneeze.

Marine iguanas have the most powerful desalination glands of any lizard. This is essential because they never travel far from the surf, so they do not have access to fresh water. The problem has been solved by creating a salt gland through the most common of evolutionary methods—the modification of an existing structure to serve a different function. In this instance, the tear gland that used to secrete a weak salt solution to cleanse the eye and nasal passages has become hyperefficient and functions to excrete excess salt from the body. Now called a salt gland, it releases a concentrated salt slurry into the nasal cavity that is periodically eliminated with explosive force, sending the spray

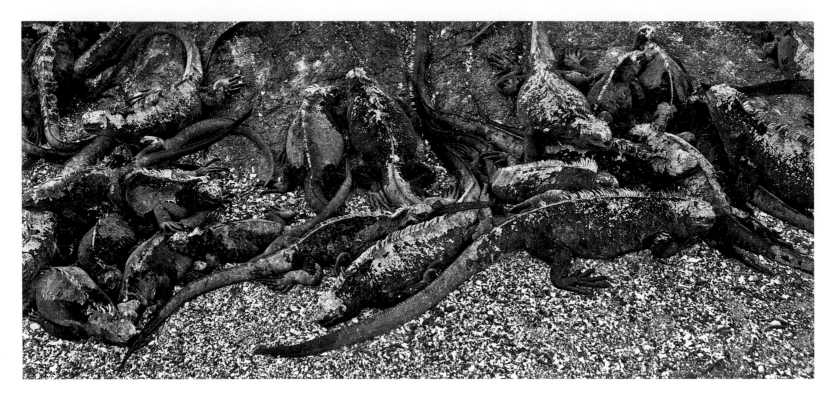

8.6 The iguanas on Fernandina lack the red pigment of the Españolan forms, but like marine iguanas everywhere, as night falls they form themselves into piles almost as if the wind had drifted them into place.

several feet. Frequently it falls onto the pile of iguanas beneath the sneezer. From time to time, it lands on passing tourists and their cameras. Usually, all of the iguanas are sneezing during this time, explosively and unpredictably. It creates quite an effect.

After the iguanas have hung out many evenings sneezing salt en masse, some of the salt binds with the protein of their epidermis and crystallizes, creating salt-crusted scales around the head and back, and leaving the rest with the frosted, late-winter look of a city car. This covering is shed piecemeal as the scales are replaced from beneath creating the fragmented mantle seen in these photographs.

When Herman Melville published *The Encantadas* in 1854, he reinforced the perception of earlier authors that the Galápagos Islands are desolate and hellish and possibly a window into the Inferno, so his novella provides a glimpse into the expectations of visitors of that time.* In this frame of mind a person setting foot

on land may be anxious about unseen dangers, watchful, alert, and ready to respond to the gathering of iguanas as darkness falls. Today we reach into our collective psyche to tickle ancient fears and embrace our love of being frightened. The scene in Figure 8.9 does look like something worthy of Dante—gargoyles, black reptiles on black rocks whose crevices could pass for open graves. Hellish creatures appear to come to life as the iguanas rise from the lava. In this moment, they are imps of darkness. Melville would consider himself vindicated.

* Melville pounds a drumbeat of horror and loathing in *The Encantadas;* here is a sample taken from a vast reservoir: "Another feature in these isles is their emphatic uninhabitableness. . . . The Encantadas refuse to harbor even the outcasts of the beasts. Man and wolf alike disown them. Little but reptile life is here found: tortoises, lizards, immense spiders, snakes, and that strangest anomaly of outlandish nature, the iguana. No voice, no low, no howl is heard; the chief sound of life here is a hiss."

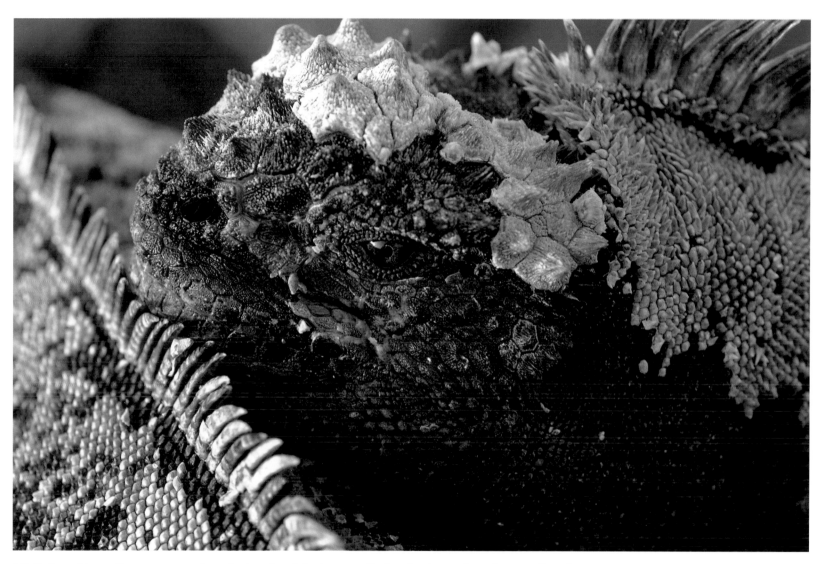

8.7 Gathered into piles to conserve heat during the night, iguanas display the tiaras of royalty as well as the nozzlelike apertures on their nostrils that direct their "sneezing"—this one might blow at any moment.

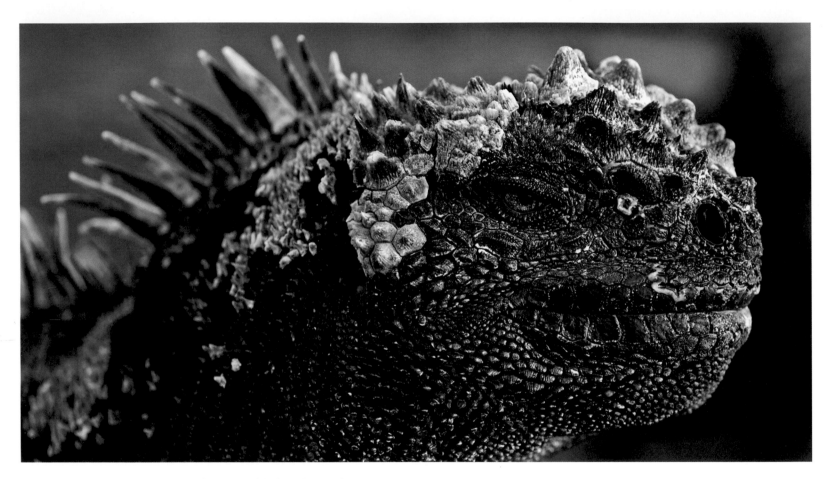

8.8 A profile accentuates the short face of *Amblyrhynchus,* and this one has a bit of salt slurry remaining on its upper lip.

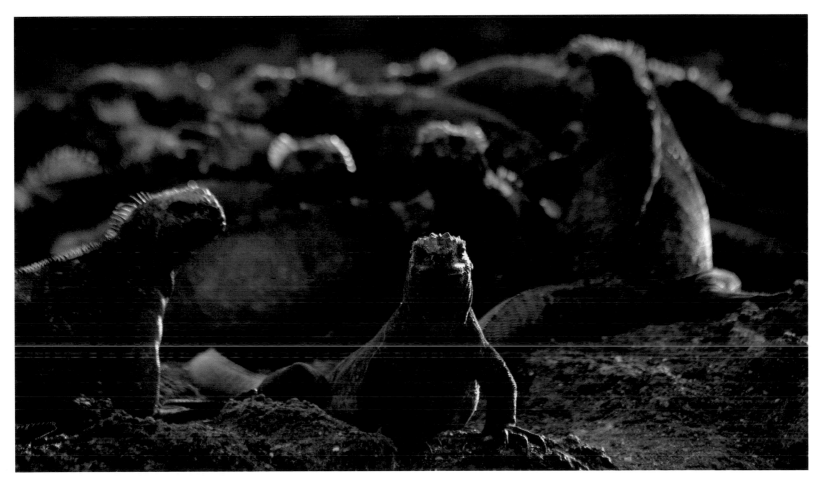

8.9 As darkness falls on the black lava of Fernandina, the dim light and ghoulish head adornments of the iguanas combine to create a macabre ambiance.

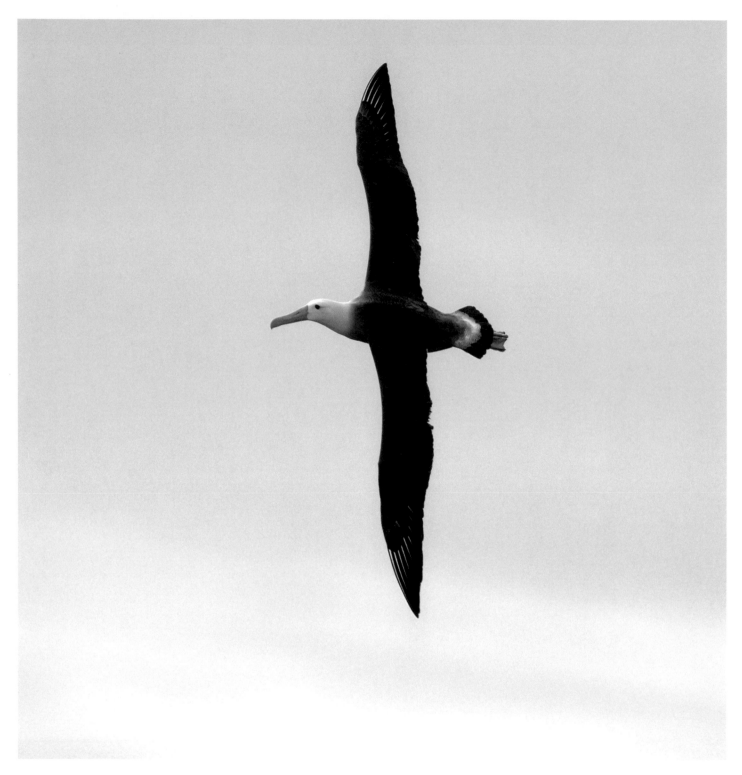

9.1 A waved albatross making a turn displays the effortless
grace that is the hallmark of albatrosses.

Phoebastria irrorata
—*ENDEMIC*

9

———— Waved Albatross ————

And lo! the Albatross proveth a bird of good omen.—Samuel Taylor Coleridge, "Rime of the Ancient Mariner"

Albatrosses are creatures of the wind and the sea. The most elegant of soaring birds, everything about them is a consequence of honing an avian body for life in the air and on the water. They eat and drink and sleep on the trackless oceans in fair weather and foul, and they have no need of land at all except for their lengthy and elaborate reproductive activities. When they finally come to land, the design that makes them masters of the air renders them awkward and comical to our eyes. Ashore, graceless and tentative, they have attracted the pejorative but still endearing nickname "gooney bird."

The silhouette of an albatross harvesting the wind is unmistakable. Its wings are long, narrow, and pointed—ideally proportioned to maximize lift, minimize drag, and control turbulence. One can only admire the perfection of the eight-foot wings that serve the needs of this bird. They are ill-suited for powered flight or for tight maneuvering, especially at low air speeds, but there is little need for flapping with wings of that design, nor are there obstacles that require maneuvering so long as they are at sea.

9.2 A comparison of landmasses in the 30° to 70° latitudes, as seen from the earth's axis—the left image is viewed from above the North Pole, the right from above the South Pole.

The waved albatross—called a "wavy" by its admirers—is moderately sized, one of only twenty-four species and the only albatross of the Galápagos.* The oldest of the islands, Española, with its lava cliffs, bleak tableland, and lack of freshwater, is the only place they nest. In spite of these limitations—or maybe because of them—Española is the cradle of the species.

Like penguins, albatrosses are birds of the Southern Hemisphere. Only three of the twenty-four species call the North Pacific home, and then there is our waved albatross, which sits on the equator.** The rest are at home in the South Pacific between 30°S and 70°S latitude. These are the windiest regions on the planet, where no significant land masses interfere, so it is fitting for a bird whose body has literally been shaped by the wind to call these blustery climes home.

A waved albatross has a commanding presence on the ground, so long as it stands still. The species name is derived from the

<hr>

* The International Union for the Conservation of Nature (IUCN) recognizes twenty-four species of albatrosses, while other authorities count as few as thirteen.

** A very small colony of about ten pairs of waved albatrosses has established itself in recent years on Isla de la Plata, seventeen miles from the Ecuadoran coast. In contrast, Española has a breeding population of about twelve thousand pairs.

small wavy lines on the neck and breast—unusual among the albatrosses. It is a large bird, about nine pounds, but the thing that immediately fixes one's attention are the large, intensely black eyes bordered by a fleshy black eye-ring. The shadowy tinge of gold that frames the face and that senatorial forelock hovering about the eye add a touch of class to the bird's appearance.

The second feature is the outsized bill, which is suitable for snagging squid and fish and for scavenging when the opportunity presents. And then there is that peculiar tube-shaped nostril, for which the tube-nosed swimmers (order *Procellariiformes*) are named. No one is quite sure what function it serves, but there are opinions. Pelagic birds have a salt gland—a modified tear gland like that of the marine iguana—that permits them to drink seawater. The brine from this gland is guided away from the plumage by the groove leading to the tip of the bill. Seabirds of many kinds are frequently seen with a drop of water at the tip of the bill. It comes from the salt gland through the nostril, but most of them lack the benefit of a tube. In the closely related black-footed albatross, the nostril is divided into two sections, which separate the air and salt passageways. A close look suggests that this may be true for wavies as well.

It is often hard to get a good look at the eye-ring and unique tube nose. In the nesting colonies, one's presence is invasive, but a long lens permits us to indulge our curiosity. The bird's partial squint shows the lightly feathered lower eyelids that could be mistaken for bags under its eyes—adding to the senatorial aura. Unlike our own eyelids, it is the lower lid of birds that is mobile and causes that small bit of folded skin. Albatrosses have an exceptionally strong olfactory sense that helps them to find feeding areas and shorelines, both of which emit characteristic odors. Most birds have a poorly developed sense of smell, and it is possible that the tube nose relates to this capability in some way.

Dancing as part of a courtship display among birds is commonplace, but the dancing of albatrosses really captures our imaginations because it is amusing and because it is so easy to identify with the birds. Who can look at the courting female in Figure 9.5 and fail to see in her eyes a complicated mix of urges? Albatrosses spend a lot of time dancing. Unmated birds dance and socialize

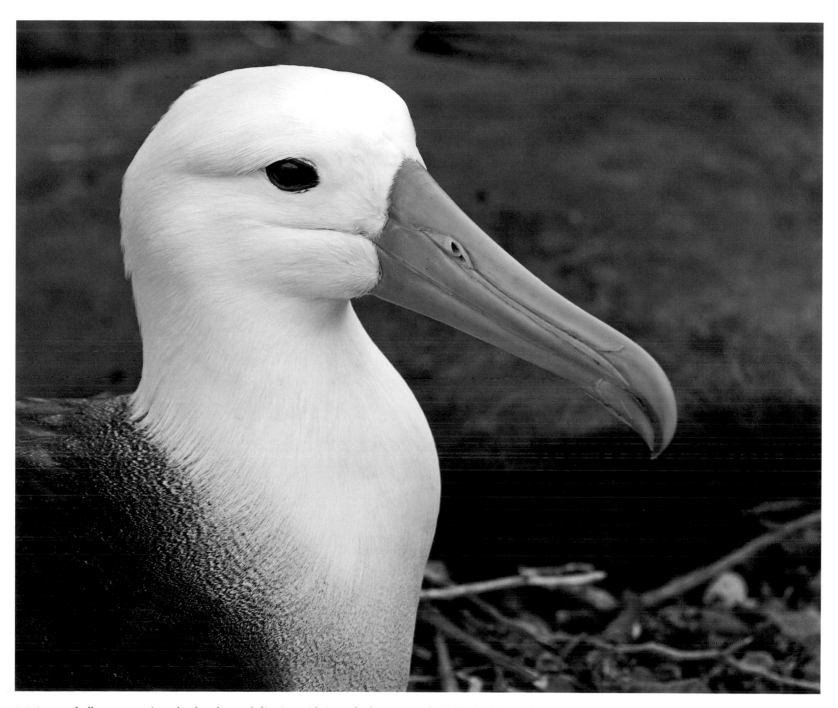

9.3 A waved albatross projects both calm and dignity with its soft plumage and subtle shadings of color.

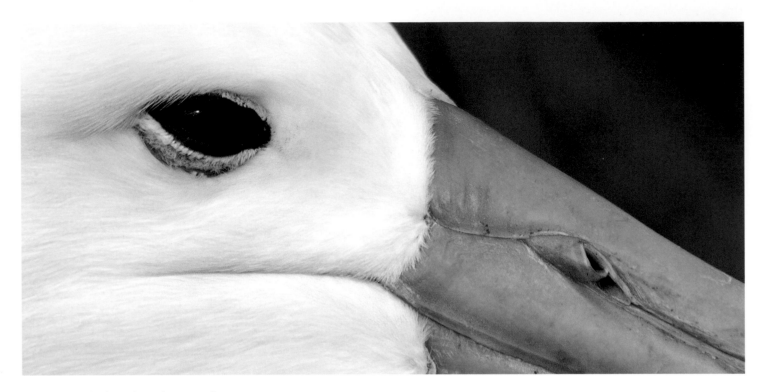

9.4 A close look at the tube-nose shows
what appears to be a divided opening.

for years before settling into their monogamous relationship, and dancing occurs regularly between mated pairs as a means of maintaining the pair bond and as a prelude to copulation.

When juveniles return to Española for the first time, they begin to establish a pair bond that usually lasts for life, and they do it through dance. Their dance consists of a seamless series of movements that animal behaviorists, adopting the role of choreographer, have dissected and given charming names, including sky pointing, bowing, nodding, ducking, side preening, bill rattling, bill circling, and gaping. These behaviors are not performed in rigid sequences, but clearly there are better ways and worse ways to perform. In these first years as adults, the birds dance and court, but it may take them five or six years to figure out the complexities of successful reproduction. It is unlikely that any of their early attempts will produce a chick.

By the tenth year or so, the pair forms a monogamous bond, and eventually they lay a single egg. During the two months of incubating and the six months of feeding that follow, the parents trade duties in three- or four-week sessions. Their foraging pattern, revealed by satellite tracking of tagged birds, appears remarkably consistent. The parent relieved of nest duty flies a thousand miles to the choice foraging area, the upwelling off the coast of central Peru—a travel time of five days. That flight is followed by fifteen to twenty days of foraging for fish and squid, often at night, and then a return flight home carrying a large reserve of concentrated fats and oils in its stomach, very much like a fuel tanker. There must be enough to feed the chick and for the parent to sustain itself until relieved by its mate. If one of the pair fails to return soon enough, its mate will abandon the egg or chick in order to feed itself, and the year's nesting effort will have been lost.

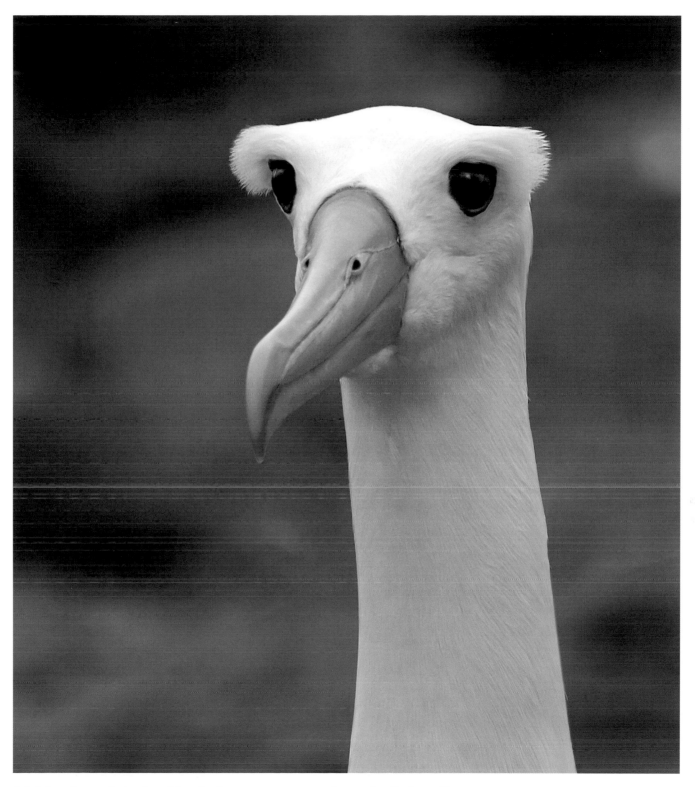

9.5 A female, caught in the midst of a dance, pays rapt attention to the displays of her mate.

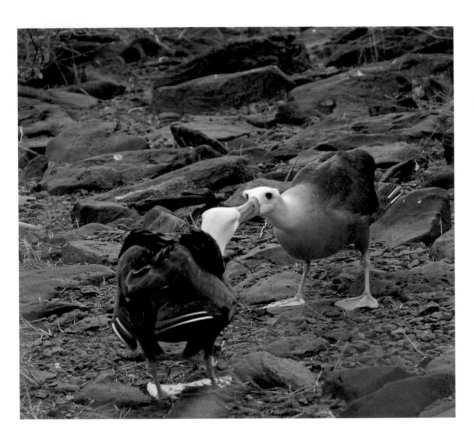
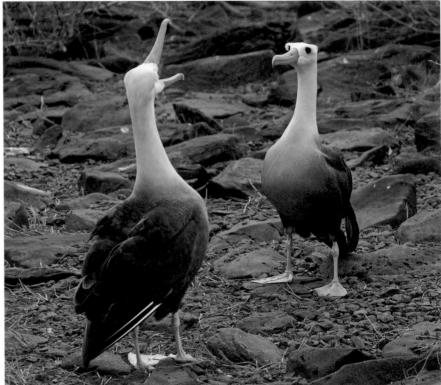

9.6 These are four of the common postures of wavy courtship dances. Males are slightly larger than females, so the bird facing us is a female. Their behaviors (*left to right*) are: bill circling (*both*), gaping (*male*), sky pointing (*male*), and side preening (*female*).

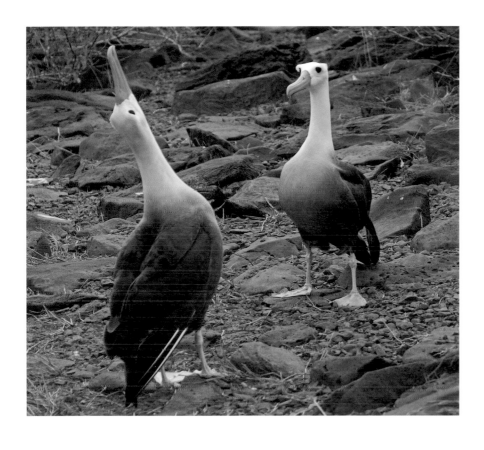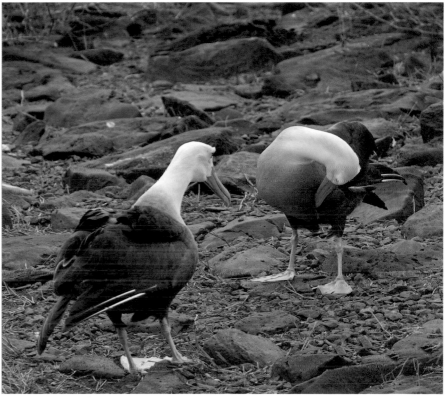

Monogamy doesn't mean the same thing to albatrosses as it does to us—they engage in "social monogamy," a circumstance where the nesting, incubation, and rearing of young is accomplished by a single pair. The male, however, sometimes cares for young that may not be his own, although the probability is high (80 percent) that he has indeed fathered the chick that he is tending.

Many things about these birds tickle our funny bones, but the strangest is the tendency for an incubating bird to take the egg for a stroll—moving the egg between its legs across the rocky terrain. An egg might be moved as much as four yards every seven or eight days before it hatches, so it is not an occasional bump or nudge or rollover. It's called mobile incubation, but it is hard not to think of it as very slow egg hockey. The hazards are obvious: Some eggs are broken, and some become lodged in the rocks and abandoned. Still the birds persist, so there must be some advantage that overrides the loss of more than 10 percent of the eggs to this peculiarity.***

The albatross's mastery of the wind comes at a price, and that price is the loss of lift at low speeds. So when wavies approach the twenty-three square miles of boulder fields, brush, and lava that is Española, they must leave their home in the air and drop onto the alien landscape of their birth. Using their feet on land for the first time in months, they must feel as we would mentally preparing to leap from a bus that is moving a bit too fast.

The term *runway* was, no doubt, applied to the albatross's landing zone by either a comedian or a real estate agent. It is littered with large rocks and here and there, boulders and patches of stiff brush. Coming to rest on land is never easy for a bird with such specialized wings. If there is not sufficient headwind for a controlled stall, the bird will abandon the attempt and return for another try, like a pilot who missed his first pass at the deck of an aircraft carrier. Like a carrier pilot, they too eventually must land. Their approach to the runway calls to mind the deliberate and majestic movements of a huge cargo plane, slowing to the limit of controlled flight. Miscalculations can be fatal, breaking the long, lightly constructed wing bones by tumbling over the rocks or crashing into the brush.

Returning to the air is a different challenge, and it is usually the most energetically demanding part of most journeys. There are reports of albatrosses pattering furiously along the surface for a mile and a half before managing to gain the sky, and others sitting in becalmed seas, unable to become airborne. For the albatrosses of Española, however, achieving flight is easily accomplished by taking advantage of the nearby cliffs. When the time arrives to take wing, there are only a few running steps, followed by a brief, controlled plummet. Then those perfect wings spread and the bird is at home, safely in the air once again.

*** Early reports suggested that moved eggs were more likely to hatch, but recent work indicates otherwise. There is no consensus at the time of this writing.

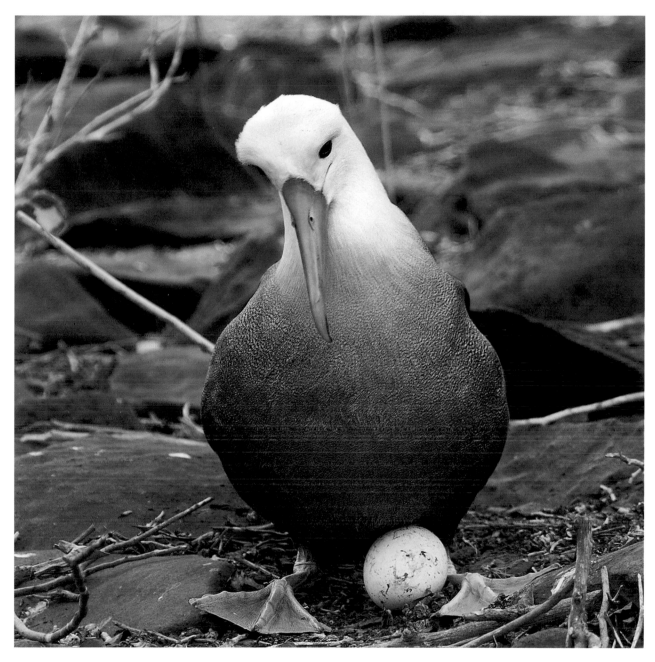

9.7 An albatross cradles its egg between ungainly
feet, greatly oversized for their function on land.

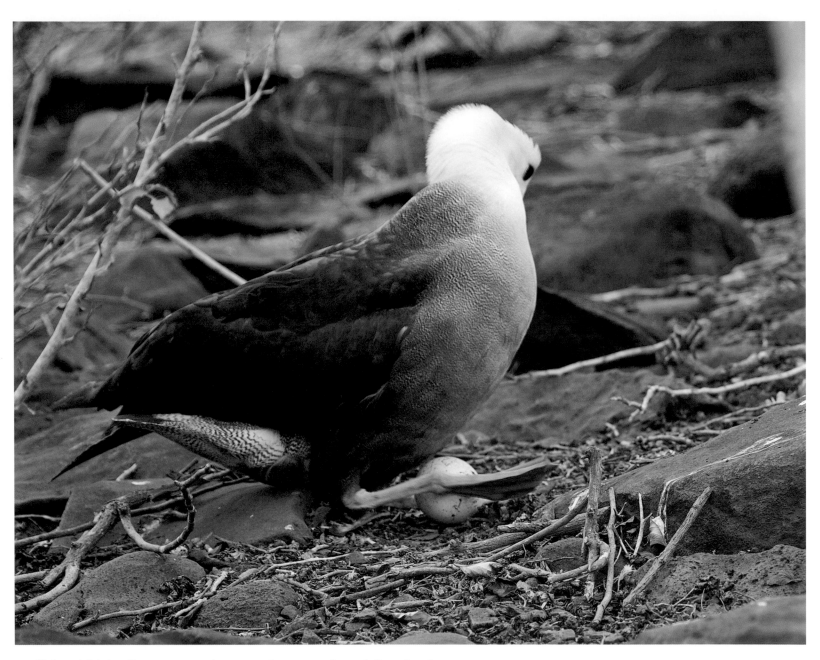

9.8 (*left to right*) An albatross moves its egg to a better spot for a while, to incubate.

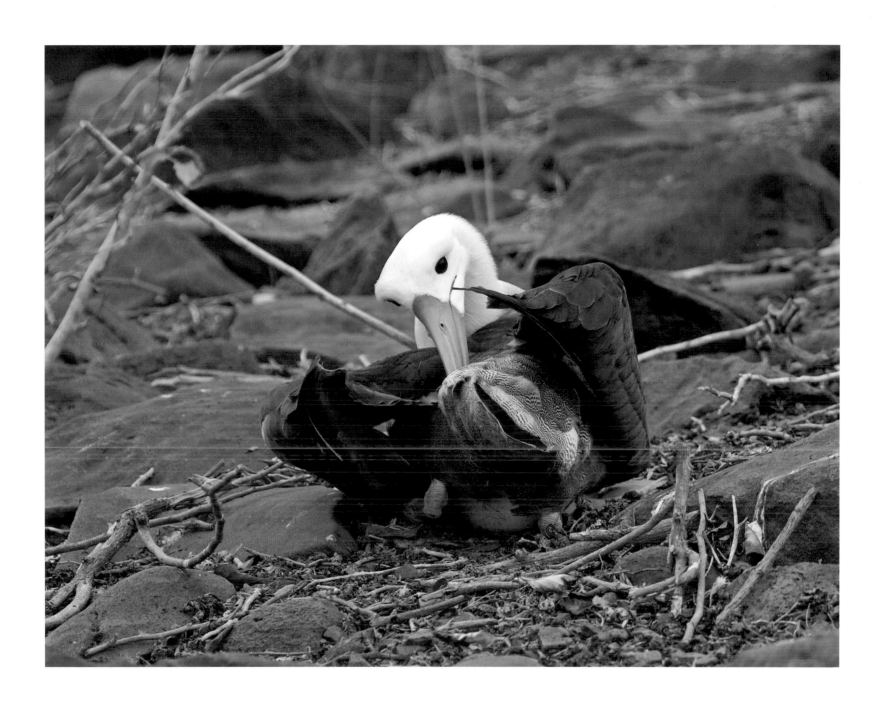

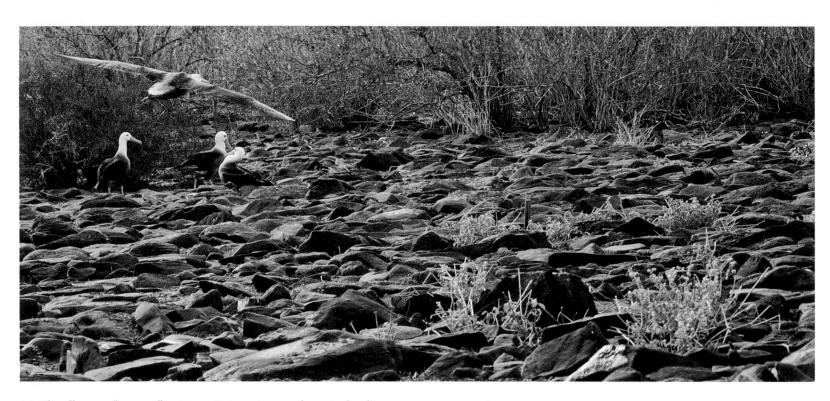

9.9 The albatross "runway" at Punta Suárez. A wavy aborts its landing attempt to try again.

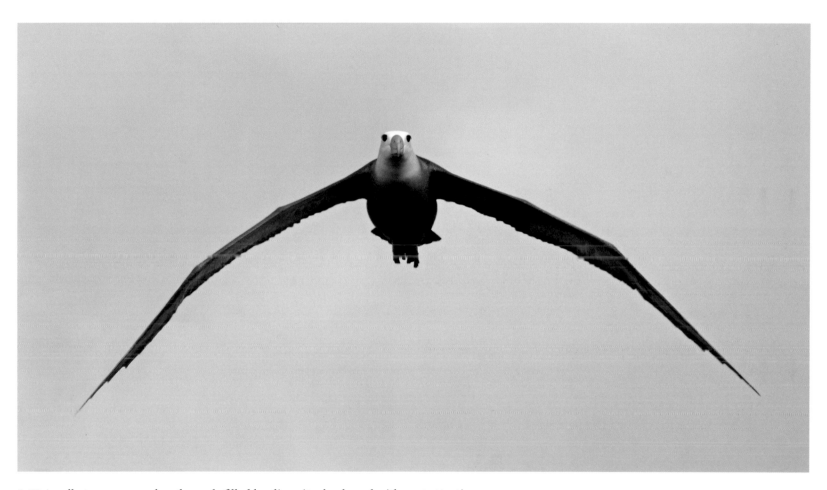

9.10 An albatross approaches the rock-filled landing site slowly and with rapt attention.

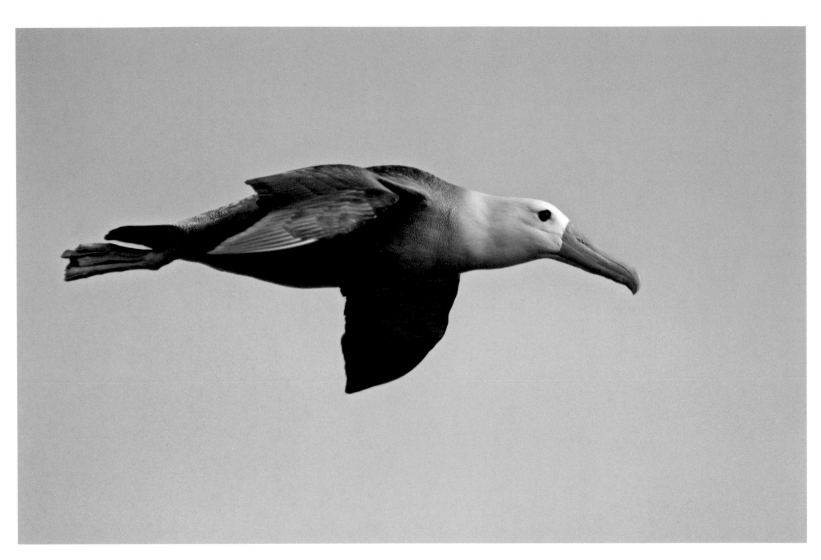

9.11 In the last seconds of its approach, a wavy must evaluate a sizeable range of factors and make a last-second decision on whether to land or abort.

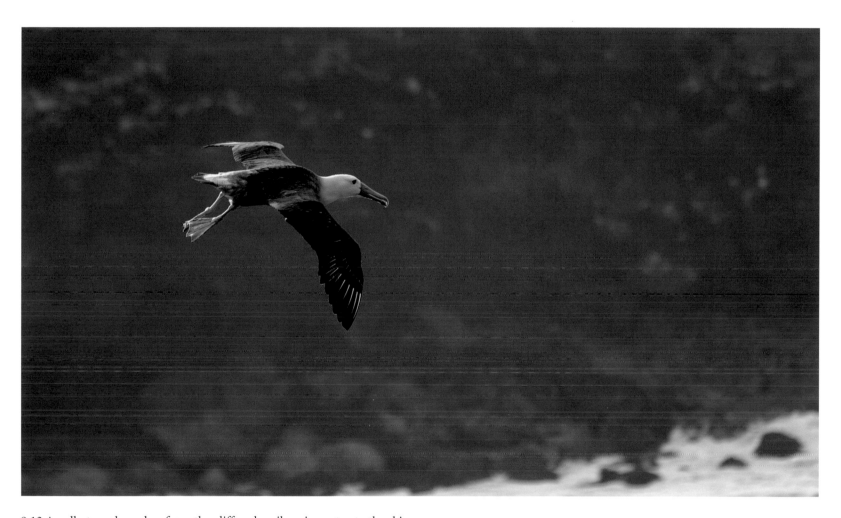

9.12 An albatross launches from the cliff and easily gains entry to the skies.

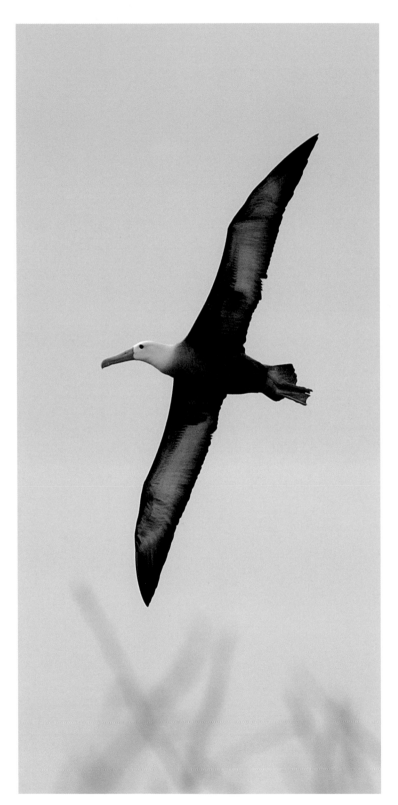

9.13 Released from its handicap on the ground, an albatross exemplifies the effortless soaring that is the envy of humans.

10.1 A magnificent frigatebird shows itself a perfect metaphor for piracy.

Great Frigatebird
(Fregata minor)

Magnificent Frigatebird
(F. magnificens)

10

———— The Frigatebirds ————

A rollicking band of pirates we,
Who, tired of tossing on the sea,
Are trying their hand at a burglaree,
With weapons grim and gory.
—Gilbert and Sullivan, *The Pirates of Penzance*

In the seventeenth and eighteenth centuries, frigates were warships, but not just any warships. They were long and sleek, with decks close to the water and plenty of canvas. They were lightly built, lightly armed, and very fast—a vessel made for piracy. In those days the ships were manned by sailors who recognized a pirate when they saw one, and "frigatebird" was the name they chose for these birds. They too are fast, light, and agile, and they too are predatory. The bill has a hook worthy of a pirate, and frigatebirds know how to use it, both to capture their own food and to harass other birds and steal their catch. Their silhouette is unmistakable—angular, sleek, elegant. They are as black as a Jolly Roger.

Frigatebirds have been around for fifty million years, but only five species remain to work the tropical seas of the world. The two species from the Galápagos, called "great" and "magnificent," are the largest of them, and they belong to the same genus—that

is, they are congeneric. As congenerics they are closely related—are in fact sibling species—so we know that they are genetically and behaviorally quite similar. This knowledge flows from the insights of Charles Darwin.

Because congenerics are so similar, they usually compete for the same foods, but natural selection pushes them to diversify by finding ways to minimize the competition for necessities, usually food. Ecologists call this "resource partitioning," a strategy that eventually fills holes in the tapestry, like the one filled by the woodpecker finch.

In the case of great frigatebirds and magnificent frigatebirds, the sibling species divide the area geographically. Great frigatebirds forage at sea out of the sight of land; at upwellings, current convergences, and other locally rich zones. They prey on whatever is handy, mostly squid and fish but especially flying fish, which they pluck from the air. If great frigatebirds can find a school of dolphins or a school of predatory fish like tuna, there are likely to be large numbers of fish driven to the surface and of flying fish

taking to the air. Magnificent frigatebirds work the more broadly productive shallow zones, so they are seen more frequently and thus seem more common. Both species have established breeding colonies on several islands of the archipelago.

Frigatebirds are not always easy to identify, especially the males, who can be distinguished by the color of the iridescent plumes on their backs—purple for the magnificent, green for the great frigatebird. The females are easier, as the great frigatebird female has a white throat and fleshy pink eye-ring that the magnificent females lack. The female in Figure 10.2 shows the eye-ring, hints at the white throat, and shows the green iridescent scapulars that are more prominent on the backs of males. Female magnificent frigatebirds have a dark eye-ring, similar to the males, and a black throat.

The optimum hunting zone for both species is the water's surface, which in fact is an undulating plane only a few inches thick. Frigatebirds have become highly skilled at "surface snatching" as a foraging technique. They swoop toward the water and glide just above the surface. Reaching down with perfect timing and

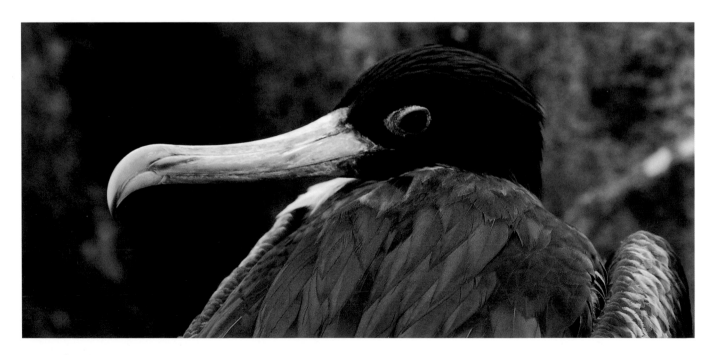

10.2 A female great frigatebird on her nest displays a fearsome bill that is perfectly adapted for surface snatching.

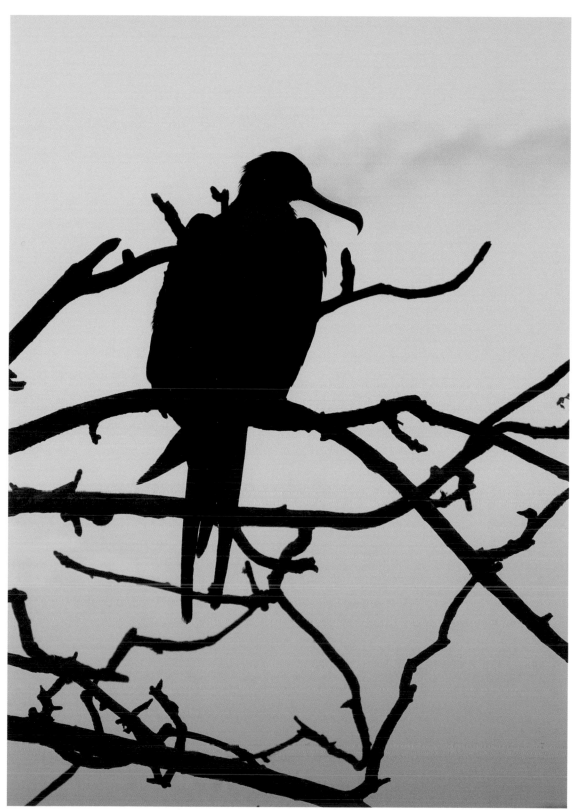

10.3 Settled for the night, a female great frigatebird settles into her roost in a palo santo tree high on a cliff.

unhurried grace, they use their long, limber necks and that magnificent hook on their bills to snag the prey and drag it from the water. The sensation (as I imagine it) is that of driving slowly past a mailbox at six or seven miles an hour, to mail a letter from your car. With your teeth. Ludicrous perhaps—we simply are not built for it, even moving in only two dimensions—but they are, and they do it in three dimensions with the surface heaving beneath them. They do it for a living. A successful surface snatch is followed by an upward sweep where the prey is lofted into the air—fish are taken headfirst—and then swallowed. It requires exquisite timing and control. It is especially daring because frigates can't swim, and if they fall into the sea it is unlikely that they will ever leave it. So we are presented with another cliché—a pirate who can't swim.

Being unable to land in the water is possibly the most bizarre limitation one might imagine for a bird that fishes the open ocean, especially one that is so aggressive and seems to relish physical contact with its opponents. The inability to swim arises from two peculiarities, both of which might be understood as benefits when it comes to weight reductions. The oil gland of frigatebirds, located on the rump, is greatly reduced in size and has been described as vestigial. Consequently their waterproofing is inadequate, and their feathers would quickly become soaked if they land in the water.

The second peculiarity is physical: the birds' legs are very short and the feet small and poorly webbed. So oddly proportioned are frigatebirds that they cannot easily take off even from level

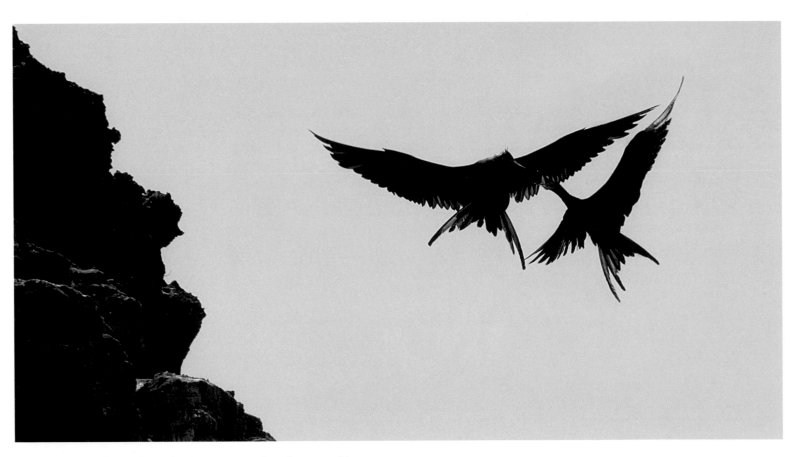

10.4 Two magnificent frigatebirds continue a brawl triggered by a surface snatch—and the eventual escape of—a marine iguana.

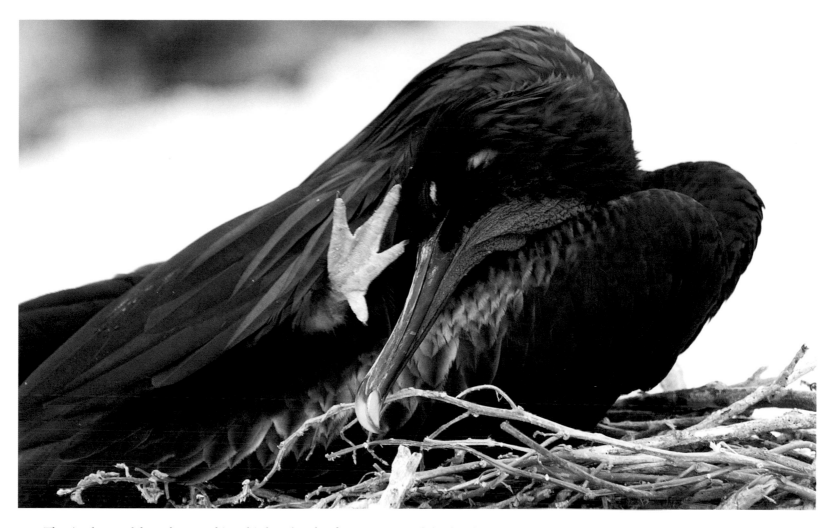

10.5 The tiny legs and feet of a great frigatebird are barely adequate to scratch his head.

ground—the wings are too long, and the legs are so short they can barely walk and cannot run. They can, however, take wing from places that allow them to complete most of the first downstroke: trees, isolated bushes, and cliffs. A grounded frigatebird can climb a bush if it isn't too dense, using the bill and feet parrot-style.

Since frigatebirds are a success (that is, they're not extinct), there must be a positive spin to put on all this bad news, and there is. The wings are very similar in design to those of the waved albatross, just short of eight feet from tip to tip, but a frigatebird weighs only a third as much as the wavy. It is the largest wingspread-to-

weight ratio in the bird world. With those very long wings, their much lighter body, and their long, highly mobile tail feathers, they are very maneuverable. Albatrosses are like fuel tankers. Frigatebirds are like tactical fighters, designed to harass.

Boobies and tropicbirds provide a rich target as they return to their nests carrying a full load of food for their young. These species are heavily built, suited for plunge diving, and they are vulnerable to attack by frigatebirds awaiting their return. The frigatebirds harass their targets in a variety of ways, including pulling the tails of their victims in flight and forcing them to

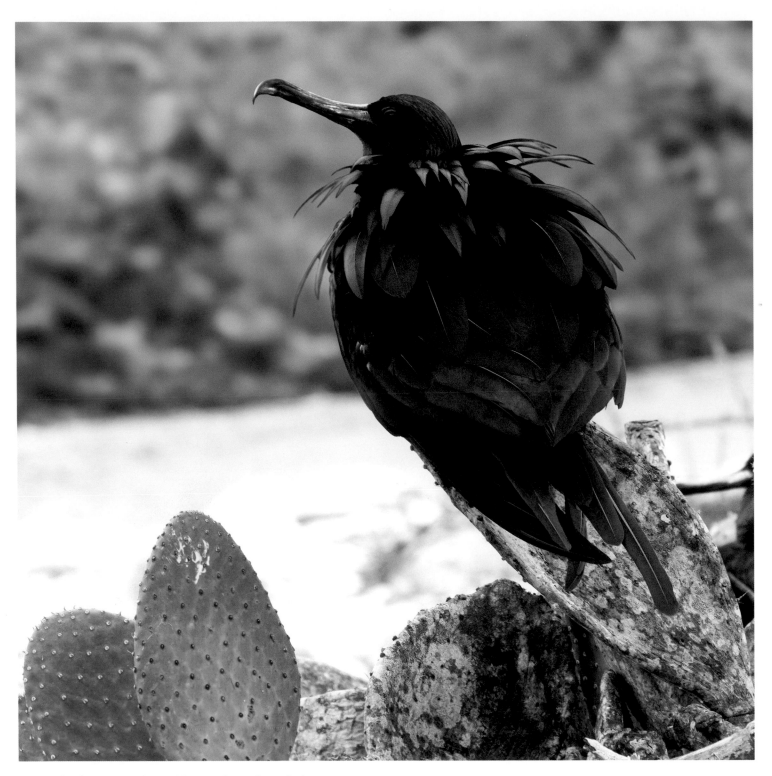

10.6 A dead cactus pad provides an elevated perch for a great
frigatebird to keep informed on the events of Darwin Bay.

regurgitate their prey in midair. What then follows is a free-for-all in the style of a scrum that is joined by all within reach, the prize being lost and regained by the participants until a "winner" eventually swallows it. Frigatebirds are not only the perfect visual metaphor for the idea of piracy with their outsized, "crook'd" black wings and fearsome hooked bill—they *are* pirates.

The best place to experience birds of the sea is at a breeding colony, where their numbers are large and the most exotic behaviors commonplace. It is a limited experience, and it doesn't shed much light on their nonreproductive existence, but it is otherworldly. On the margin of Darwin Bay is a low dune covered with saltbush, and males occupy prominent positions, often on nests or on nest-

ing sites; when females fly over, the males display themselves and their nest sites, hawking their wares like a shill on a carnival midway. The most eye-catching instrument of display is their gular sac, a balloonlike red pouch that requires about twenty minutes to inflate. Once it is inflated, the males seem reluctant to deflate it and often fly with it "deployed" in spite of flawed aerodynamics and what must be a huge blind spot. I should think landing would be very difficult for them, especially with those tiny feet.

During the time of display the nesting area is an arena that carries the smarmy ambience of a singles bar, and well it should. The females make passes (flyovers) singly, and the males respond with great enthusiasm. All at once. They shake their wings in a

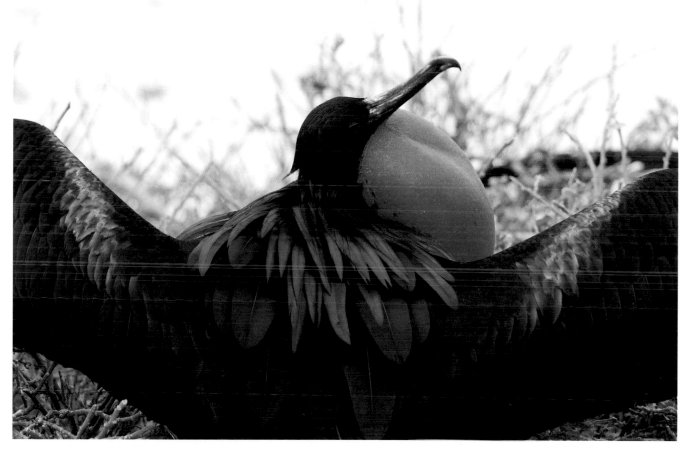

10.7 The full monty—spread wings, inflated gular pouch, and elevated scapular plumes shimmering with green iridescence—a male great frigatebird anticipates a female flyover.

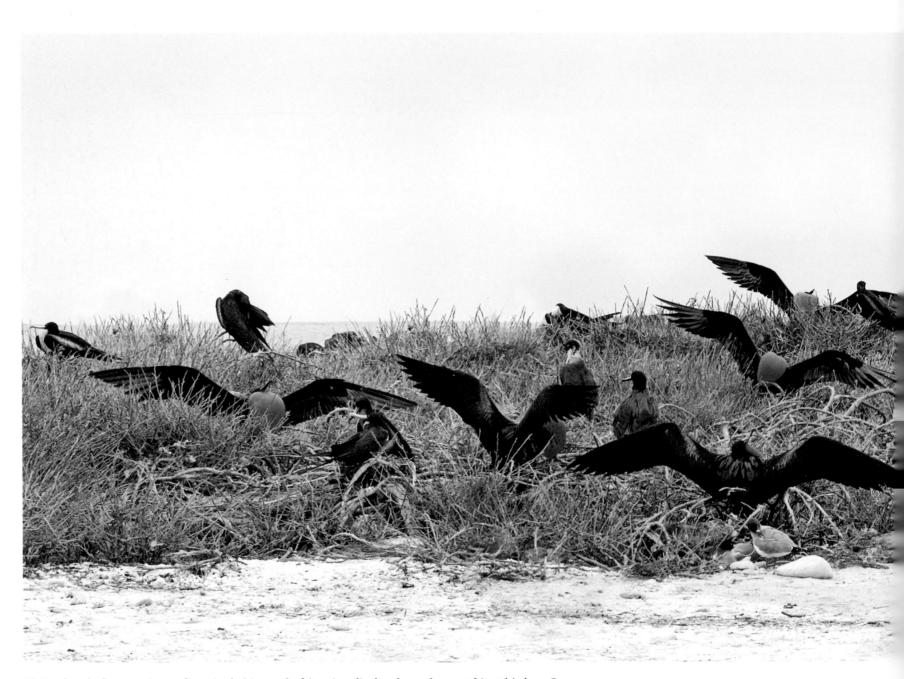

10.8 A female flyover triggers frenetic shaking and whinnying displays by male great frigatebirds at Genovesa.

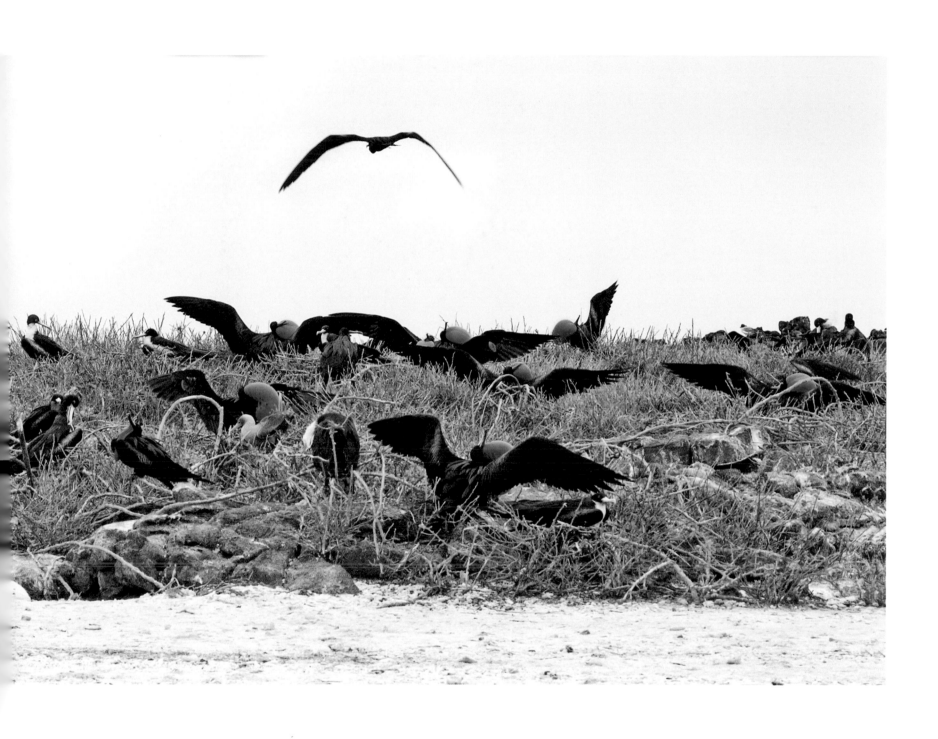

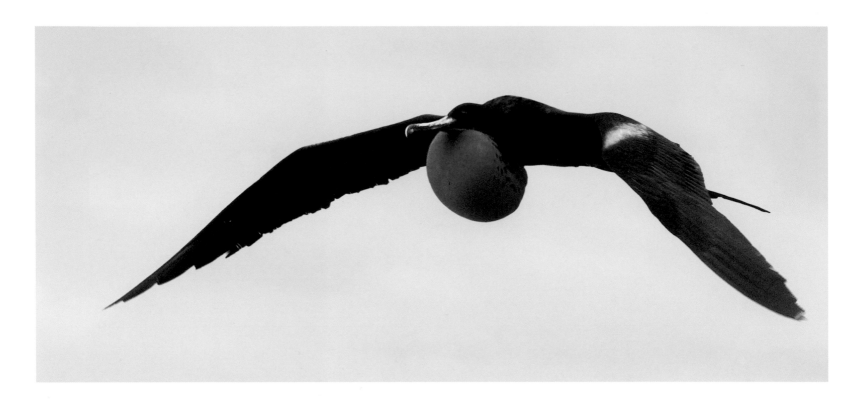

10.9 A great frigatebird approaches the colony to take up a position on his nest.

10.10 A close look at an inflated gular pouch reveals strong colors and the green iridescence that marks a male great frigatebird.

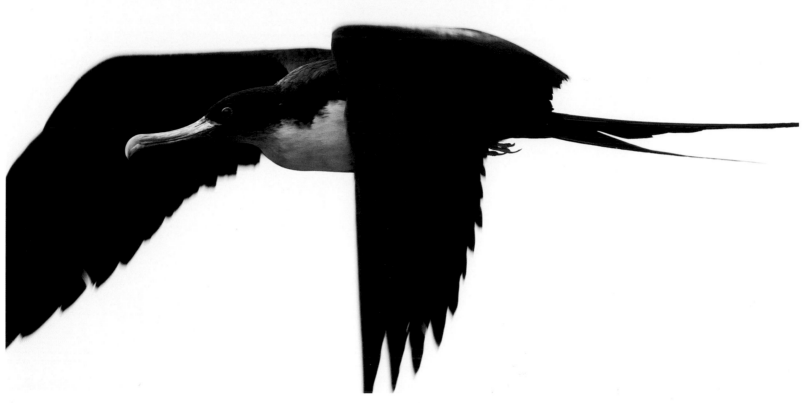

10.11 Sleek and powerful, a female great frigatebird inspects a group of males as her wings reach forward into the next power stroke.

palsied manner, waggle their heads from side to side, jiggling the gular pouch in a lascivious way, and they call. I've given some thought to how I would describe this sound, and I've placed it somewhere between a castrato turkey-gobble and the infamous "Woo-woo-woo" of the Three Stooges. Female frigatebirds find this attractive.

Flying over this sea of testosterone, a female surveys the lot as if she were inspecting a display of melons in the produce department. Eventually she selects her melon, and the couple forms a pair bond that remains largely monogamous through the period of the chick's dependency. Having chosen a male and a nest site in one swoop, the female guards the empty nest, arranging and rearranging the sticks into a nest that suits her. The initial division of labor requires the male to provide the sticks (seventeen on aver-

age) that constitute the nest. The female's guarding of an empty nest is necessary because stick piracy is one of the ways that males reach their quota.

With the nest complete, a single egg is laid, and from that time on the nest is always occupied by an adult until the chick is large enough to be left alone. The sexes trade off incubation duties precisely so that eggs are rarely exposed. That's important, because unattended eggs are invariably destroyed by other males pilfering twigs for their own nests. There is not only the defense of twigs—home-alone chicks are vulnerable as prey to patrolling short-eared owls and even to other frigatebirds.

Figure 10.12 is a frontal portrait of a great frigatebird sitting on his nest in a waist-high saltbush. Once we have studied him and his steely eye and no-nonsense beak, our eyes drop

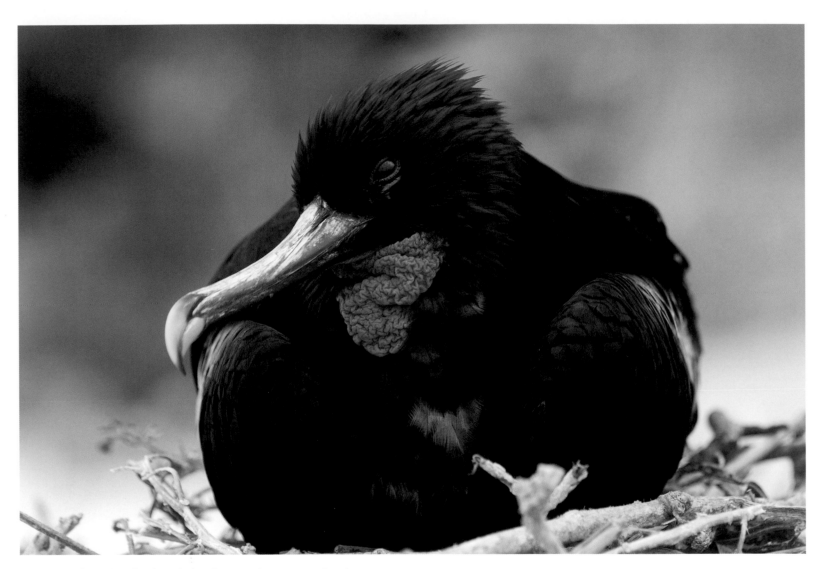

10.12 This frigatebird's shriveled gular pouch suggests that it has not been inflated for some time—maybe he is incubating.

eventually to the wings. The wings of birds are mostly bones, feathers, and tendons—anyone who has paid attention while eating a roasted chicken knows how little meat is carried on the wings. This arrangement allows the muscles that control the wings to be packaged tightly against the torso while still controlling the movements of the wing with long tendons. Concentrating the muscle masses near the axis greatly enhances the maneuverability of the bird.

The exotic body proportions of frigatebirds that make them so successful can be appreciated here. The wrists dominate the image. Positioned as they are, they look like a bodybuilder's thighs, but they are just wrists—all the more bizarre given the tiny legs of frigatebirds. The wrists are so prominent in this posture because the wing bones are so long that they project toward the viewer. A sitting gull, or even a slender-winged tern, barely shows them, and in most birds they are covered by the overlap of breast feathers.

Figure 10.13 provides a second perspective from which to grasp the enormity of the wing sections. The front part of the folded wing, so prominent in the portrait, is the wrist, positioned in this figure near the white chest. The bulge of the shoulder can be seen through the plumage, and the upper arm extends from that bulge to the elbow, which is marked here, fortuitously, by a spot of white on the bird near the base of the tail. The forearm reaches from elbow to wrist—about the length of the torso. The remainder of the wing is constructed of the hand and the primary feathers. The latter are longer than the other two wing sections combined, and they reach all the way from the chest to near the tips of the forked tail. A British ornithologist once referred to frigatebirds as "creative licence gone mad." One can see where he might have gotten the idea—frigatebirds seem to be a compilation of extremes. A successful species that is extreme by almost every measure is not "creative licence gone mad"—it is a stunning evolutionary achievement.

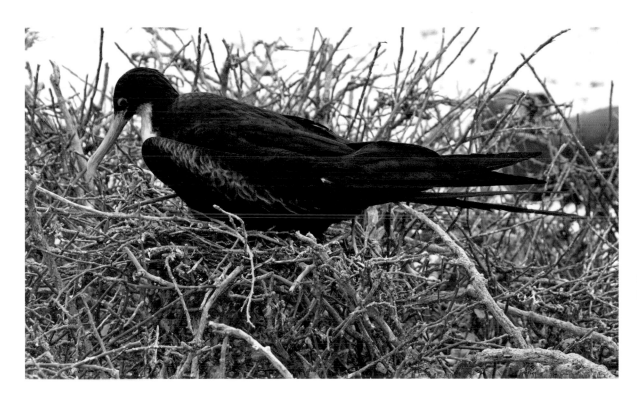

10.13 A female on her nest shows another perspective of those magnificent wings.

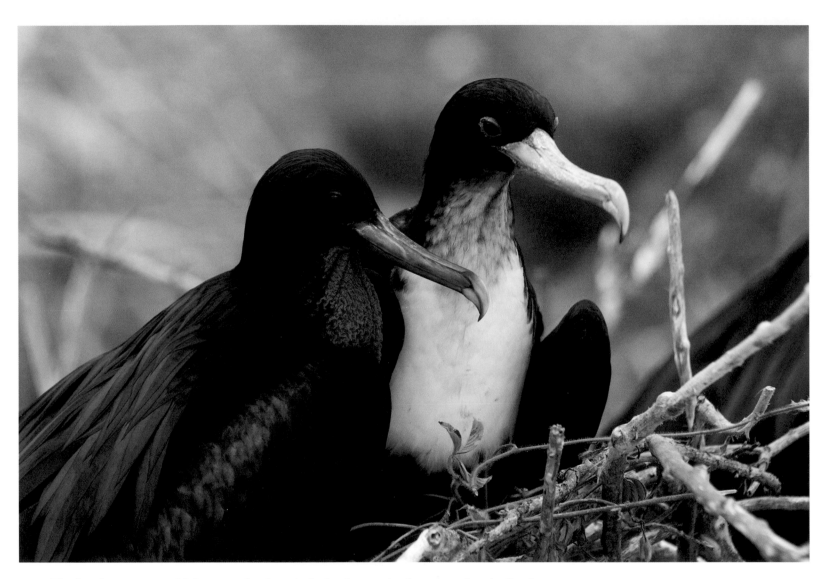

10.14 The female, on a nest with her mate for the year, looks about to begin rearranging the furniture.

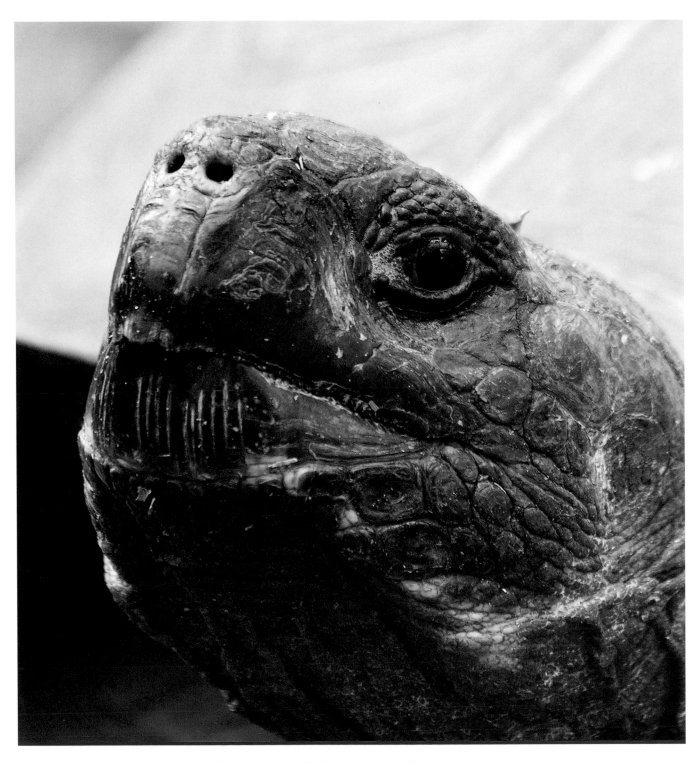

11.1 A youngster traveling through the brush on a hillside in the west of Santa Cruz pauses to evaluate a human impediment to his line of travel.

Geochelone nigra—ENDEMIC

11

———— Galápagos Tortoise ————

These huge reptiles, surrounded by the black lava, the leafless shrubs, and large cacti, seemed to my fancy like some antediluvian animals.—Charles Darwin, *Voyage of the* Beagle

No resident of the archipelago so captures the otherworldly ambience and timelessness that permeate these islands as the Galápagos tortoise. Darwin's now-ironic reference to Noah's flood was in keeping with the science of his time and with Darwin's own views. The geologic periods were just being defined, the great age of the earth had not even been proposed, and the massive rock strata were seen as artifacts of the flood. There was the "time before," and there was "now." These reptiles certainly are from the time before.

Turtles are of ancient stock. Their ancestors watched the dinosaurs grow up, and one senses in them a great body of experience held in a profound silence. Greek myth has it that a nymph named Chelone, disrespectful of the marriage of Zeus to Hera, was changed into a tortoise and condemned to eternal silence. Chelone is worth remembering because we find her name echoing throughout turtle taxonomy. Here in the Galápagos she survives as the sea turtle *Chelonia* and as the tortoise *Geochelone*—"earth turtle." The tightly closed mouth and soulful eyes of this

tortoise, wizened even in its youth, hint of great secrets locked away—stories that will never be told.

One of those secrets is its geographic origin. It remains a mystery, although there are some tantalizing clues. Giant tortoises were common on all the continents until less than two million years ago. *Geochelone* fossils have been found in both south Florida and Cuba, so it is probably best to think of them as relicts of the ice ages that survived only by virtue of their escape to island refuges. They really are from the "time before."

How they got here is another mystery. Improbable as it seems, rafting has been a remarkably effective means of inoculating islands with immigrants, especially with reptiles, because of their tolerance of extreme conditions. It requires only a raft, a storm, and a lot of luck. Once adrift, they are pushed by the currents and the winds. Sometimes rafts drop their entire cargo on islands, but mostly they disappear at sea with all hands lost. If this seems improbable beyond belief, here are four tantalizing bits of information to prop up this idea. First, in 1535 the bishop of Panama set sail from Panama to Peru. Within a month and after many days of severe storms, their craft was blown—one might say rafted—to the Galápagos, initiating the first European contact. It was exactly three centuries before Charles Darwin arrived under more controlled conditions. Second, the tolerance of Galápagos tortoises is such that they could be stacked in the hold of a ship and live for a year without either food or water—a fact that did not escape the notice of sailors. Third, the high dome of a tortoise houses the lungs, making a buoyant scow with a significant sail—both the Panama Current and the Trade Winds push in the right directions to make the bishop of Panama more of a reenactor than a pioneer. And fourth, the reproductive life of Galápagos tortoises is about 125 years, and female tortoises can retain viable sperm for several years. It is entirely possible the tortoises got here by rafting.

Fate is unkind to the inhabitants of islands. The ecological facts of life are aligned against them under any circumstances, and then the Age of Exploration unleashed hordes of hungry sailors, and a wave of extinctions began. The Galápagos Islands were peripheral to most of the damage but not exempt. There were the pirates of the seventeenth and eighteenth centuries and the explorers, including the crew on the HMS *Beagle,* who took their share. The whalers continued the assault. Later, cats, rats, dogs, and goats became a second wave of the assault. There are many island stories similar to this one, but the tortoise proved to be nearly the perfect victim. It was large, defenseless, and naive as well, plus it was tasty. The tortoises not only were abundant but also congregated near fresh water, where sailors already had in place the machinery to haul large casks. It was not a giant leap to haul large tortoises, which were not much more animated than casks, back to the ship, where they were stacked in the hold with the casks and provided fresh meat for many months. Just the *known* ships' logs record that whalers took about two hundred thousand tortoises, roughly 80 percent of the species, during the nineteenth century alone.

Fast-forward a century or two, and we arrive at the sad spectacle of Lonesome George, the last of his subspecies, shown here with a young female probably not half his age. Like every other tortoise in the world, she is from a different island than George. She is his consort. She is there to provide every opportunity for a sexual encounter and maybe, failing that, to keep him company. But even a nubile young female fresh from a mud bath fails to interest him. He is thought to be over a hundred years old, which is late middle age for tortoises. When he dies, he removes from the world the last genes of a population that once numbered in the thousands. Unless he successfully reproduces, the Pinta Island tortoises will pass into extinction—and at best only tortoises of mixed parentage would be produced.*

It is hard to imagine what life as a tortoise might be like, but any effort in that direction would have to focus on being very heavy and very slow at absolutely everything, even aging. It would be like living in a chain-mail suit with limbs projecting through holes in a steamer trunk. It would require great patience and persistence. Here are some round numbers. A full-size male like Lonesome

* As this book goes to press, thirteen eggs fathered by Lonesome George have been found and moved to incubators. The period of hatching is likely to include Charles Darwin's two-hundredth birthday.

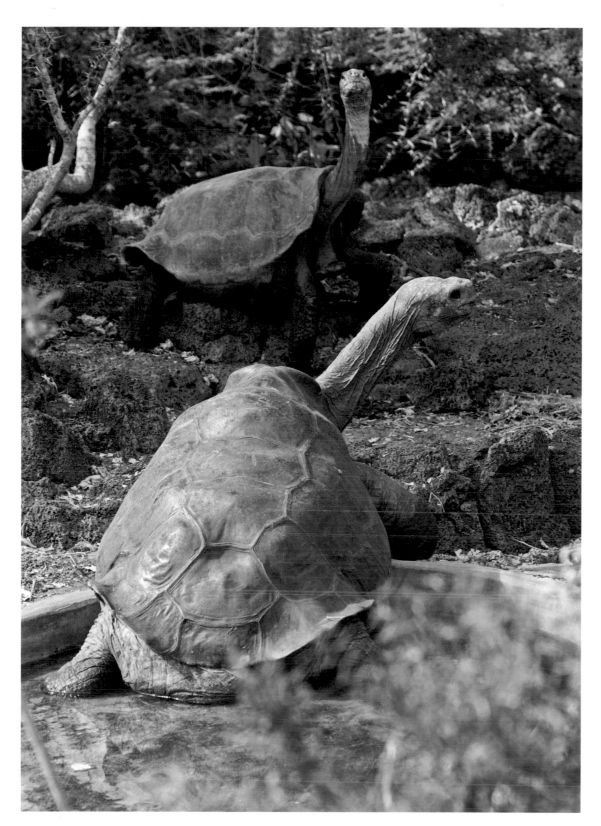

11.2 Lonesome George, the last known tortoise from Pinta Island, and one of two consorts are cared for at the Charles Darwin Research Station.

11.3 A wild tortoise dozes in a small pond, or what remains of it, at the close of the dry season.

George weighs about 650 pounds, and a third of that is carried in the shell. Their top speed is a fifth of a mile per hour, as clocked by Charles Darwin. For food, they pursue nothing faster than a cactus. They have no natural enemies after they reach the size of a box turtle, and they become sexually mature at about thirty; by then they have a good chance of living to the age of 150—a time span that would encompass the presidencies of both George Washington and Harry Truman. The recent death in 2006 of Harriet, aged 176 years, who was taken from the islands by Charles Darwin himself, would extend that span into the administration of Lyndon Johnson.

Females are about half the size of males. They lay a small clutch of about ten eggs, often fewer, of which 20 percent will die before they climb out of the nest. Their sex is determined by the temperature of the embryos during their time in the egg, so it follows that there is no genetic difference between male and female tortoises.[*]

One feels a vibrancy in wild tortoises that is lacking in their captive cousins in spite of the excellent care they receive. All of these enormous tortoises move with the labored shuffle of a prison

[*] The eggs fathered by Lonesome George are being raised to yield eight females and five males.

work crew, but in wild tortoises, there is an alertness in the eye and a spark of interest that accompanies their immersion in a broader world. None of this shows on the tortoise caught napping in Figure 11.3. Catching a tortoise napping is no great trick, as they sleep sixteen hours a day, often in a water hole. This one occupied the entire remnant of a "pool" that when full would have been fifty feet long. It put me in mind of a buffalo wallow as a catch basin, and I began to suspect that some of the pools are maintained by countless generations of tortoises rising from their soak and walking off with twenty-five pounds of mud.

Tortoises are browsers more than they are grazers, nipping the more tender parts of brush and cactus, but they fill both of those ecological roles in this low-diversity ecosystem. The cutting edges of a turtle's mouth (tomium) create a formidable processor of food, their power suggested by the size of the shields that form the upper and lower tomia. Turtles don't have teeth, but that doesn't mean they gum their food. The tomium, shown in greatest detail in Figure 11.1, is serrated, sharp, and controlled by very large muscles. Even with that, they don't make short work of their food, much of which is coarse and fibrous, because their feeding movements are slow and labored, like everything else about tortoises. Filling the ecological role of herbivores, it is not surprising to find that many generations of tortoises have, like cattle, blazed trails that identify the easiest and most direct route from favored place to favored place. One of those favored places is the nearest pond.

I had occasion to spend a little time with a young wild tortoise foraging in the low brush on Santa Cruz. Just him and me. It was like meeting someone from the ancient past but outside of any particular time frame. He was about eighteen inches high at the carapace, probably twenty-five to thirty years old, and maybe 150 pounds. The youth of this tortoise was apparent by the detail in the growth rings on the carapace. As he ages, those rings will wear smooth, like the male in the pond, as will the scales on his brawny limbs, now armored like a Samurai. His gait was tentative and lurching, almost as if he were using a walker, and he carried a look

11.4 A tortoise leaves the pond and heads into the brush on a well-worn trail in the Tortoise Reserve on Santa Cruz.

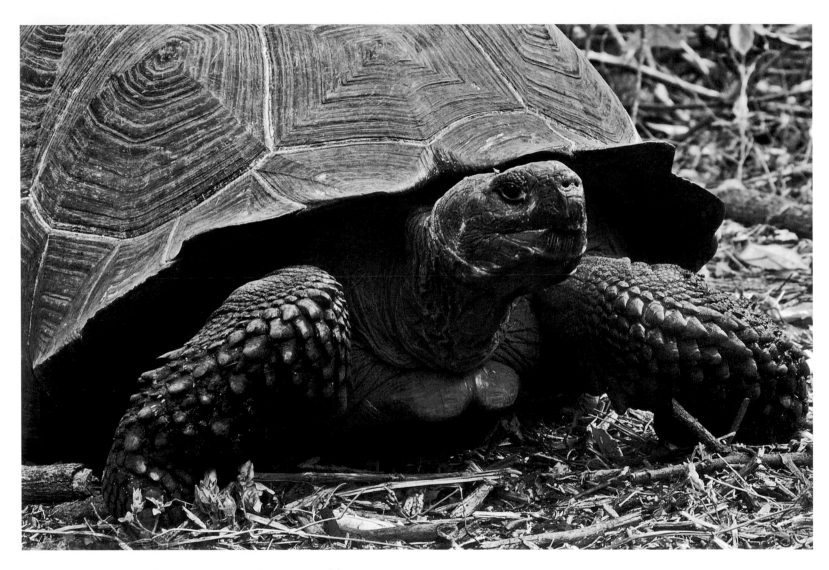

11.5 A young tortoise of my acquaintance carries a wealth
of textures on his body and emanates a profound silence.

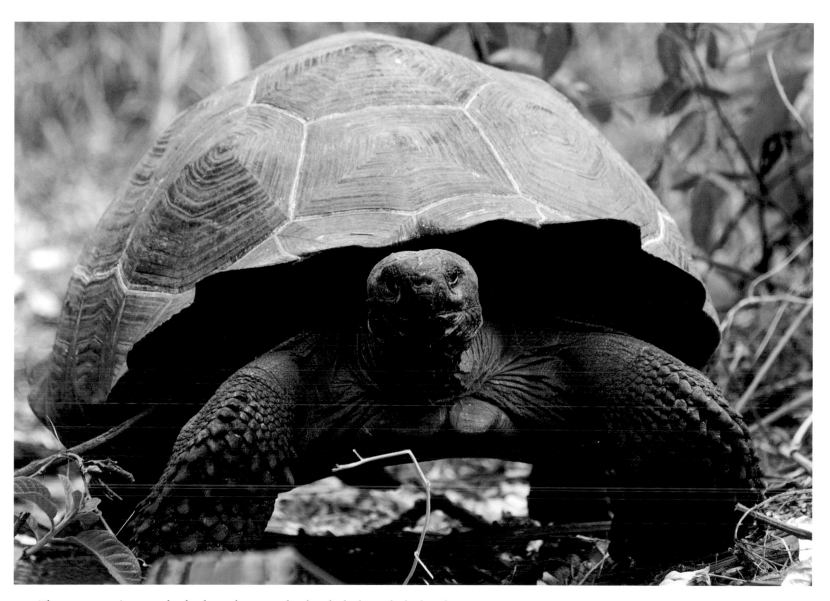

11.6 The same tortoise completely clears the ground as he plods through the brush.

of antiquity that did not befit an animal just leaving childhood. He would be about twelve in human years.

He lumbered toward me, approached to about seven feet, and gradually slowed to a stop. I was crouching on his level, and he looked at me this way and that. I looked back. I think he was trying to decide what to do about me. I was trying to imagine what was going on inside his brain. It was a very powerful moment for me. After a long while, he deflected his path by a few degrees and moved on, passing me to my left, unafraid and, I imagine, unimpressed. We both moved on, one of us richer for the encounter.

The tortoise in Figure 11.7 is taking a drink after his nap. I knew he was drinking because I could see the pulsing of his throat muscles. This is not the clumsy buffoon that one might imagine from the image in Figure 11.8, or the naive youth in Figure 11.5. He is alert, powerful, and calculating; even though he is toothless and encased in a hopelessly cumbersome body, deep inside, one gets the sense of an inner *Tyrannosaurus rex.*

After his drink, he took an interest in a female on the far side of the pond. He proceeded to court her—a process that lacks subtlety in tortoises. Courting males respond to the scent of receptive females and pursue them. Slowly. The female attempts to escape—also slowly. If the male catches her, the seduction involves ramming her from behind with his gular horns, those blunt, forward projections of the shell just below the neck that are prominent in Figure 11.5. She responds by dropping to her belly, and while she is thus immobilized, he mounts, pinning her to the ground with his great weight. The copulation itself is a long, slow process.

As we watch tortoises, many different moods surface. They possess great flexibility for animals with such rigid form and no facial muscles. There is the alert youth, the lethargic layabout, the buffoon, and the crafty codger. Maybe Chelone speaks to us as best she can.

11.7 After his nap, it is time for a long, slow drink by a sly, fully alert male.

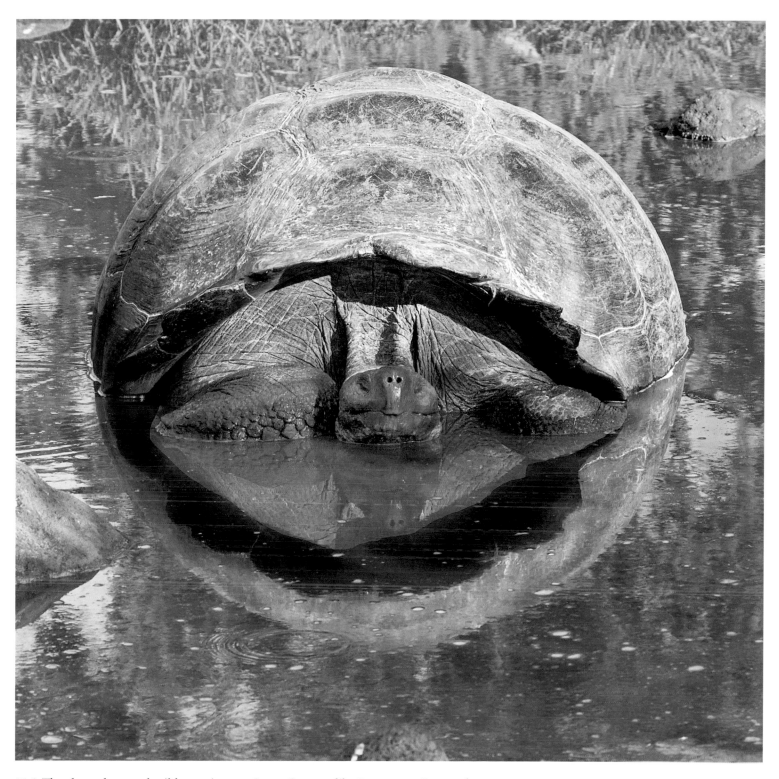

11.8 The three thousand wild tortoises on Santa Cruz, unlike Lonesome George, have dome-shaped shells, as evidenced by the nearly perfect circle created with his reflection.

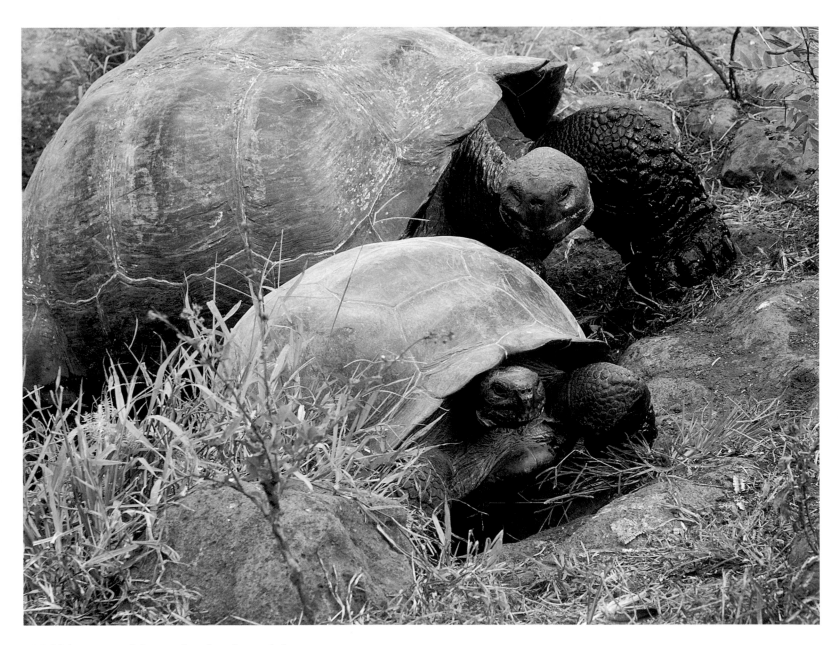

11.9 Males are much larger than females, and they use
their great weight to advantage during courtship.

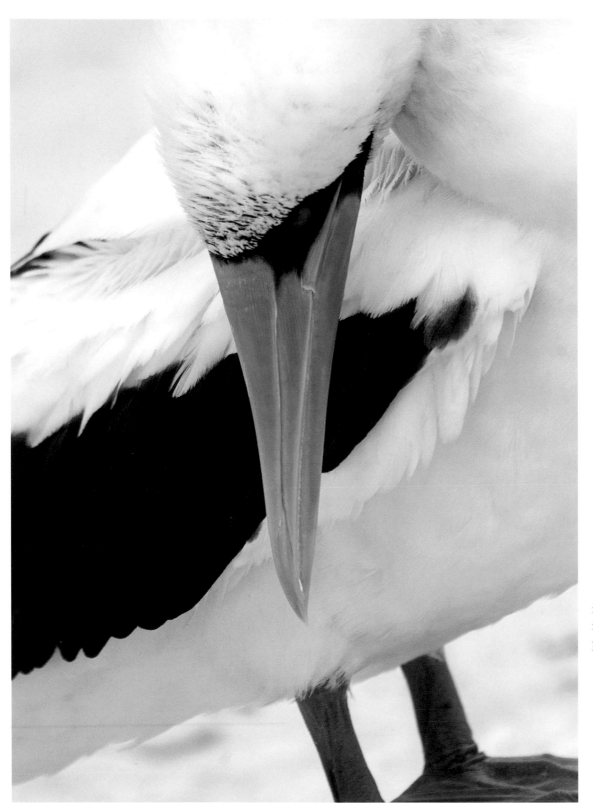

12.1 A Nazca booby pauses while preening to model the business end of its fishing apparatus, evolved to strike and penetrate the water at high speed.

Nazca Booby
(Sula granti)—ENDEMIC

Blue-footed Booby
(S. nebouxii)

Red-footed Booby
(S. sula)

12

—————— T h e B o o b i e s ——————

The [booby] is a species of gannet . . . tame and of stupid disposition. [They] are so unaccustomed to visitors, that I could have killed any number of them with my geological hammer.—Charles Darwin, *Voyage of the* Beagle

Visitors to the Galápagos heap their affections on the boobies, especially the blue-footed booby, which is the most accessible, flamboyant, and exotic of the three species. Their name is pejorative and the sentiment that launched it archaic, but there it is, firmly in place, so it is best to find it charming and maybe quaint. On land, boobies are graceful and clumsy at the same time, a paradox one must really see to accept, but when they are at work—fishing—they plunge dive with stunning grace and precision. Plunge diving is a method of fishing that involves a targeted entry at high velocity to reach fish at a chosen depth, a trade that has shaped their behaviors and their ecological positions as surely as it has sculpted their bodies. Aside from their beauty and their quirky charm, the boobies offer us a wonderful insight into that part of the Darwinian world that is unlovely but necessary: the behavioral rules in force at the nest site are brutal but efficient.

All boobies are plunge divers by trade. It is a good place to begin our understanding of these birds, because food capture is the foundational requirement. The other

critical facets of their lives—when and where they nest, where they forage, and how they structure their reproductive lives—are built around this core. Like the two frigatebirds and other congenerics that must share a particular area, the three species of boobies avoid competing for food by partitioning the habitat into zones where each can become most proficient. The Nazca booby is the heaviest of the three but serves as a good model to characterize the adaptations of plunge-diving birds. It dives from altitudes of nearly a hundred feet, using its wings to accelerate the way a downhill skier uses his poles as he leaves the chute. Nazca boobies hit the water at speeds in excess of forty miles per hour in pursuit of prey and make use of their weight to penetrate twenty to thirty feet below the surface. Their shape is so perfect that they experience no deceleration as they pry apart the water with their bills. Their nostrils are permanently closed and the spaces filled with bone to reinforce the bill. In addition, they've accumulated subcutaneous fat on the head and adapted air sacs in the neck and chest region to cushion the impact. They plummet to the target depth and brake by deploying their wings. This extraordinary performance is repeated many times a day.

The partitioning of feeding areas works like this. The red-footed booby is the lightest of the three and feeds well out of the sight of land, about sixty miles from shore. The Nazca booby fishes in waters of intermediate distance, thirty miles or so offshore, and the blue-footed booby works the near-shore areas and sometimes the shallows. The three boobies also nest in different areas, a circumstance that correlates with their foraging. The Nazca booby chooses ledges and cliff tops; it doesn't take off easily, even from the water's surface, so running over rocks and through bushes clearly won't do. The nearby cliffs solve the problem. The red-footed booby takes advantage of its small size and unique prehensile feet to nest in trees near the shore, like the dense red mangroves that protect them from raiding frigatebirds. Blue-footed boobies choose the plateaus sprinkled with scrubby brush and rocks. They are usually found back from the cliffs where they would conflict with the Nazca boobies, but they have little difficulty in flying to and from these areas. The three boobies are so different from one another in plumage, lifestyle, and persona that we'll look at them individually.

Nazca Booby *(Sula granti)*—ENDEMIC

Formerly known as masked boobies, in 2001 Nazca boobies were recognized as a distinct, endemic species and named for the tectonic plate on which they nest. Their markings are bold, and they cannot be confused with any other birds of the islands, except perhaps the white phase of the red-footed booby.

The "nun in reverse habit" pictured in Figure 12.3 carries an irony, given the position of the Roman Catholic Church on the death of embryos and the Nazca booby's equally strict but opposite position on trimming family size. Nazca boobies engage in "brood reduction." This is a scrupulously neutral descriptive term that characterizes the evolved behaviors of boobies—behaviors that created this successful species. Brood reduction collides directly with our sense of what is moral—from which we must excuse amoral animals—and fits well with the persona we are likely to apply to the Nazca booby. Natural systems are rife with such events, but usually not in a species with which we can identify so easily, and usually not right before our eyes. The issue is frequently sidestepped by true but vacuous commentary that notes that "only one chick survives to maturity." This is indeed true, because the oldest chick kills its sibling, either directly or indirectly. The parent may watch but does not interfere.

The term is *siblicide,* and among Nazca boobies it is obligate. They usually lay two eggs, one chick always kills the other, and the action is independent of the food supply. Things are black and white among the Nazca boobies.* What is unthinkable among humans is, like eating and sleeping, a fact of life for these birds.

Figure 12.4 shows us the doting mother and her chick that appears helpless. It is worth getting past our revulsion to understand the

* Stephen J. Gould, in his essay "The Guano Ring," treated the issue eloquently and in some detail. It was published in *Hen's Teeth and Horse's Toes* (1983).

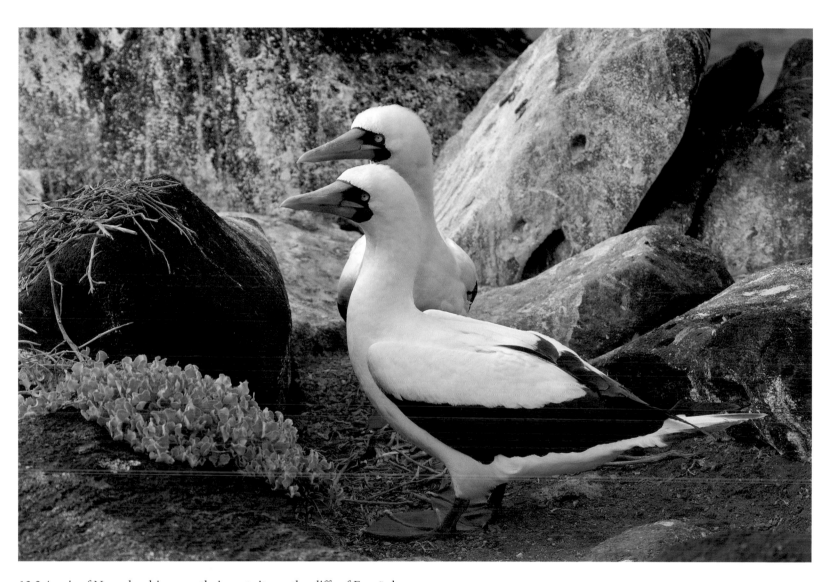

12.2 A pair of Nazca boobies near their nest site on the cliffs of Española.

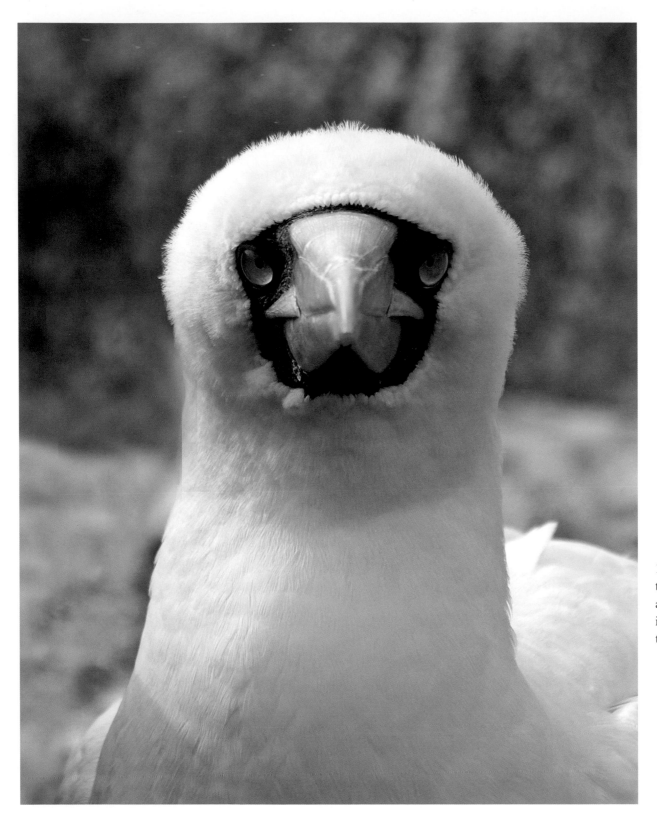

12.3 One can easily imagine the Nazca booby abiding by a strict code of conduct, but it is perhaps more revealing to take a fish's point of view.

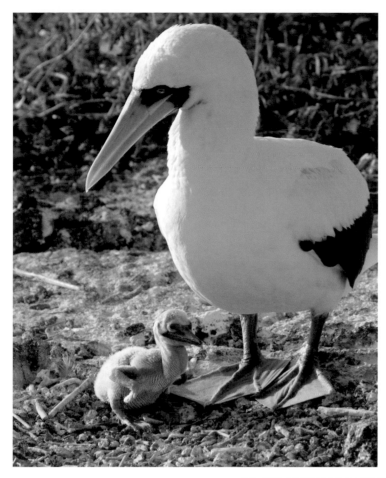

12.4 Two Nazca boobies, a parent and a single chick, occupy what passes for a nest among boobies.

12.5 A nestling Nazca booby, its egg tooth highlighted by the evening sun, is the sole survivor of the brood, having followed its genetic instructions to the letter.

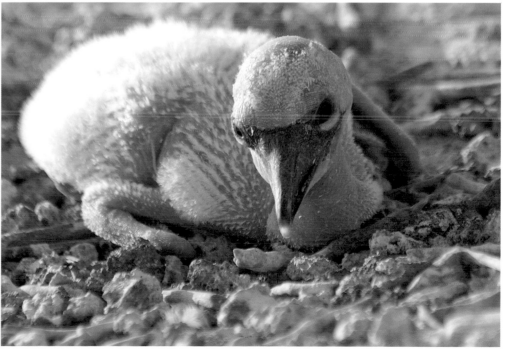

forces at play. For Nazca boobies, it is a round trip of sixty miles (on average) to the fishing area. That is about two hours of flight, depending on the wind, plus the time required to catch a suitable number of fish and squid, some of which they must eat to regain the energy spent on the flight and to maintain themselves. They carry back only what they can fit into their gullet during the twelve-hour day at the equator, and that means only one or two trips in a day. The second parent cannot help, because he or she must remain at the nest to care for the young one, protecting him against predators and the elements. So when feeding time comes for the young, there may not be enough to feed two chicks to adulthood.

Nazca boobies lay only one or two eggs. Research has shown us that pairs producing one chick and a "spare" are twice as likely to fledge a single chick as a pair that lays only one egg. A margin of that size might well be the difference between survival and extinction, so it is not surprising that the Nazca boobies have adopted brood reduction as strategy. It is a grim story, but in the hard light of Darwinian calculations, it is favored and it may even be essential. It is hard to imagine a circumstance more suited to aggrieve human sensitivities, but while our romantic notions are offended, the logic is plain.

Blue-footed Booby *(Sula nebouxii)*

Blue-footed boobies have the persona of clowns with a hint of psychosis. This impression is nourished by the pale, constricted irises that we have come to associate with adrenaline-hopped junkies, mad scientists, and fiends in general, but these boobies are comical and endearing nevertheless. The most remarkable thing about them is their blue feet, which at times seem almost luminous. The color is so intense and their feet reflect light so effectively that their bellies thrum with the glow of glacial ice, even under an overcast sky. Such feet must be very important to them, and in fact they are. They don't just "happen" to be

blue. Blue feet are central to their social life. Watching them for a while, one is left with the impression that they are exultant over a new pair of shoes, and they miss few opportunities to show them off.

When boobies return to the nesting area and prepare to land, they brake with their broad webs spread in front of them like forward parachutes, flashing them at the residents—behaviorists call this a "foot salute." Their feet are also conspicuous during their courtship displays, but like many seabirds, booby courtship involves wing displays and posturing as well. They often wave

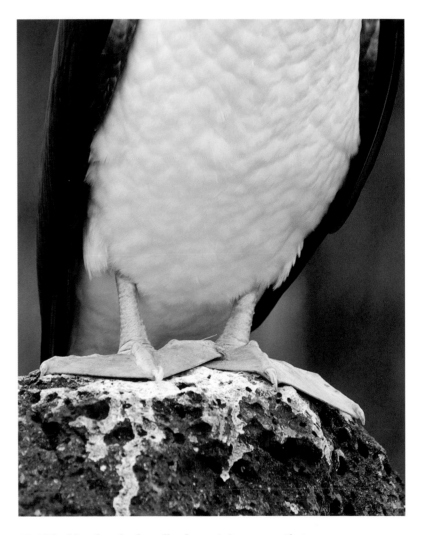

12.6 The blue feet don't really glow—it just seems that way.

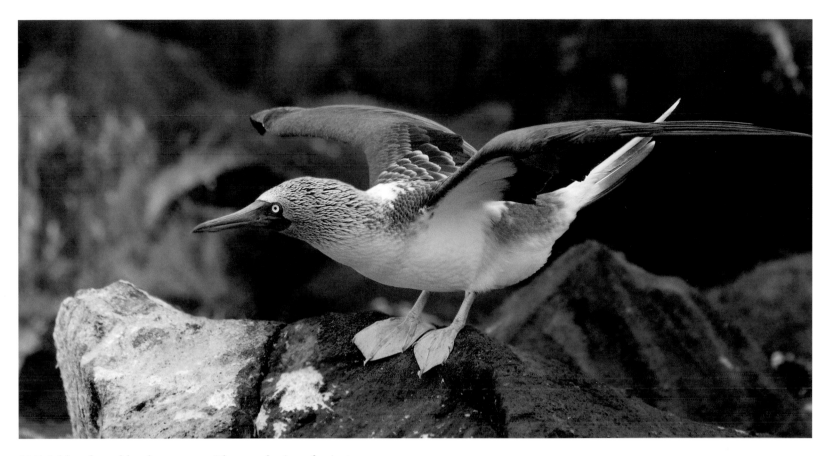

12.7 A blue-footed booby pauses with spread wings for just a moment before taking wing from a convenient launching pad.

their feet about while walking or standing in place—"parading" is the term adopted by behaviorists. This display is more of a high-stepping, slow-motion waddle than a dance, and they perform with such gravitas that few can resist a smile. They even use their feet to incubate, with the vascular webs between their toes draped over the eggs.

Figures 12.8a through 12.8d open four windows into their courtship display. Both boobies and cormorants are distantly related to pelicans, and similarities in persona surface. For instance, the "snake-neck" posture assumed by flightless cormorants in their courtship rituals can be seen prominently here. During his displays, the male emits a whistle that lasts a second or

so. It is a beautiful, textured, flutelike call with the pitch rising and falling, almost like an arpeggio.

Blue-footed boobies also engage in brood reduction, but the rules are a bit different to accommodate the demands of their unique foraging niche. Two to three eggs are laid, but (unlike the Nazca boobies) their survival is dependent on food supply. With their feeding location near the shore, there is little "travel expense" to reach the foraging areas, whether measured in time or calories. If fish and squid are abundant in the shallows, all three chicks may survive. If not, only the oldest two or perhaps just one is likely to fledge. There is no way to know what will happen to the two chicks in Figure 12.9.

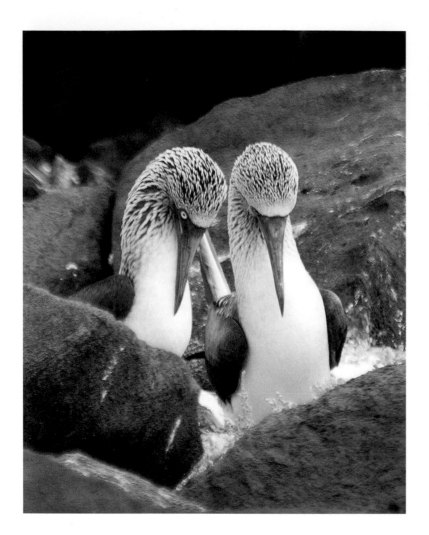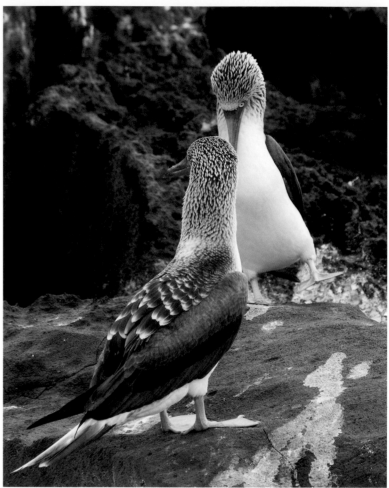

12.8 These are four moments in the extravagant courtship displays of blue-footed boobies. The behaviors are (*left to right*) pelican posture and, with the male facing, parade, parade (again), and sky pointing.

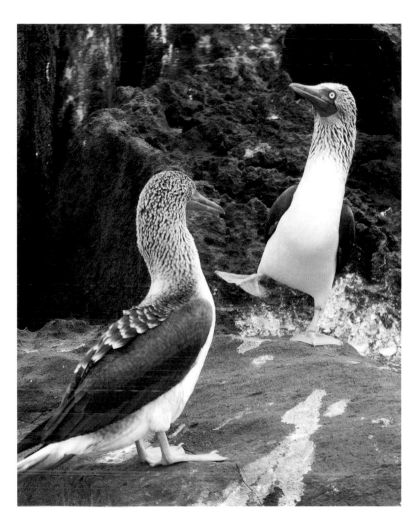
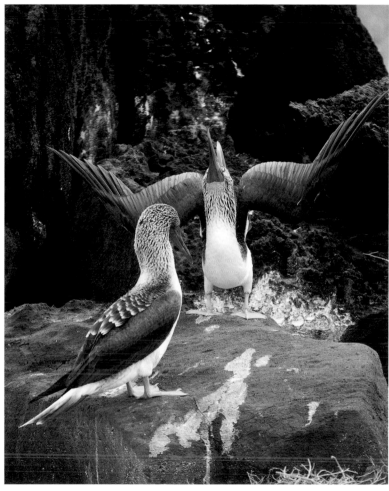

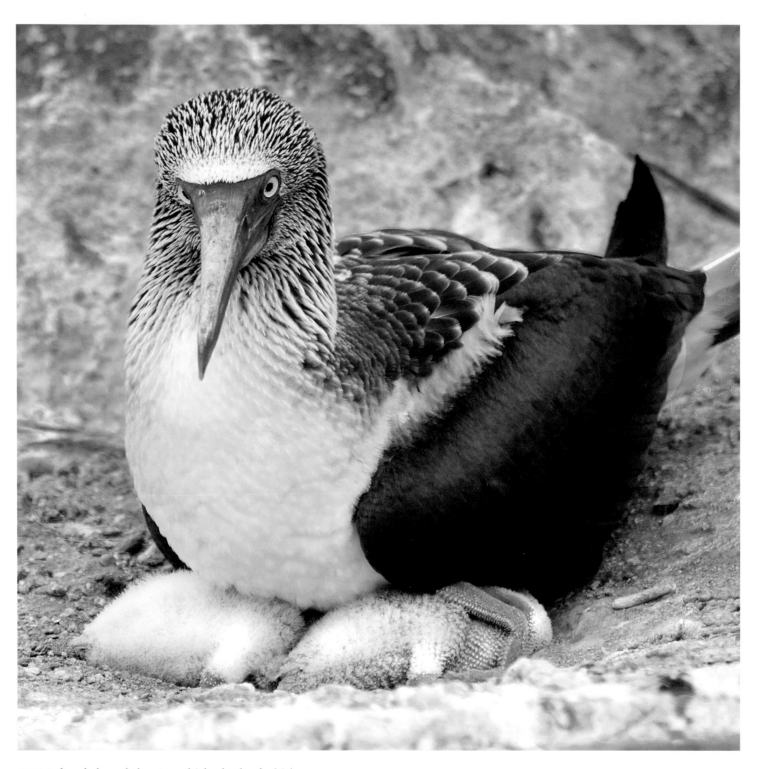

12.9 A female broods her two chicks, both of which
may survive, unlike those of the Nazca booby.

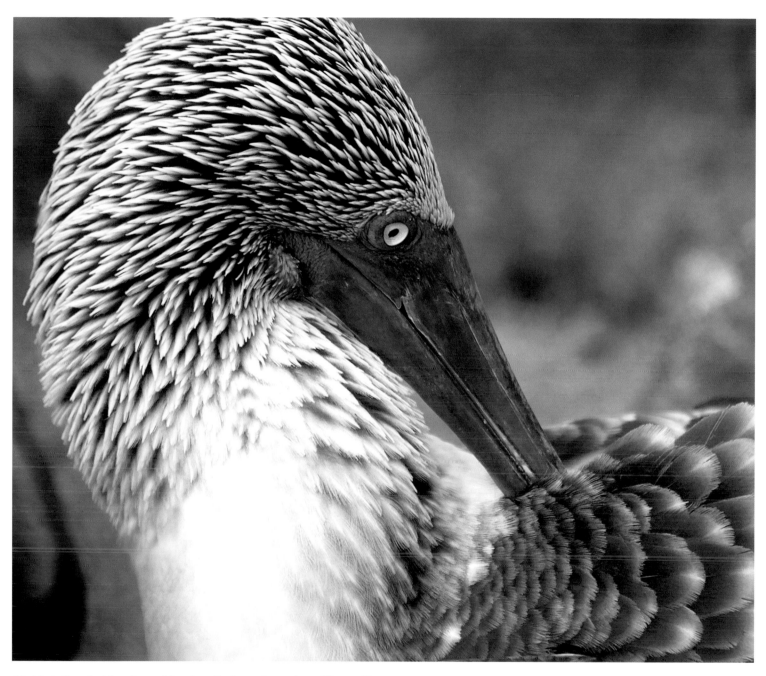

12.10 A female blue-footed booby displays the unique "frosted" appearance of her head feathers as she cleans and oils the feathers on her back.

Red-footed Booby *(Sula sula)*

The red-footed booby is the smallest and the fastest of the three species. It takes nearly two of them to make a Nazca booby, and they hunt even farther at sea, beyond the already distant foraging area of the Nazca booby, with which they would otherwise compete. Their weight disadvantage and an apparently milder temperament suggests that they would be pushed to the periphery by their competitors, and other aspects of their life are consistent with that assessment. They are shallow plunge divers, which seems to be partly a function of their body weight.

As in the other boobies, the foraging distance is a critical matter. Their extended foraging distances limit the possibility of raising more than one chick, even such a small one, and they lay only a single egg. The mortality of young red-footed boobies is high in the Galápagos, partly a consequence of the long distances traveled by the adults and the constant harassment of frigatebirds. When they return from their 120-mile (on average) foraging expeditions, which require an entire day, they must run a gauntlet of frigatebirds, who try to force them to disgorge their catch by physical harassment. In defense, red-footed boobies have learned to move to high altitudes to get above the frigatebirds as they approach the shoreline, and then descend quickly and dart into the safety of the mangroves. It is a strategy that speaks volumes about the pressures applied by the frigatebirds.

The persona of the red-footed booby is sweet and gentle. It reminds me of a little girl waiting in her red rubber boots for the bus to carry her to first grade. Figure 12.12 shows a female standing on her nest in the mangroves—Little Miss Muffet. Their small size and prehensile toes permit red-footed boobies to nest in

12.11 The prehensile feet of red-footed boobies permit them to grasp branches; their slender toes and thin, flexible webs are very different from those of the other boobies.

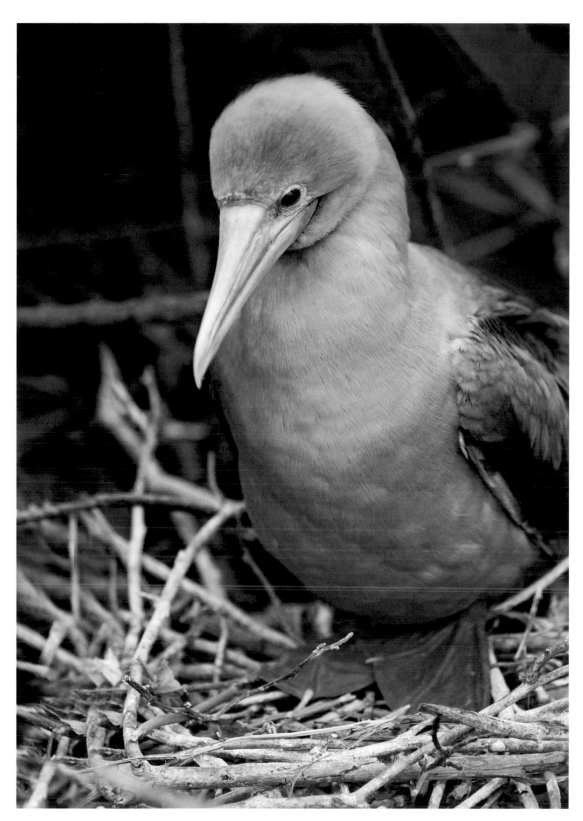

12.12 A red-footed booby evaluates the twig pile that is her nest, tucked away in the mangroves where frigatebirds cannot reach.

small, thickly branched trees like mangroves. This nesting preference may initially have been coerced, as the ancestors of this species were expelled from more open areas by the larger boobies and forced into the brush by the frigatebirds, whose long wings prevent them access.

The breeding behaviors of red-footed boobies are much less dramatic than those of the blue-footed boobies. There is no parading or saluting in the trees, although typical body movements are recognizable even if the flamboyance of their display is constrained by the location.

Red-footed boobies come in two color forms (morphs): a white one—*morpho blanco,* which comprises about five percent of the population in the Galápagos—and the common brown morph. The white form can be mistaken for a Nazca booby in flight and at a distance, although the red feet, colorful face, and small size make that error unlikely at close range. They mix with the brown forms and nest in the same mangroves.

The complex of interlocking behaviors and physiologies among the booby species makes it difficult, if not impossible, to sort out the sequences in which they evolved. Clearly the combination of properties that allow red-footed boobies to fit so snugly into their niche are interdependent. Those properties include their lightweight body, a long commute with shallow dives, and a single chick with high mortality, among others. But their status was entangled with the Nazca booby, which was evolving to find its own unique solutions to the problems of life on the Galápagos, not to mention interactions with the blue-footed boobies and the frigatebirds. It is a compelling spectrum of evolutionary biology, simple enough to be appreciated but complicated enough to be enlightening. Together, these three boobies tell many stories with mythic elements. There are courtship intrigues, phenomenal athletic abilities, precision strikes, evasive strategies, competition, and specialization. There are pirates and treasures, there is comedy and tragedy. There is Cain and Abel.

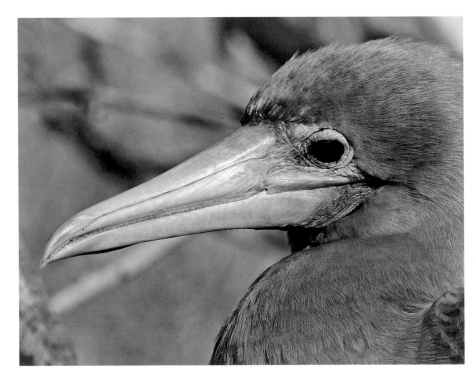

12.13 The face of a red-footed booby (brown morph) is a rich palette of colors and textures, and it provides a clear view of the fish-gripping serrations that substitute for teeth near the tip of its bill.

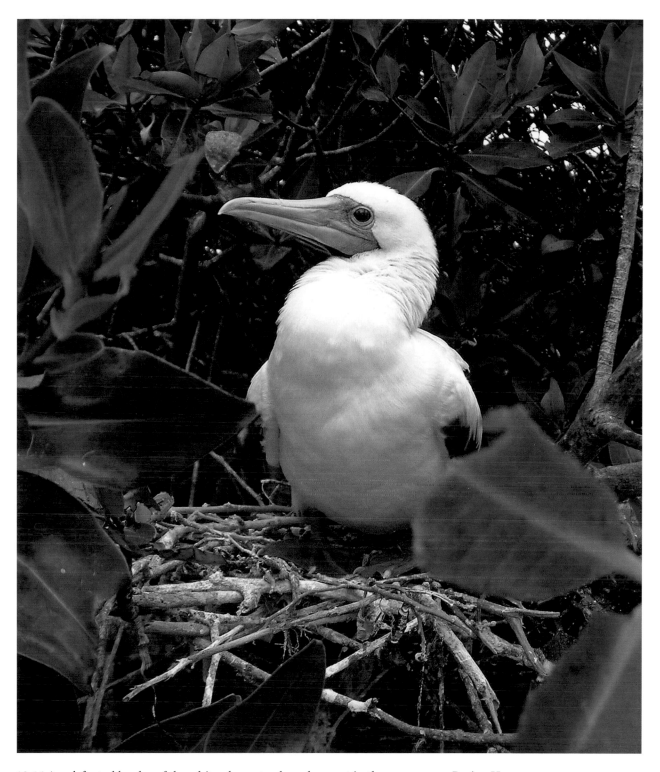

12.14 A red-footed booby of the white phase stands on her nest in the mangroves. *Regina Hess.*

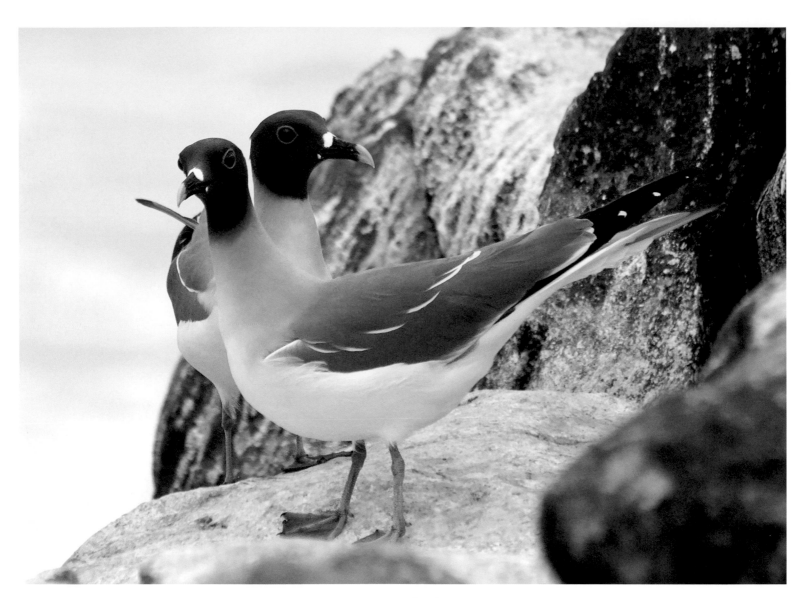

13.1 A pair of swallow-tailed gulls display their unique proportions on the cliffs of Galápagos.

Creagrus furcatus—*ENDEMIC*

───────── Swallow-tailed Gull ─────────

But resign this land at the end, resign it
To its true owner, the tough one, the sea-gull.
—T. S. Eliot, *Landscapes: Cape Ann*

Swallow-tailed gulls are not icons of the Galápagos, but they are royalty, and the word that hovers about any discussion of these birds is *unique*. They have no close relatives, and no one knows quite who their closest kin might be. The swallow-tailed gull is the only nocturnal gull in the world, and it hunts the surface waters of the deep ocean, feeding on fish and squid at night when those creatures are near the surface, using their dim bioluminescence to target them.

The gulls quickly become favorites of visitors by virtue of their soft beauty and grace; they have been described as one of the most beautiful gulls in the world. Their plumage is immaculate, with white-edged scapulars delicately stitched across the mantle and fleshy, crimson eye-rings that define and accent their exceptionally large eyes. The tail is somewhere between notched and forked, not really swallow-tailed. In fact it is more like that of a tern, and the shape is not coincidental: this bird has become more ternlike to optimize its performance in its niche.

To those familiar with the shapes of gulls, these birds look a bit odd, and not just their eyes—the neck is too long and tapered, the beak too delicate, the body too thin, and the wings too pointed; also, the wings and the tail are unusually long. The legs are short, like those of a tern, although they have retained the large, strong feet typical of gulls. These oddities suggest that this is a very different gull that has evolved to fit a peculiar niche. The demands of that niche interacted with its ancestral anatomy, its suite of behaviors, and its physiology to sculpt its DNA—it is a unique bird for a unique place.

This bird is both beautiful and mysterious. It is a pelagic gull during the three or four months a year that it is not nesting, spending that time foraging in the rich upwelling off the coast of Peru. By the time it returns to the Galápagos to nest, it has completed its molt into breeding plumage, so visitors to the Galápagos Islands never see the adult in its nonbreeding plumage. Swallow-tailed gulls nest about every nine or ten months, but the breeding period is not seasonally synchronized, which seems puzzling to folks from the temperate zones. Somewhere on the islands, in separate pockets, swallow-tailed gulls are always breeding.

Because they feed at night, their daytime activities are largely sleeping and preening, along with tending the nest, during which they may sleep and preen some more. When foraging, they leave the island just at dark and return before first light, so they have never been observed feeding except for the odd glimpse from boats at night, boats that are likely to have distorted the gulls' activities by stirring up debris and injuring prey species. Where the gulls go at night and how they forage is not clear. They don't travel great distances like the Nazca and red-footed boobies, a fact uncovered by recording the time lapsed between the departure and return of marked birds.

The allure of swallow-tailed gulls lies in the delicacy of their plumage, displayed most attractively in Figure 13.4. The loft and softness of the plumage over the shoulders begs to be stroked, and the overlapping, gray-fringed feathers along the forearm suggest the smoothness and softness of whipped cream on the tongue.

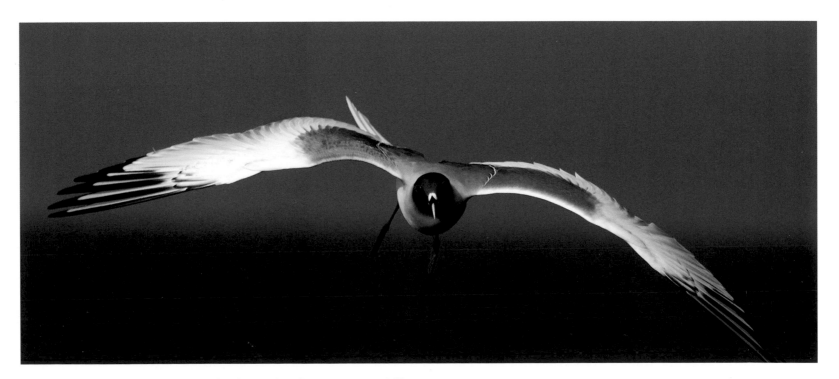

13.2 A master of nuance, this bird rides the wind with consummate skill.

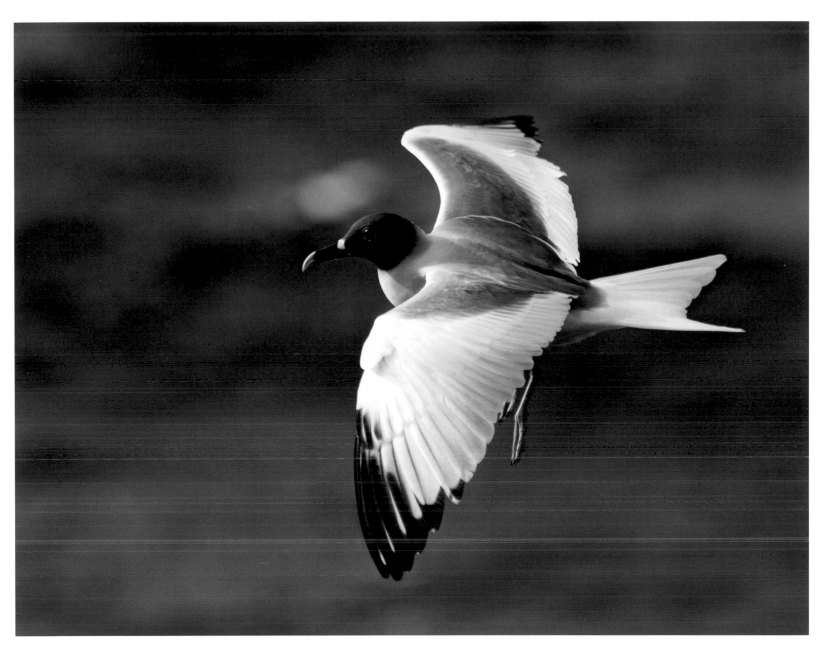

13.3 A swallow-tailed gull floats, legs dangling and motionless,
on a strong updraft at the top of the cliffs.

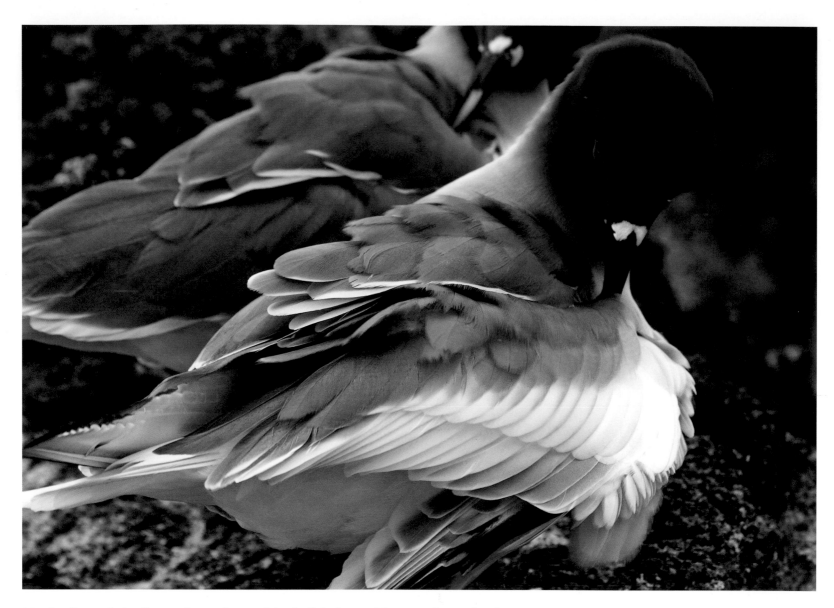

13.4 Swallow-tailed gulls spend a good part of the daylight hours either preening or sleeping.

The display lasts for only a short time. Then the lofted feathers are compressed, the wing folded, and those delicacies are hidden like lace on a petticoat.

There are several advantages to feeding at night. The biggest probably lies in avoiding the damn frigatebirds. Elsewhere in the world, terns nest near frigatebirds, but gulls never do except for our swallow-tailed gull, another unique property. But for an occasional full moon, frigatebirds go to roost just before the gulls begin to assemble for their nightly foraging, and begin their day shortly after the last gulls have returned and fed their young. Thus the night shift neatly avoids the problem of harassment and piracy by the frigatebirds; this strategy also allows both parents to defend the nest against the active frigatebirds and Galápagos hawks during the daylight hours.

There are other advantages. Squid, one of the staples of the swallow-tails' diet, rise to the surface during the hours of darkness and are thereby most available to a surface feeder who cannot plunge dive like the boobies. Exactly how the gulls capture their prey is not known, but the presence of the very large eyes in association with bioluminescence of the prey suggest a sort of night-vision technology. The enormous eyes and the unusual goggle-like eye-ring hint at some novel capability. Something unique.

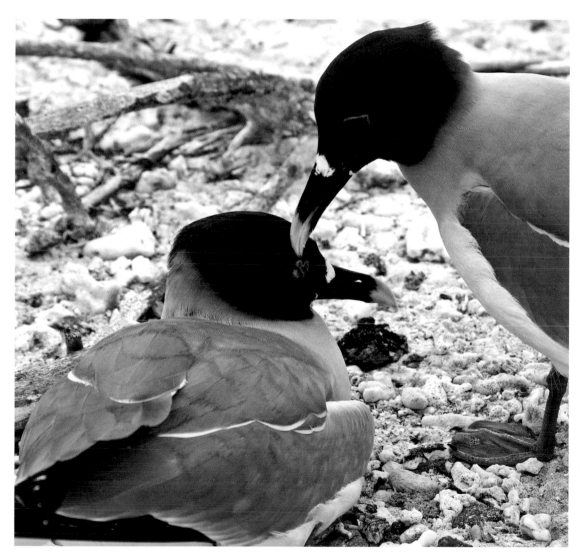

13.5 Mutual preening is another of those activities that strengthens a pair bond.

The behavioral repertoire of many birds is replete with small movements that have significance, like a flip of the head, or placing a small chunk of coral in a particular spot. Mutual preening is one of these activities. Its equivalent in primates, grooming, is a powerful force of social cohesion, but among these gulls the behavior is limited to mated pairs before egg laying. So we can be fairly sure that, in Figure 13.5, the resting bird being preened by its mate is not incubating.

The nest is typical of gulls and terns: a scrape in the sand with little to separate it from its surroundings other than a few decorations. Although the decorations are minimal—small pieces of coral, or spines from a pencil urchin—there is great symbolic importance in their presentation. Among boobies and frigatebirds, the twigs used as nesting material are valuable because they are in limited supply, but bits of coral and urchin fragments litter the beach, so we can assume that the value lies in the giving rather than in the gift. These carefully collected bits of debris are meticulously placed in the nest and then, having served their purpose, forgotten.

Swallow-tailed gulls prefer to nest on cliffs where there are crevices for the young birds to hide in, but brushy beach margins are suitable, too. They lay only a single egg. In this respect, also, they are unique among the gulls of the world. Regardless of their nest's location, young swallow-tailed gulls abandon it about a week after they hatch to hide in rocky crevices or among the stiff branches at the base of scrubby salt brush or prickly pear.

Food is brought to the young and regurgitated by the parents. It has long been known that the red dot on the lower bill of many gulls serves as a regurgitation trigger: the young bird pecks at the spot, and the adult produces the food. But nocturnal feeding alters the situation. In the dark, young birds require a more prominent target than a red spot on a yellow bill. The problem is solved by substituting a white spot on a black bill and two more white spots on the feathers around the base of the bill. These spots unambiguously define the position of the mouth through triangulation, in a way that a single spot cannot. Very young chicks know where the food comes from, but not exactly how to get it out, so they peck at the bill, the white spots at the base of the bill, and sometimes the red eye-ring. When the parent opens its mouth, the young one is apt to pull at the red tongue. The parents are thus motivated to give up whatever they have. As the chick becomes a bit older, it solicits food by giving a short call, assuming a submissive hunched posture, and with the bill up, pecking at the white tip of the parent's bill.

About sixty days after hatching, the young bird takes its first flights, so one might guess the age of the youngster in Figure 13.9 to be about forty days. The older bird in Figure 13.10 is still begging for food even though it is able to fly. By the time the chick has reached about four months of age, the family of three leaves the island and works its way to the upwelling near Peru, where the adults molt into nonbreeding plumage. When they return to the breeding colony five or six months later, they will have recovered their breeding finery. The offspring will not return to the colony for another three years, and when it does, it will be indistinguishable from the other adults.

The younger bird and the members of its age group will be genetically different from their parents in minuscule ways due to their various successes and their failures. That is what each preceding generation has done. That is how swallow-tailed gulls changed from the traditional sort of seagull to become so peculiar and so perfectly adapted to this unique set of circumstances. A nocturnal gull, capturing fish and squid, using the squid's own bioluminescence . . . amazing.

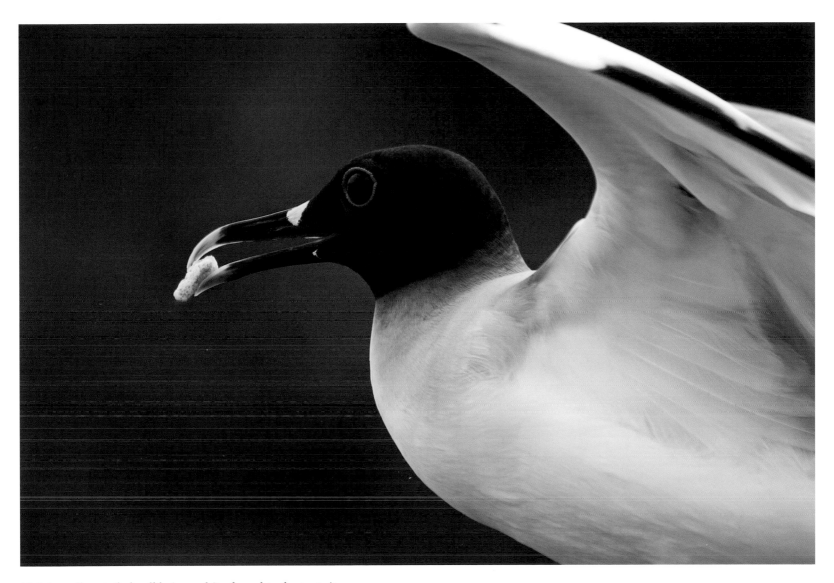

13.6 A swallow-tailed gull brings a bit of coral to the nest site.

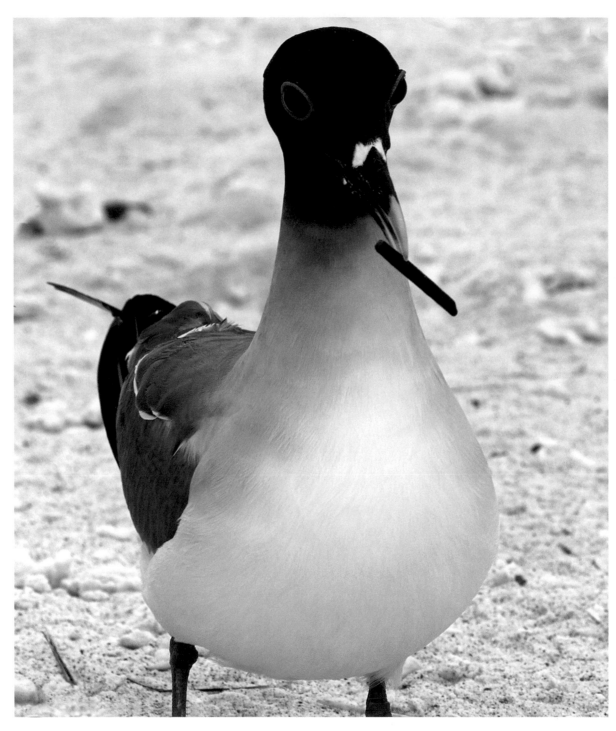

13.7 The collection and presentation of nesting materials, such as this spine from a pencil sea urchin, is an important behavioral component of the pair bond.

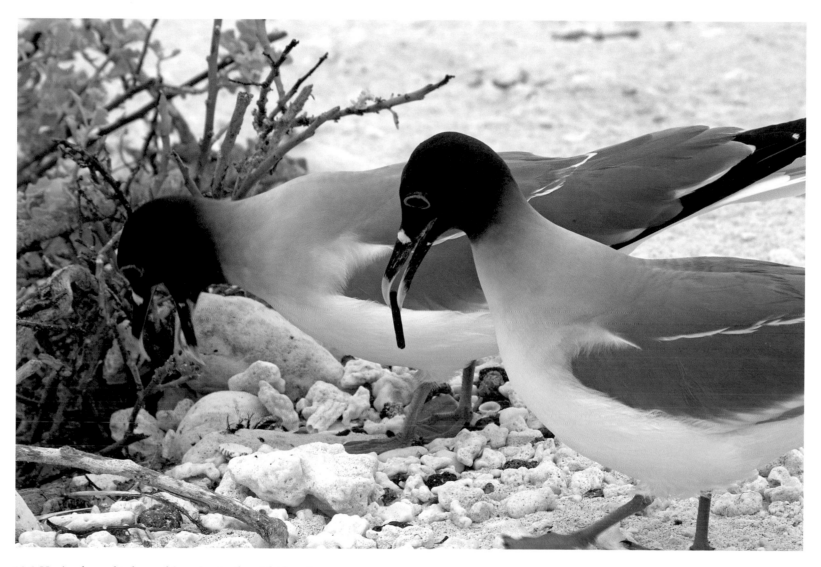

13.8 Having brought the urchin spine to the right location,
the birds must find the right spot for the nest.

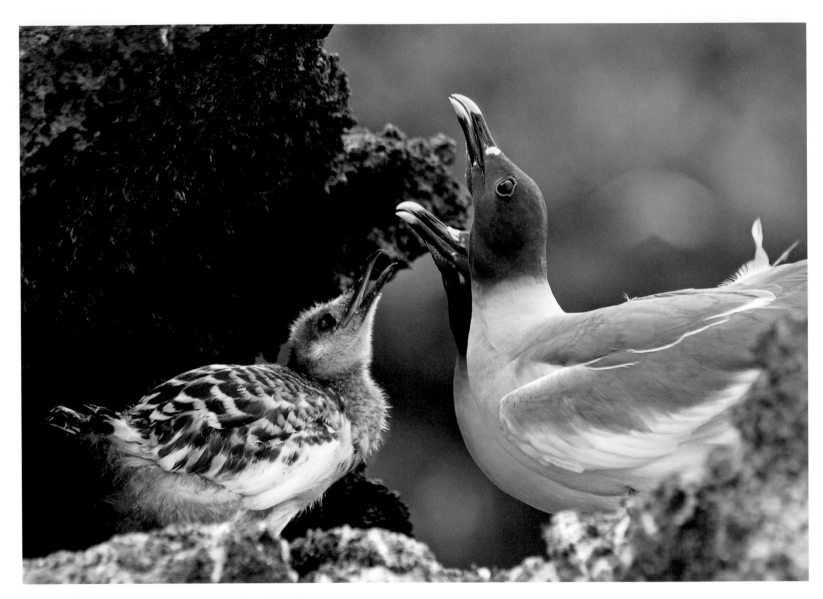

13.9 A chick about forty days old solicits food from its parents.

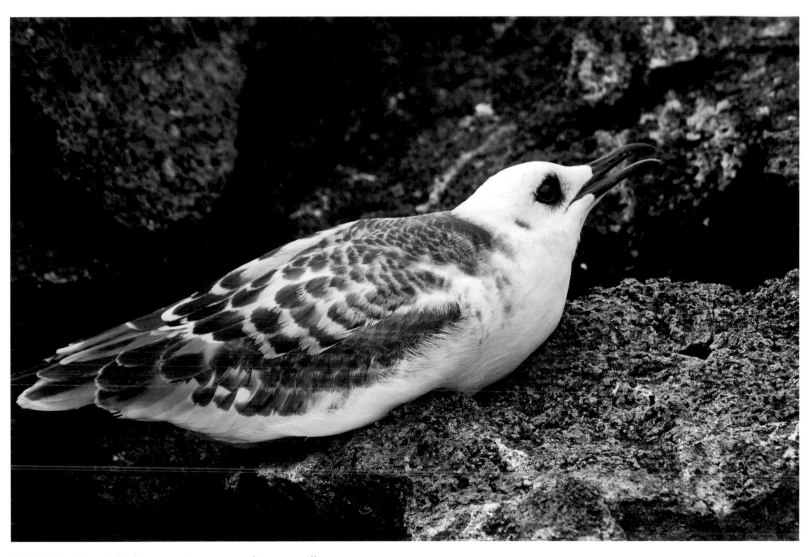

13.10 This fledged chick, now in immature plumage, will soon be leaving the islands, but it still begs food from the adults.

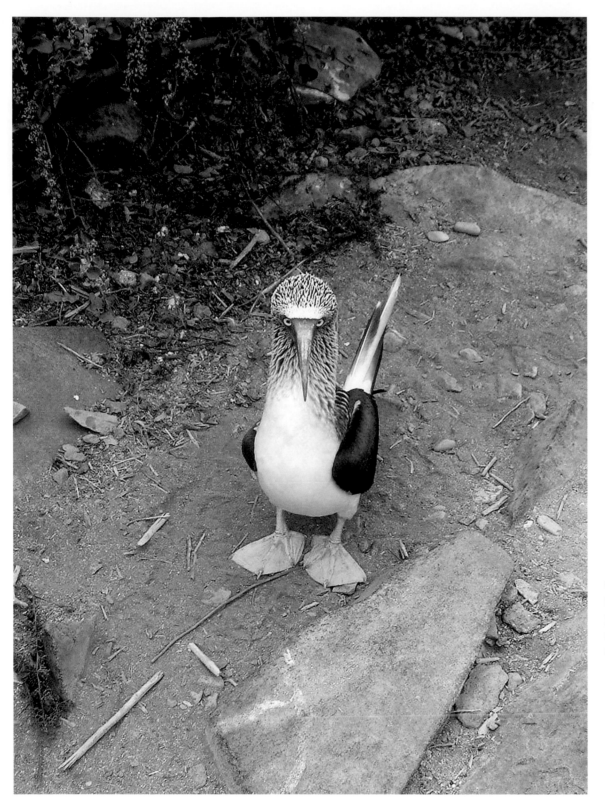

14.1 A blue-footed booby stands like a sentry on a well-worn trail on Española. Her posture, placement, and persona combine to present the perfect metaphor for the future of the Galápagos. *Regina Hess.*

14

Preserving the Sacred

In the end, we will conserve only what we love. We will love only what we understand.—Baba Dioum, Senegalese conservationist

The Galápagos Islands are different things to different people. They are an obscure bit of history for aficionados of the Age of Exploration and the days of buccaneers and whalers. They are the place to go for connoisseurs of vacation spots, and if the big boats begin to ply the islands, they will become a fashionable backdrop for floating casinos, a shopping destination, and a zoo. For the Galapageños, they are also a resource from which to make a living, and they are home.

The islands are clearly one of the world's great treasures. I view them as sacred, the same way Buddhists revere the Bodhi tree under which Gautama Buddha achieved enlightenment. Charles Darwin was not a religious figure, but the ideas he put forward are of mythic proportions. They provide a context for understanding our origins, our place on earth, and our relationships with all other living things. They make clear that we may use and enjoy this tapestry but that we do not own it. They illuminate the question of how we can best relate to those species with whom we share this small planet, species that not only enrich our existence but also make it possible. Attaining this understanding is the coming of age of our species.

Understanding Darwin's idea makes it clear that honoring our responsibilities as users of this tapestry is increasingly important in the pursuit of ethical behavior and self-interest. It would seem an easy sell because the consequences of our failure to act on these ideas are also of mythic proportions. And yet . . .

The history of human interactions with island ecosystems has been remarkably consistent and catastrophic. This is not the place to catalog this record of rampant exploitation, but it might be noted that economics is not the only dismal science. An example or two drawn from a vast literature will suffice to flesh out the claim. The dodo, from the island of Mauritius, was first recorded in 1596 and last recorded just sixty-six years later. Many species met the same fate as the dodo in the last thousand years or so—the thousand-pound elephant bird of Madagascar and the eleven species of moas from New Zealand come to mind. All of these birds were flightless, undoubtedly nutritious, and probably toothsome. All of these extinctions came with the arrival of humans. As noted earlier, islands are inherently fragile—island birds are about fifty times as likely to become extinct as mainland species, and the smaller the island, the greater the risk. For every extinct species, there are many whose populations are vastly diminished. They are the walking wounded, and they rarely recover. Fourteen species of birds from the Hawaiian Islands suffered major population decreases before they were pushed to extinction with the arrival of bird pox and avian malaria. Listing only the extinctions without acknowledging the threatened and endangered is like listing only the dead in a war. It implies that the wounded and maimed are not of consequence.

We are learning things from our past and current excesses. The Galápagos Islands are small, but they retain nearly all of their endemic species, and endemics are the most vulnerable. This record of success is a light in the dark. In part, it is a fortunate accident produced by the historic isolation and the desert ecology of the Galápagos, for which no one can take credit. More importantly, it is a testimonial to planning, conscious preservation of habitat, and extensive restoration efforts. It is worth studying what has been done to create such a success—maybe it can serve as a model for effective programs elsewhere.

The problems of the Galápagos are the problems of the world at large: overdevelopment of the land and habitat destruction, over-harvesting, introduced species, pollution. Too many people or too large a "footprint"—usually both. With the exception of alien species, these consequences are not problems in themselves so long as "sustainability" is the overriding consideration. Development can occur if it is consistent with honoring and preserving the very special character of this place, and so long as the ecosystem that supports it is sustained and remains vigorous. The same is true of harvests from both land and the sea. Even pollution, of the organic sort, is nothing more than fertilization unless present in excess. There are no technological barriers to attaining sustainability— only political barriers. The successes achieved in the Galápagos only prove the point.

The successive and comprehensive master plans, the strict zoning, the recent expansion of the Marine Reserve, and the careful regulation of ecotourists (who are now the principal source of income for the islands) are all models to be emulated. The issue is being aggressively addressed by organizations with a mass of acronyms, headed by the Galápagos Conservancy (GC) (formerly the Charles Darwin Foundation—CDF), the CDRS (Charles Darwin Research Station), the PNG (Parque Nacional Galápagos), and the GCF (Galápagos Conservation Fund) along with many others.

There are outstanding successes, especially in the first decade of this new century. The larger islands supported populations of pigs, donkeys, goats, horses, and cattle, plus cats, rats, and dogs, which have their own ways of being destructive. All were widely established, though some of the smallest islands were spared. Among hoofed animals, the goats are the hardest to control and the most damaging. They have been at work on the islands since 1822—even before the arrival of the HMS *Beagle*. They are close grazers that destroy much of the cover necessary for other species; they may graze less common species out of existence directly. They browse and strip vegetation and thus compete directly and very effectively with the tortoises, while they turn forests into barren grasslands.

By 2007, the work of the preceding five years had removed 140,000 goats from Isabela, bringing it into the fold with Pinta,

14.2 At the Tortoise Breeding Centre in Villamil, a hatchling tortoise, hopelessly soft and vulnerable, is shown with an egg that is still developing.

Española, and Santiago as having been successfully purged. The consequences are astounding. A Galápagos Conservancy evaluation notes, "Small trees began regenerating from the stumps left by the goats. Highland shrub species, forest tree seedlings, *Opuntia* cactus, and other endemic species increased. Scientists found several species that had previously been restricted to protected craters and fenced enclosures protected from goats." Isabela and Santiago have been rescued from their pig and donkey problems as well, and—amazingly—a rice rat, once thought extinct, has been discovered. These eradications of invasive species are very difficult, so such successes are heartening. The land iguanas that had been eliminated from Santiago have now been success-

fully reintroduced. Rare and endangered species are increasing their ranges and returning health to the ecosystem in a thousand ways. The Galápagos rail, a species of wading bird once thought to number only one hundred individuals, is now commonplace on Santiago, and young tortoises have access to an enriched food supply. Without a healthy vegetative cover, natural reproduction in the tortoises may never reach sustainable levels, but the reintroduction of so many endemic species—crucial threads in the tapestry—is assisting in reweaving the fabric so badly damaged by human indifference. It is a matter of dogged persistence and reclaiming the islands one at a time.

Finally there is the problem of being loved to death. People want to see the spectacle, and indeed, people *need* to see the spectacle. It is valuable to experience this special place. And the number of visitors to the islands has grown rapidly—to more than 140,000 in 2006. Providing a "Galápagos experience" to all of these people and more is a challenge. The Galápagos National Park Service with its naturalist-rangers does a wonderful job regulating access to productive places that can be carefully visited by small groups under knowledgeable supervision. However, pressures are increasing for more access, more boats, and bigger boats. The "Galápagos experience" is a valuable resource for the island, perhaps its most valuable resource, but the experience is fragile and individual. It simply cannot be mass-produced.

In the real world, it is essential that the people who hold something of value in trust for all of us should benefit from that stewardship. It is a fact of life that is eminently Darwinian. Much of the conservation action in Galápagos is financed by tourism visitation. There are seven ecotourist companies that partner with the Galápagos Conservancy; among them, Lindblad Expeditions appears to be the most active and demonstrates responsible ecotourism at its best. Lindblad benefits from the special places in the world and makes a profit, but more than that, the company is an active participant in protecting them.

Lindblad does this in two ways. The first is to release a battalion of excited and informed visitors into the world. Between 1997 and 2006, Lindblad Expeditions, which had both a mechanism

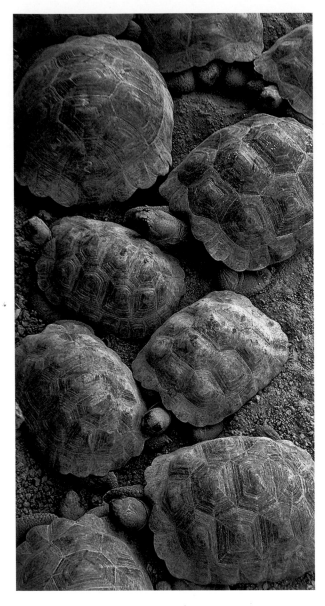

14.3 These tortoises are waiting to graduate from the Tortoise Breeding Centre, certified as rat-proof—large enough to be safe from rats—after five years of care.

and incentives to do so, collected $3.5 million dollars in donations from its passengers. And as the numbers of visitors increase, the donations have increased. Their current rate of giving is about a million dollars per year. All of that goes to the Galápagos Conservation Fund to assist conservation efforts on the islands and to support research and eradication efforts. To that end, Lindblad has "adopted" the island of Santiago, where much of the progress reported above has been funded by these gifts.

At this moment the potential of the archipelago is blossoming. Much work has been done and there is every reason to expect more progress. There has been brilliant science, devotion to a cause, elaborate strategic planning, and hard work by visionaries who are both talented and dedicated. There are of course conflicting values; most particularly, there is conflict between the need to conserve this remarkable place and the need to join with the other life forms in using its wealth of food and in shaping the environment to our needs. These conflicts would be inevitable even if the whole archipelago were given over to science.

Our power to extract food from the environment and to shape it to our tastes has become enormous, and we have yet to demonstrate an ability to limit our expansion. The complexity of the global tapestry guarantees that any human actions will produce not only the anticipated consequences but also a long chain of secondary and tertiary effects that more often than not surprise even professional ecologists. The unanticipated consequences have a way of dwarfing the intended ones, and they will be unfolding for centuries.

As a visitor approaches the Galápagos Islands from the air, there is a moment when a perfect visual metaphor for the future appears. At that precise moment, the destination is just out of sight, and anticipation itself almost wills it into being. It is a look into the future that is murky but suggestive. Whatever the future brings, it will impact the Galápagos too, and those changes will make this sacred place even more precious.

14.4 Approaching the Galápagos from the air.

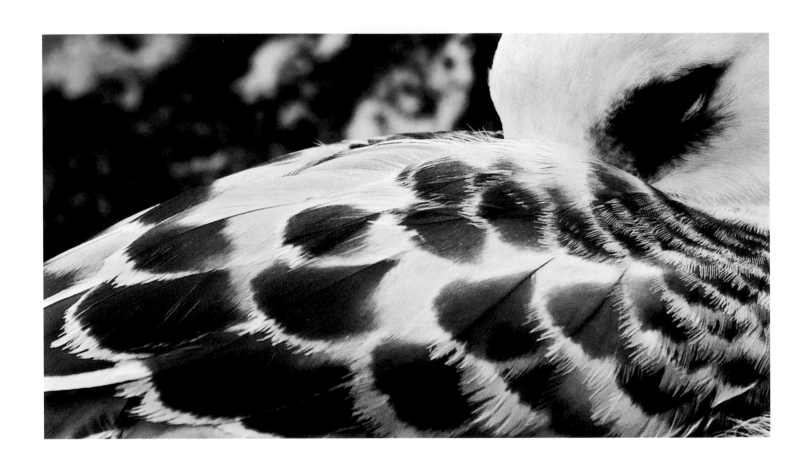

Index